GRAPHER'S CITY

EDITED BY **MARLA HAMBURG KENNEDY**

ASSISTANT EDITOR **HELENA FANG**
FOREWORD BY **ELISABETH SUSSMAN**
INTRODUCTION BY **STEVE HAMBURG**

RIZZOLI NEW YORK

New York · Paris · London · Milan

DOUG AITKEN DAVID ALLEE THEO ANDERSO[N]
BARBIERI ADAM BARTOS ERICA BAUM MAR[I]
BLASCO DON BURMEISTER ED BURTYNSKY G.[..]
KEVIN COOLEY CARL COREY JESSICA CRAIG-M[..]
JAKE DOBKIN DAVID DREBIN MICHAEL EAS[...]
FALCHOOK JOHN FITZGERALD DOUG FOGELSO[N]
FUNCH RICHARD GALPIN ANDREAS GEFELL[...]
GOICOLEA PETER GRANSER PHILIPPE GRONC[...]
HELGASON DAVID HILLIARD NORITOSHI HIRAKA[...]
IM HANA JAKRLOVA BETTINA JOHAE LISA K[...]
LEBAIN MICHAEL LIGHT ALEX MACLEAN LUIS[...]
MEILIJSON JEFF MERMELSTEIN PATRICK MI[...]
CATHERINE OPIE TONY OURSLER MARTIN PA[R...]
JACK PIERSON MATTHEW PILLSBURY MUZI [...]
ANDREA ROBBINS AND MAX BECHER LUCAS [...]
BASTIENNE SCHMIDT JAMEL SHABAZZ TIMO S[...]
BEAT STREULI THOMAS STRUTH HIROSHI SUG[...]
TILLMANS KWONG CHI TSENG SPENCER TUNICK[...]
WILLIAM WEGMAN JAMES WELLING MICHAEL W[...]
WIGHT STEPHEN WILKES OFER WOLBERGER [...]

DAVID ARMSTRONG JOSE BALLESTER OLIVO
A BAUMGARTNER JIMI BILLINGSLEY ISIDRO
RY CARSLEY YASMINE CHATILA PHIL COLLINS
RTIN JOHN CYR TIM DAVIS IANNIS DELATOLAS
MAN GERRIT ENGEL ROE ETHRIDGE JAMES
ANDY FREEBURG BARRY FRYDLENDER PETER
R RALPH GIBSON JOHN GLASSIE ANTHONY
I ANDREAS GURSKY NATHAN HARGER SKUTA
VA JOSEF HOFLEHNER JENNY HOLZER SANGBIN
ESZI ATTA KIM VINCENT LAFORET FREDERIC
MALLO ELAINE MAYES RYAN MCGINLEY DANA
RAN ABELARDO MORELL VIK MUNIZ LORI NIX
CHI PENG PASCAL PERICH SCOTT PETERMAN
JAWSON LARRY RACIOPPO ARASH RADPOUR
MARAS LYNN SAVILLE KATE SCHERMERHORN
AMMBERGER ANDREA STERN JOEL STERNFELD
MOTO BEN SWETT ED TEMPLETON WOLFGANG
RIAN ULRICH MASSIMO VITALI ROBERT VIZZINI
SELY TIM WHITE-SOBIESKI SUSAN WIDES SARA
ATT GALLERY MARC YANKUS SAMUEL ZUDER

First published in the United States of America in 2011 by
Rizzoli International Publications, Inc.
300 Park Avenue South
New York, NY 10010
www.rizzoliusa.com

COVER David Drebin
Central Park, 2006
C-print
40 x 96 in.
Courtesy David Drebin
© David Drebin

2011 2012 2013 2014 2015 / 10 9 8 7 6 5 4 3 2

Printed in China

Library of Congress Control Number: 2010933947

ISBN-13: 978-0-8478-3584-3

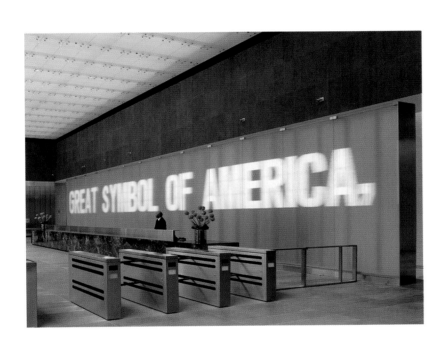

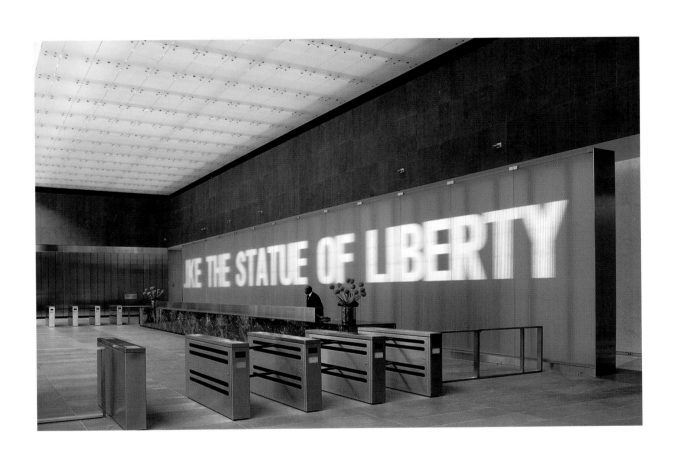

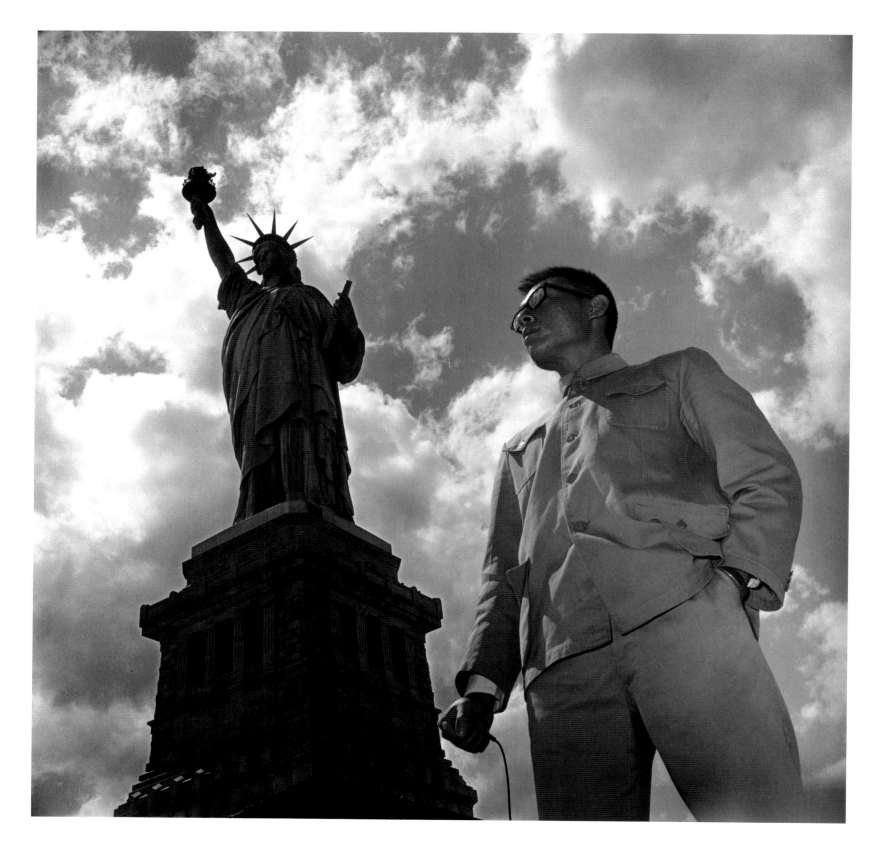

ELISABETH SUSSMAN

FOREWORD

New York has been a photographer's city and a filmmaker's city since the late nineteenth century. Our collective memory of the city's past begins with images made from box cameras and early flash technology. Prime examples of this are Jacob Riis's 1890 work *How the Other Half Lives*, pictures of tenements and their inhabitants; and from black and white silent films such as the Biograph Company's 1905 *Interior, New York Subway, 14th St. to 42nd St.*, a film about what exists under the city's streets. Photographers have captured the pulse of the place: views of the island of skyscrapers seen from the water; perilous shots of the pinnacles of the highest buildings under construction; aerial views of the readymade abstraction of meandering park paths; allegories of social spaces observed in workers pacing the streets; the documenting of scenes of dreadful crimes; and in the groups of partying habitués of fabulous nightclubs. All of these images are multiplied in the backdrops of other quintessential films of the city, such as the existential nighttime street views below the Queensborough Bridge in *The Sweet Smell of Success*, or the glitter of Fifth avenue luxuries at 5 AM in *Breakfast at Tiffanys*. People in New York, residents and visitors alike, move within a visual tableau of mythic proportions.

Gathered in *New York: A Photographer's City* are a wide range of photographers who have turned their cameras toward New York today. Yes, they are part of a long tradition of artists

depicting the city; but their work is not nostalgic. The basic geography—a crowded island connected by bridges to neighboring boroughs—is seen with fresh eyes. The post-war high-rise buildings that together fashion a city of glass glisten as never before with multiple reflections. The teeming traffic is captured as a Futurist blur. The buildings and streetlights at night disintegrate in an impressionistic haze. Aerial views of postmodern buildings are miraculous, the crop of peaks lending the city an Oz-like allure. Some views of the dense sprawl of urban streets from the air are very different: oppressive, ensnaring, and mazelike. Sometimes, the atmosphere of the city sky seems toxic, darkened by spurting smoke or chemical emissions. At other times the thin air and brilliant sun at the height of the tall buildings is nearly Italianate in its sheer beauty. The new glamour of high tech glints in shots of beautiful women sitting in penthouse living rooms. And the Statue of Liberty continues to beckon new immigrant populations.

But there is one outstanding change that marks the difference between past images of New York from new: the transition from black and white to color photography. In this book, as with other compilations of contemporary photography, color dominates. Previously, New York's image had always seemed tethered to the beauties of black and white, to the chiaroscuro of the grayscale, as if lack of color was the equivalent of the grim, the dour, the tough, the architectural, the contrasts between night and day that became trademarks of the city's psychology and geography. Moreover, color photography was traditionally linked to the commercial world and was admitted quite late into the ranks of serious stand-alone images. There were a few exceptions, such as color street photography by Helen Levitt and Saul Leiter. It wasn't until William Eggleston's 1976 color photography exhibition at the MoMA—even though he never photographed New York—that a sizable group of artists routinely began to shoot New York in color. Therefore, the images collected here are a revelation of a very special sort because they force the viewer to register the hues of light, weather, night, day, streets, and stone, and the cacophony of products, signs, and building surfaces that constitute the kaleidoscope of urban experience.

The generation of artists in this book came of age when the permanency of color in printing was achievable. But this is not the only technology from which contemporary photographers of New York profit. Undoubtedly, the other major change in the practice of this generation has been the digital revolution, which allows for all sorts of manipulations in the processing of the image: changes in color, expansion of the scale of details, the suppression of areas of representation and the predominance of others, and many other

potential treatments. The technological landscape is vast and the expressive range is large when combined with the epic scope of the great metropolis. Obviously, very traditional photographic methods, such as camera obscura, are still interesting and seem as fresh as the newest technology.

Finally, amid all the physical uniqueness of arguably the greatest city of the world, it is the image of its population—both permanent and transitory—that haunts past and present photography of New York. All of the great photographers of New York have represented its essence as revealed in the eyes and actions of people on the street or in the parks. We need only to conjure up Diane Arbus's pictures of a boy with a hand grenade in Central Park, or Gary Winogrand's photographs of people at the zoo or walking crowded streets on a hot day. There are many more wonderful examples of such chance encounters in the tradition of New York photography, and each famous image from the past provides an essential interpretation of New York at that very moment. These photographs of people in the city today also speak to what it is like to be there at this moment: when different reasons drive the need to be present in New York, whether drawn there by the power of its cultural monuments like the Japanese strollers walking the rooms of the Museum of Modern Art, or by the potential for a new beginning in the bodegas of the outer boroughs. Without an overt social agenda—such as Jacob Riis's motivations during the dawn of photography at the beginning of last century—contemporary photographers nonetheless gaze at New York City not only with wonder but also with compassion.

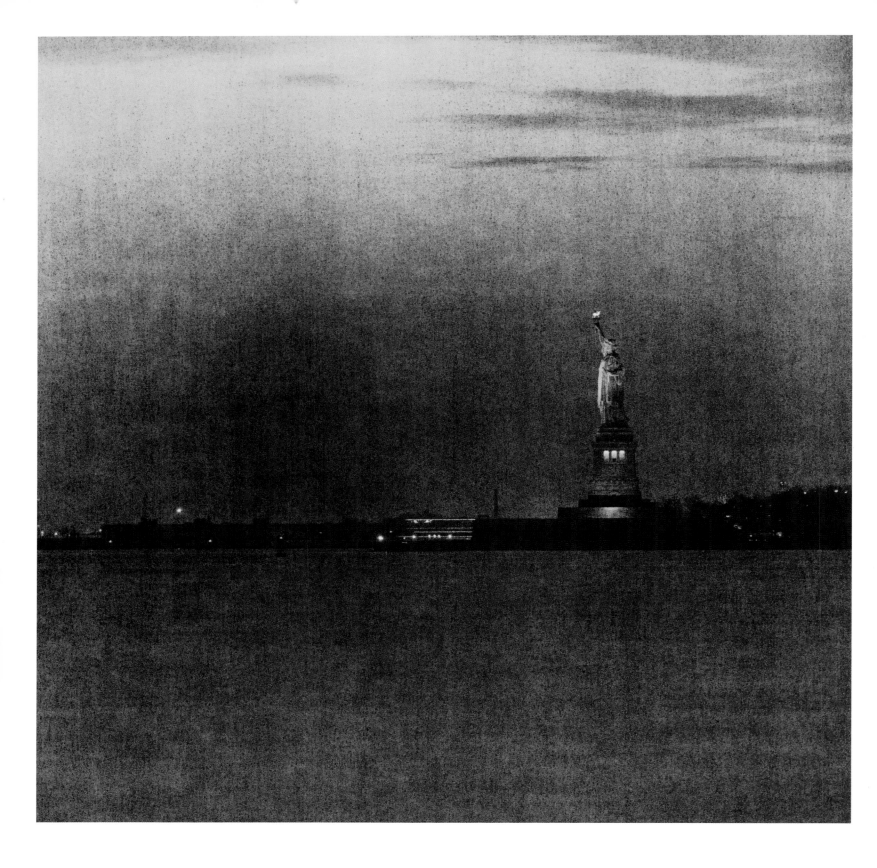

STEVE HAMBURG

INTRODUCTION

Even as other metropolises rise around the globe and pierce the sky with new variations of glass and steel, New York City remains the quintessential urban expression, a protean force that captures the dynamic and evolving nature of our identity and aspirations.

This visual and cultural dynamism continues to attract artists and inspire creative expression of every sort. Yet, of all the arts, photography has a unique capacity to capture the essence of the place, given the distinctive ways in which New York expresses itself both visually and in the moment.

Indeed, photography and New York—medium and subject—are deeply and meaningfully aligned. Both mingle tradition with technology. Both emphasize immediacy and directness. And both are expansive, steadily pushing against barriers and constraints as they edge into new realms.

Whereas painting retains something of the pace and attitude of its pre-industrial origins, photography has always embraced newness, given its reliance on the latest devices and practices, whether mechanical, chemical, or digital. One could even say that photography's marriage of the technological and the artistic—the rational and the intuitive—makes it

characteristically New York. Both are distinctly modern creations that derive their power from a multitude of sources.

In the previous century, artists such as Berenice Abbott, Alfred Stieglitz, Edward Steichen, and Margaret Bourke-White were also drawn to the city. It's no coincidence that so many of their most iconic images are architectural, given the degree to which buildings—think Empire State, Chrysler, Flatiron—were so expressive of the times. This New York was *vertical,* a place of upward thrust and boundless ambition. The restless energies of the place were directed inward, toward the central, skyscraping core of Manhattan.

New York remains a quintessentially vertical city. In recent years, however, the zeitgeist has shifted. New York has become more centrifugal, a place of *outward* thrust. The cultural center of gravity has shifted from Manhattan to places like Williamsburg, Bushwick, Greenpoint, and Astoria—not to mention Jersey City. *This* New York City speaks with a different kind of visual language, the language of texture and color rather than just the language of bold form.

New York's outward thrust has been driven by a variety of cultural and economic forces. Arguably, the most significant has been the ever-escalating level of real estate prices. Since the 1980s, wealth has been concentrating in Manhattan, governed by the rising dominance of Wall Street and the global financial services industry. With the costs of Manhattan real estate becoming progressively higher, the outer boroughs received fresh demographic infusions comprised of the educated and affluent, which added a different kind of vibrancy to the cultural and ethnic communities that already existed in those areas.

In considering New York's shift from the centralized and vertical to the outward and horizontal, one other factor deserves mentioning: the events of 9/11. Since the 1970s, the World Trade Center had come to symbolize the vertical city. Although its merits as architecture and urban design continue to be debated, the Twin Towers had undoubtedly become a cherished presence in the cityscape, admired for their purity of form and for the way they hovered serenely and, to some, even protectively over lower Manhattan. Their destruction, in addition to the incalculable human cost, was, on some level, emblematic of a cultural shift away from "upward" to "outward."

In the collection of images that follow, you will get a striking and variegated picture of New York City in motion—outwardly, inwardly, vertically, and horizontally. In the abandoned Brooklyn warehouses that Stephen Wilkes animates with color and texture; the outer borough banalities that Joel Sternfeld makes memorable; or, in the causal street ballets of Peter Funch, you will get a vivid portrait of New York in its post-heroic glory. Yet, from artists like Jean Michel Berts and Chi Peng, we can still see how soaring architecture is expressive of complex moods and emotions.

Through all the ways it articulates itself, through its incomparable density of feeling and meaning, New York City remains a singularly vibrant place—and subject—that continues to captivate the eye, the mind, and the soul.

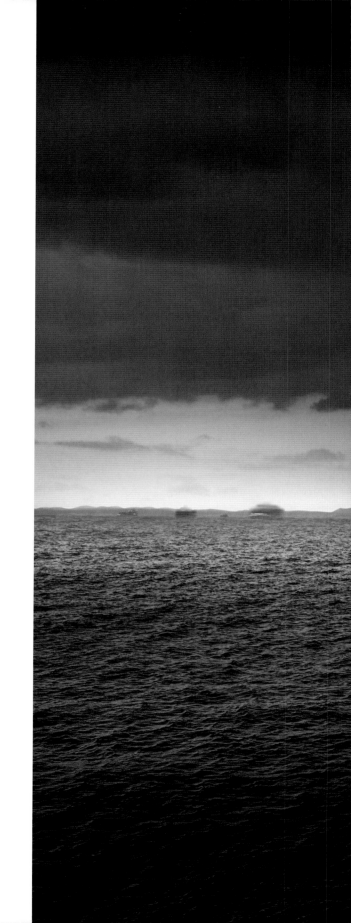

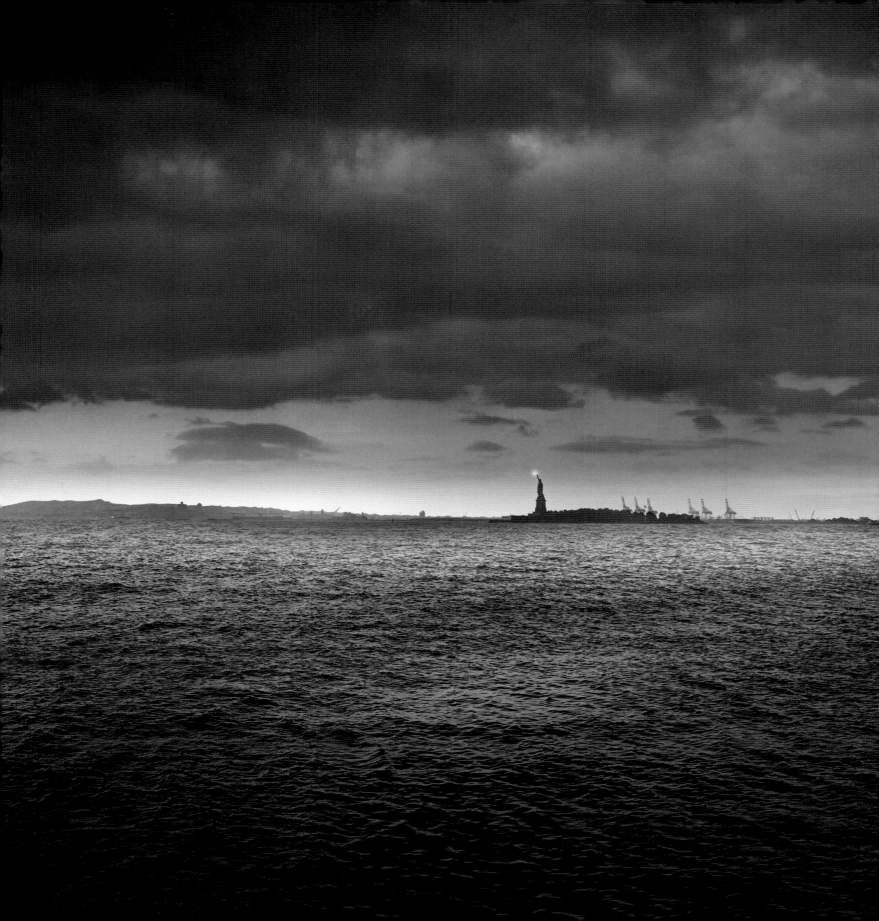

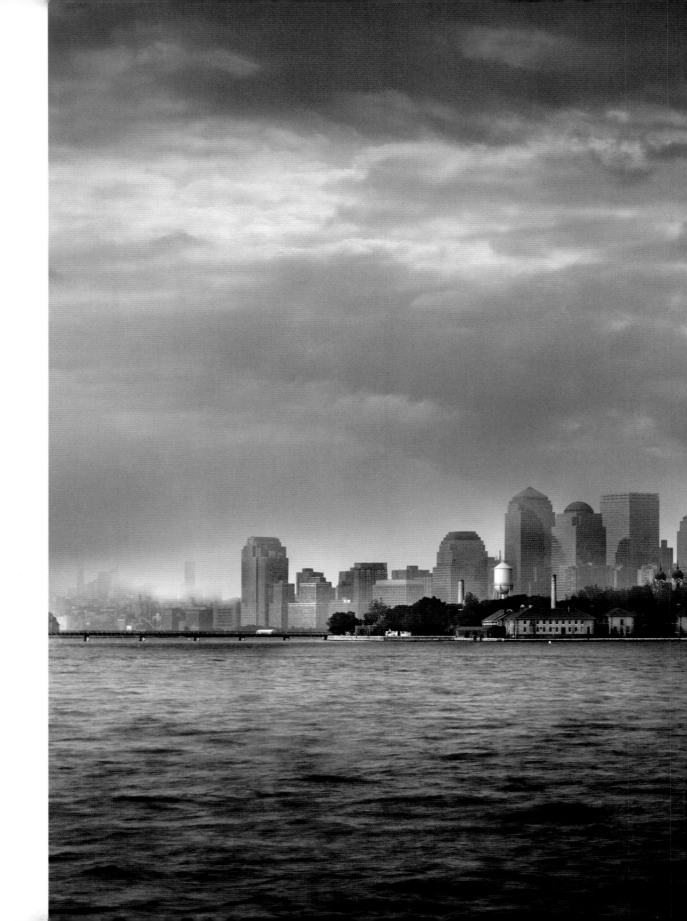

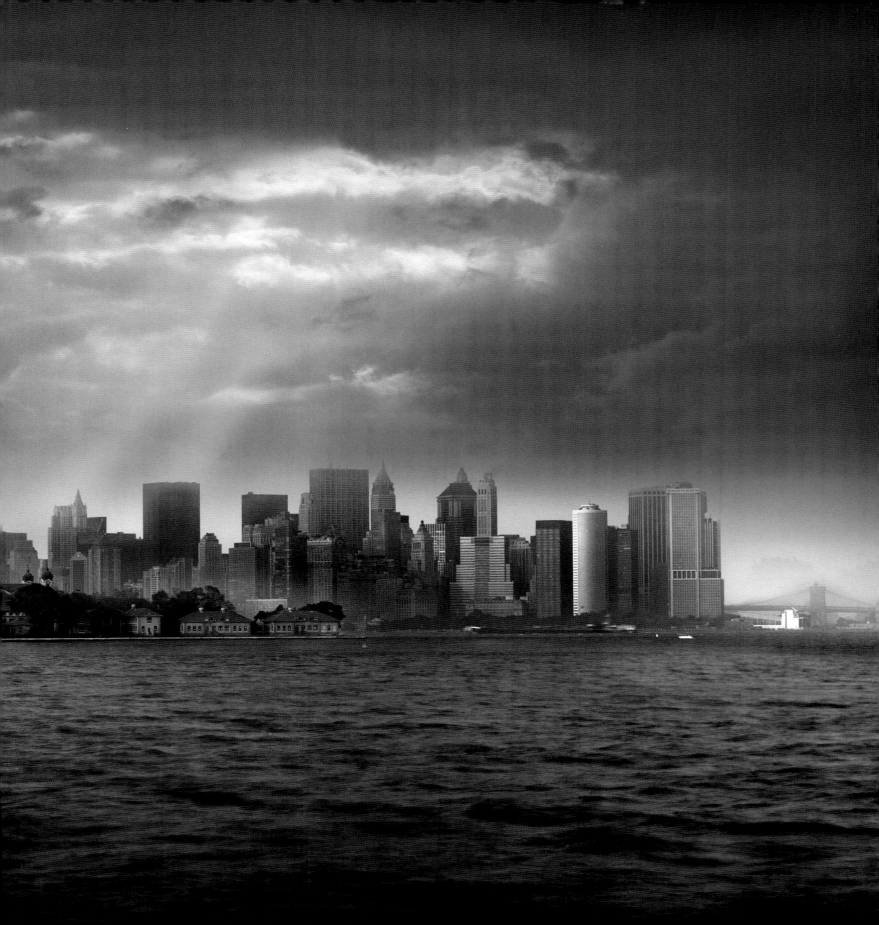

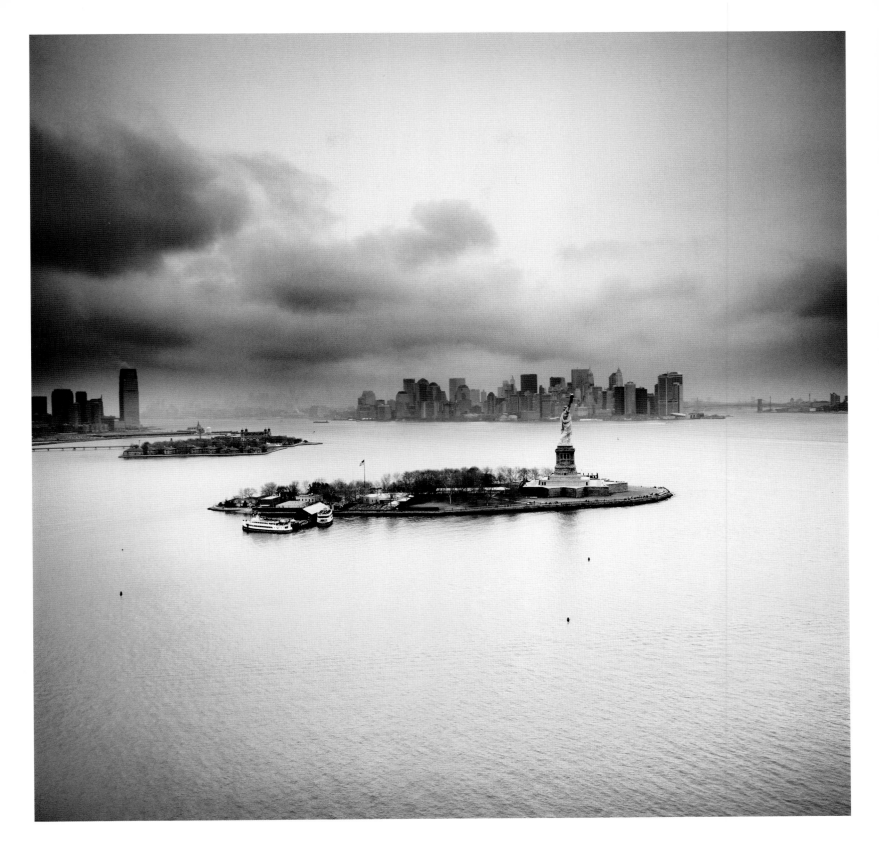

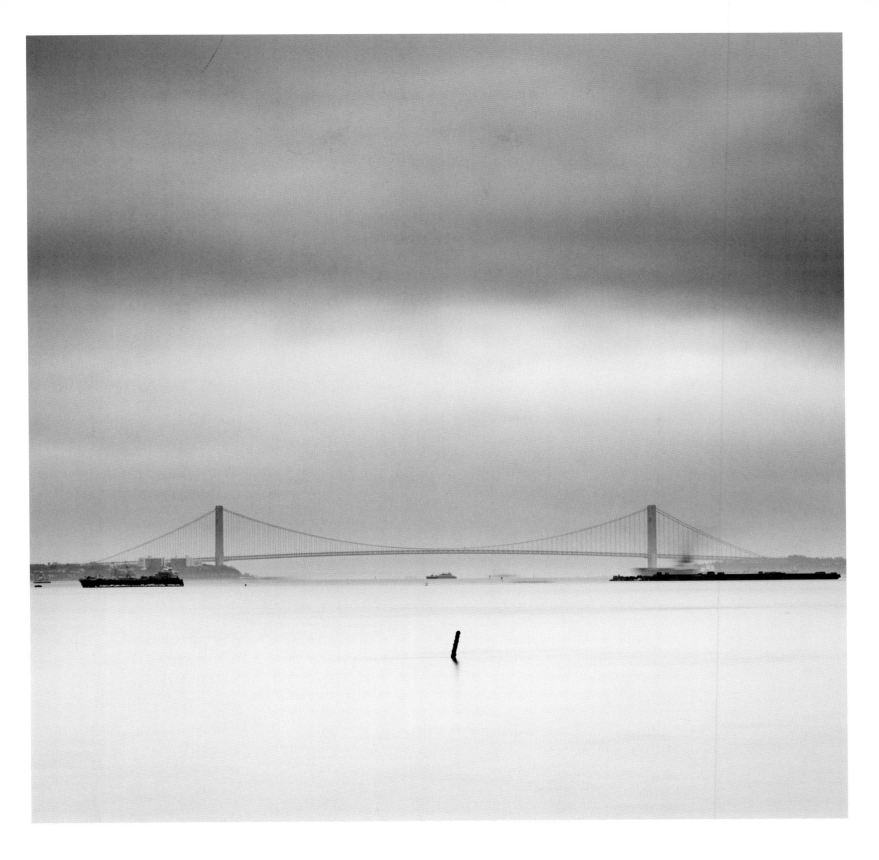

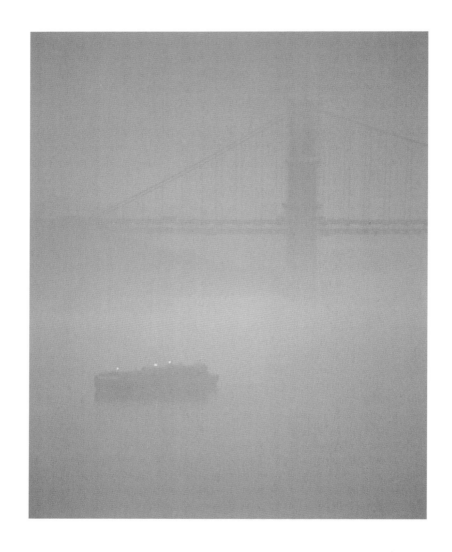

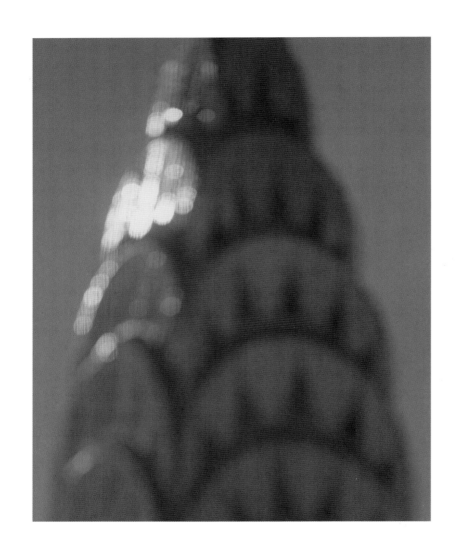

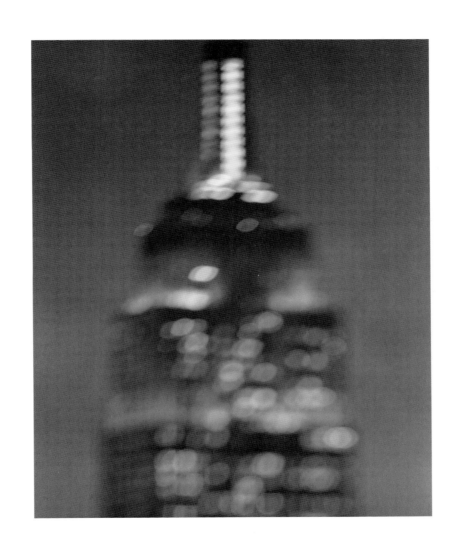

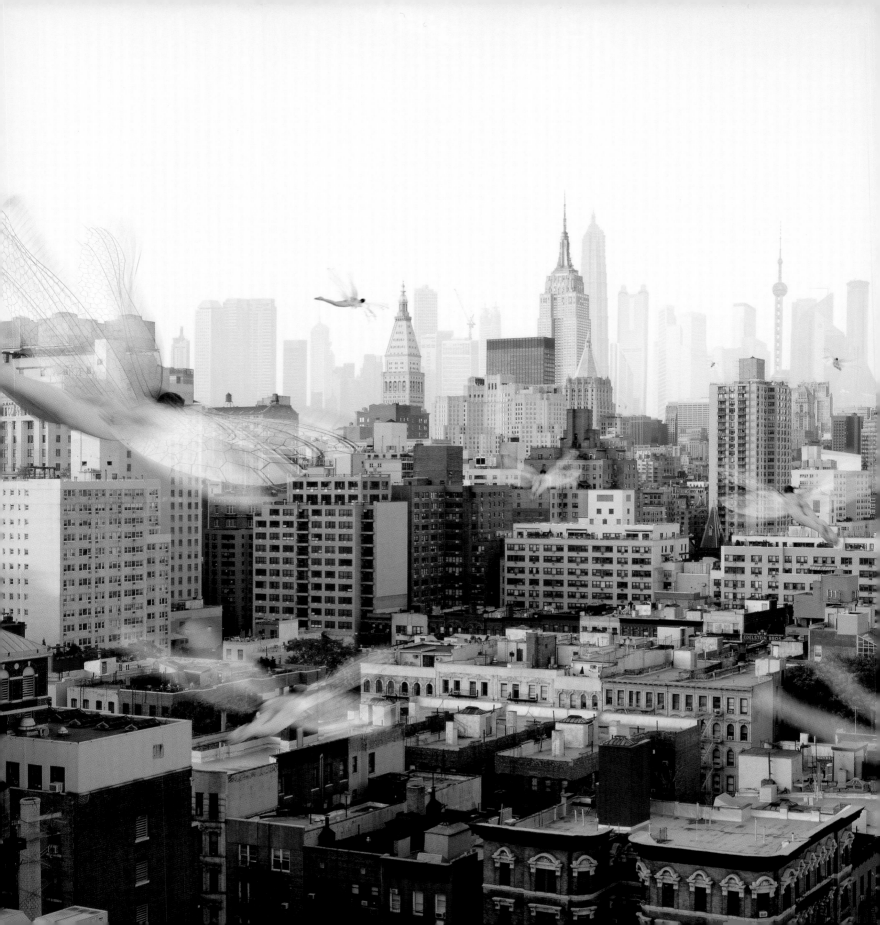

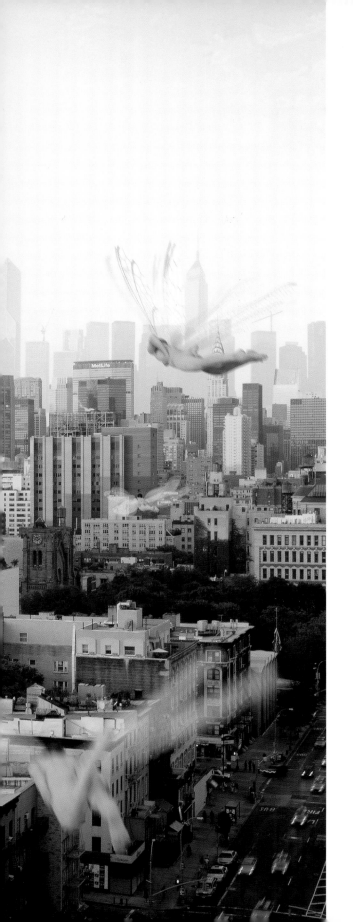

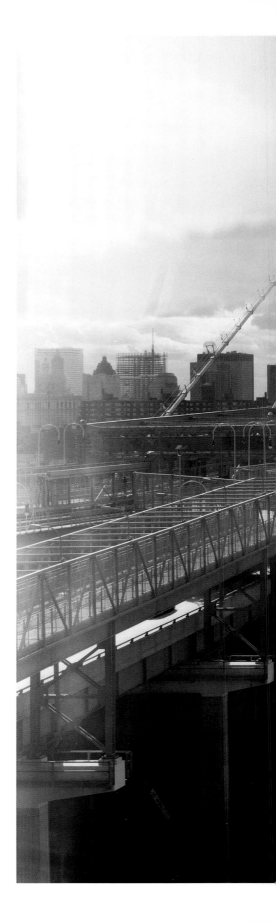

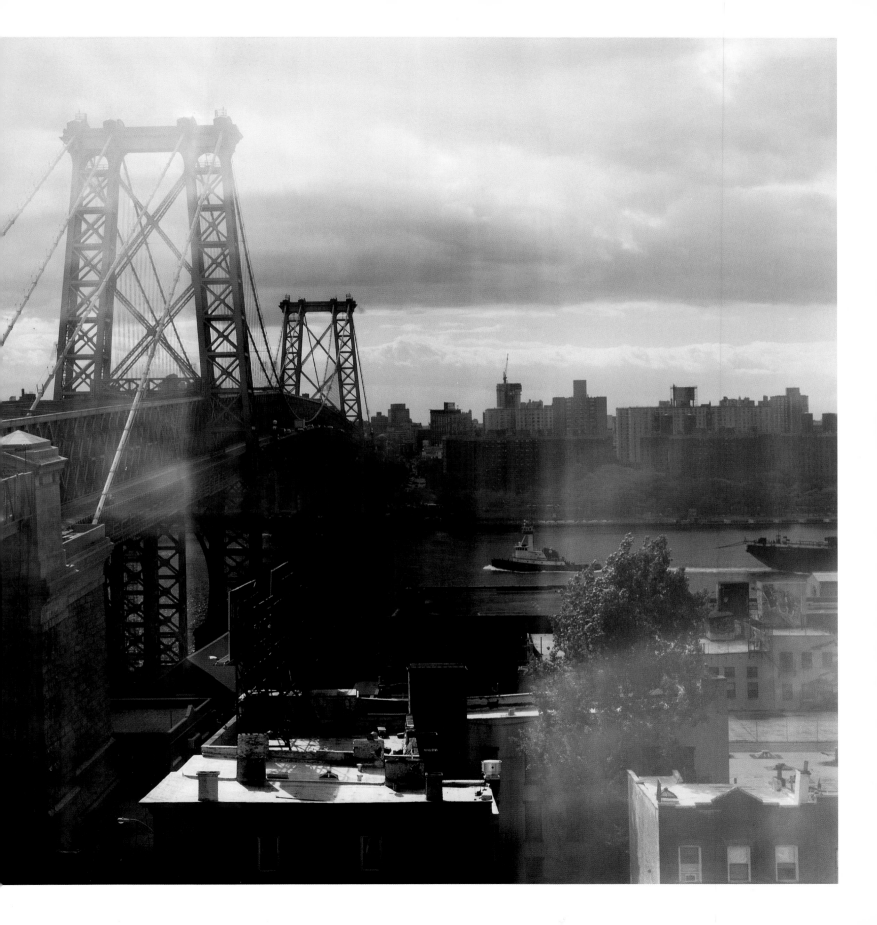

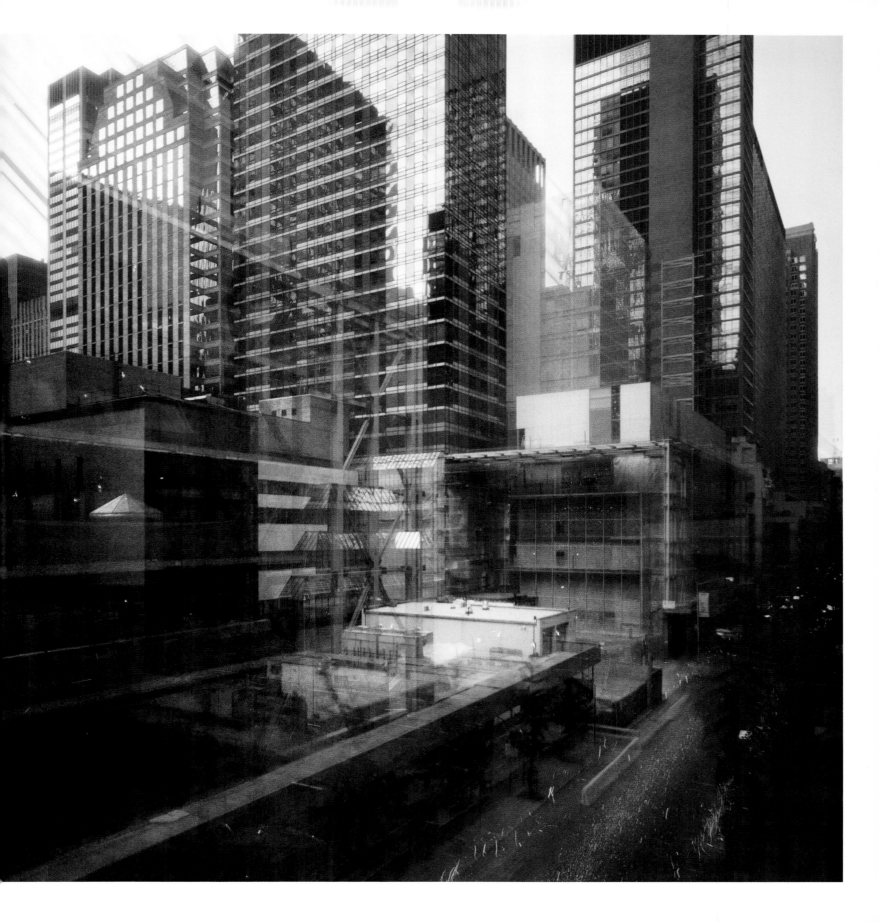

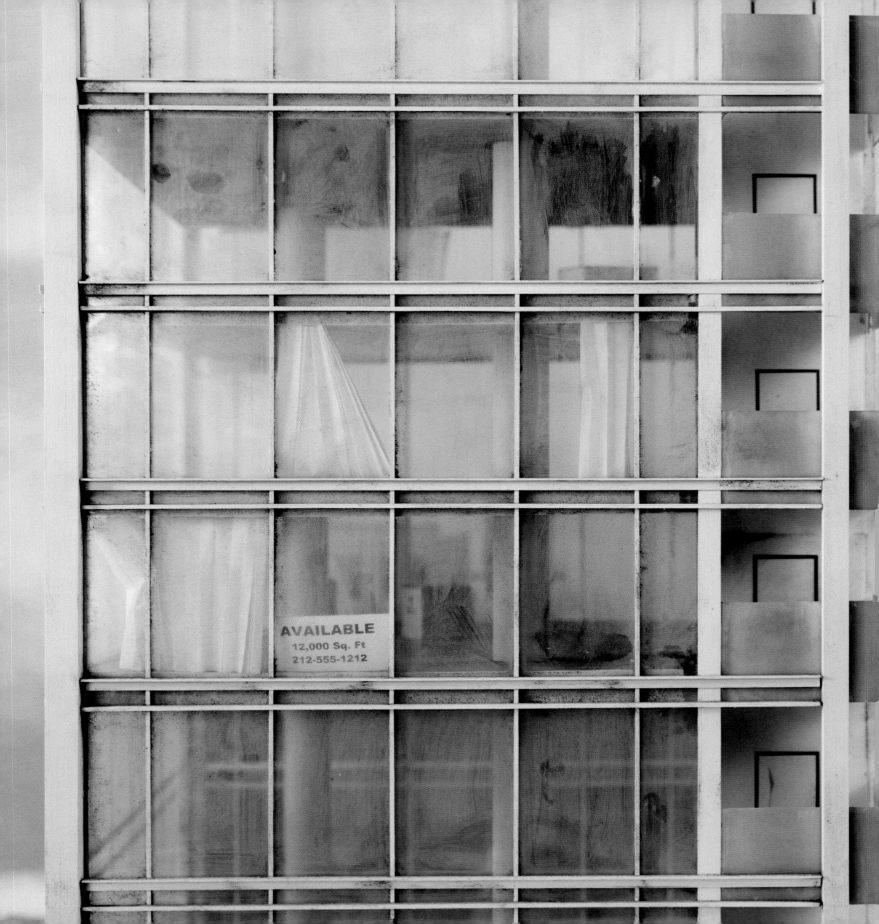

AVAILABLE
12,000 Sq. Ft
212-555-1212

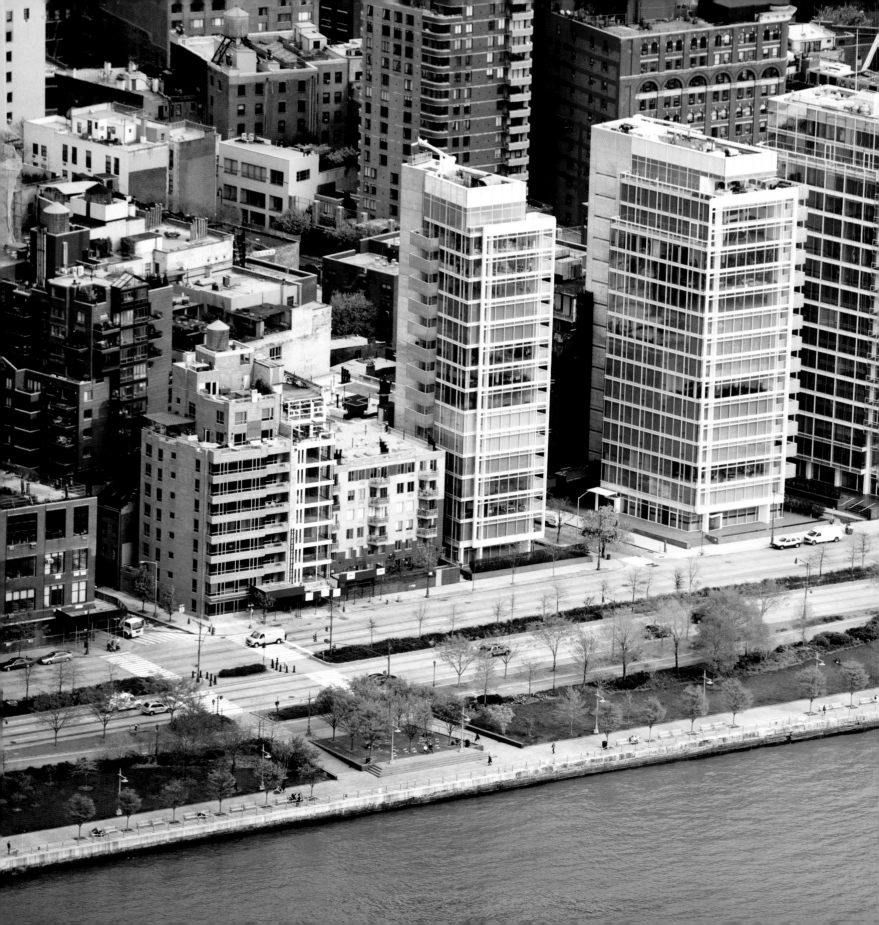

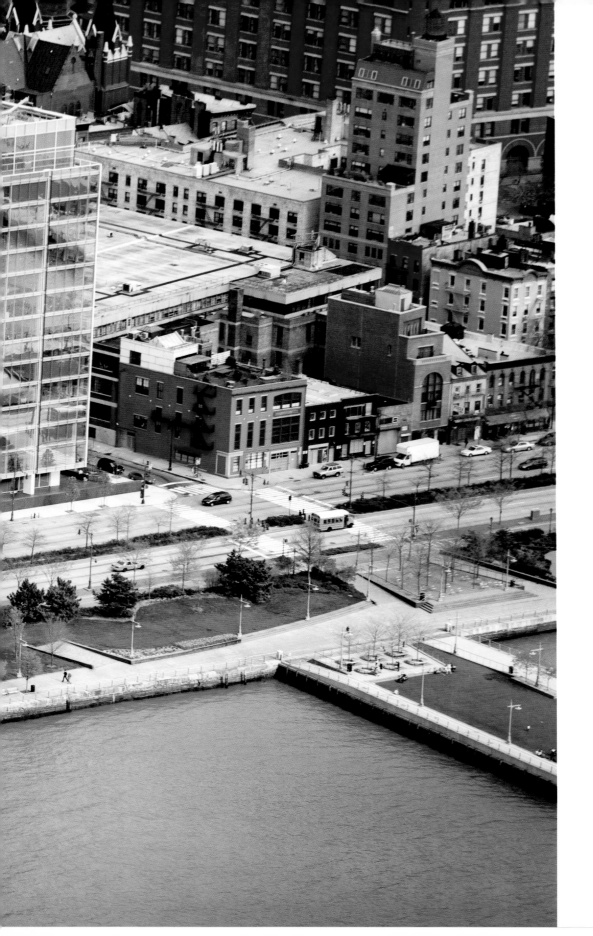

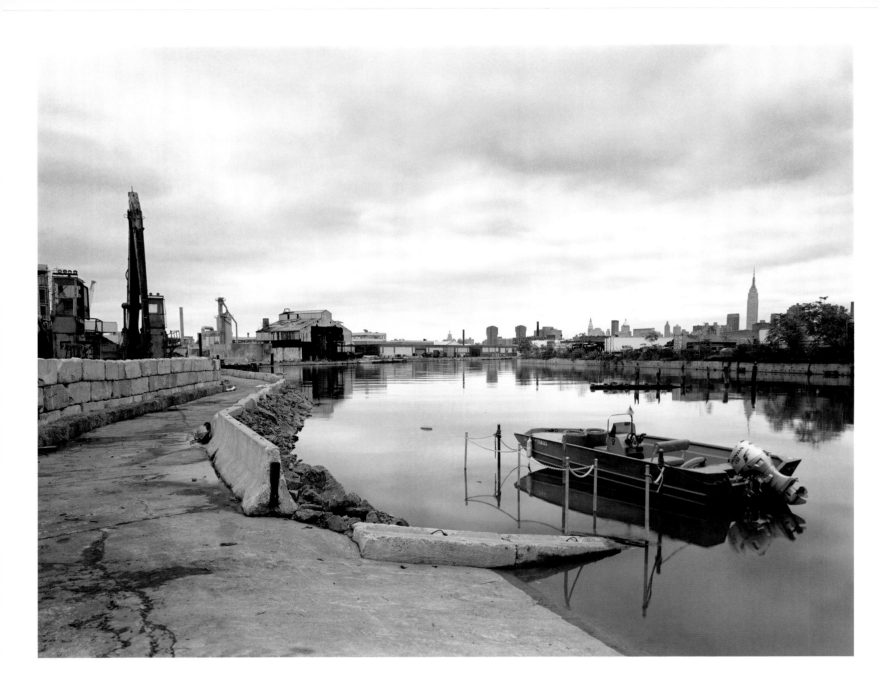

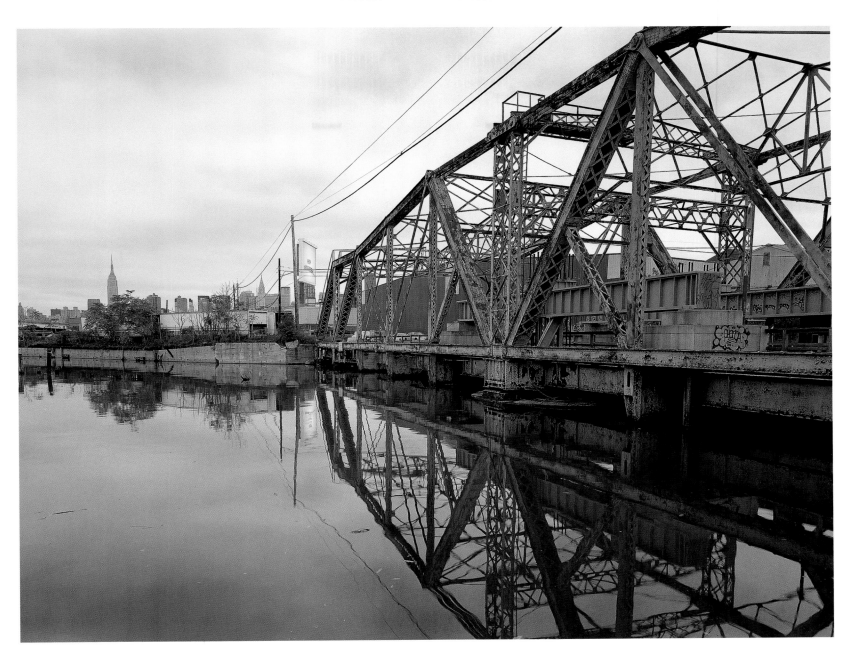

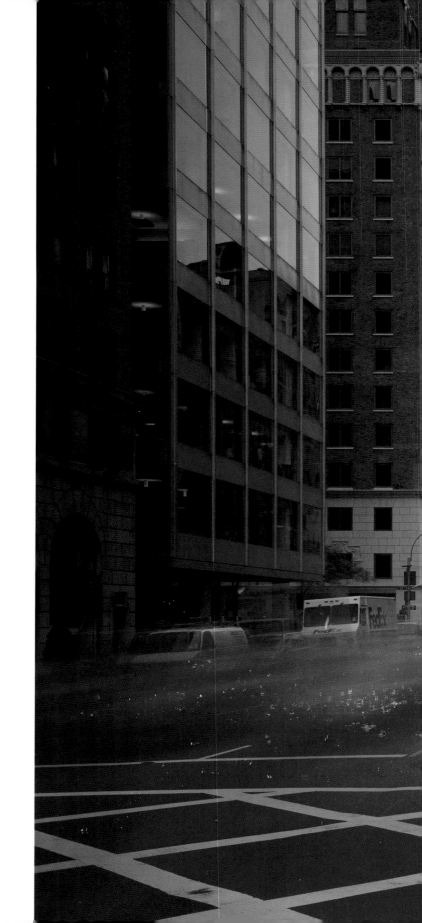

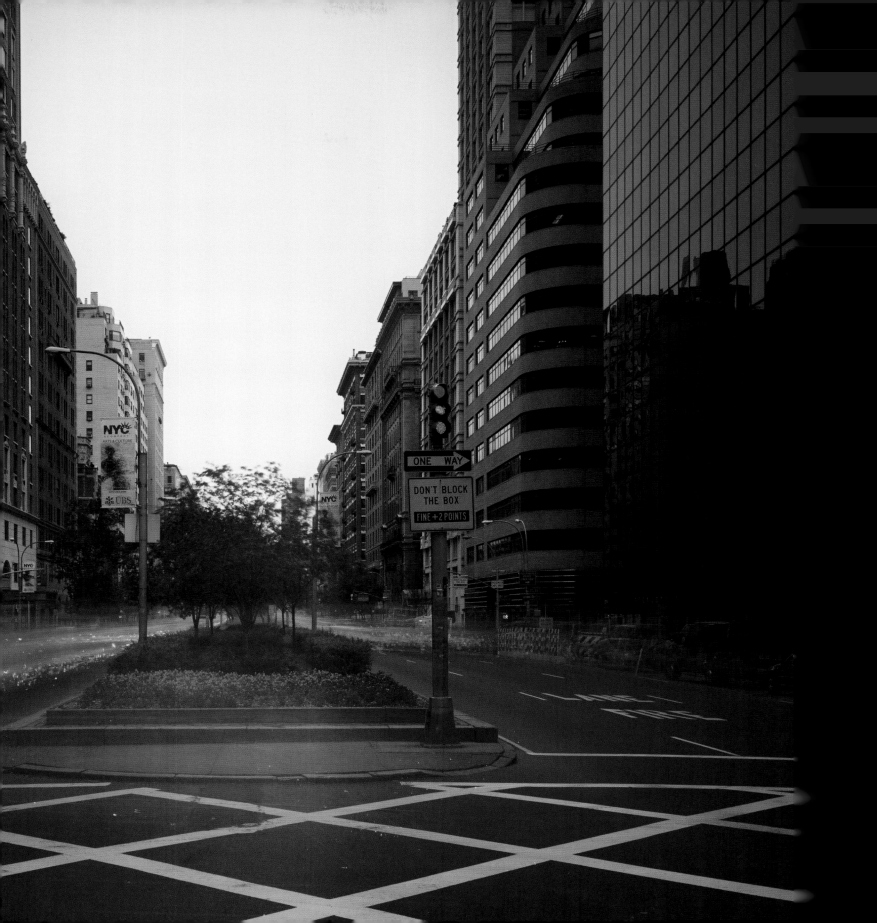

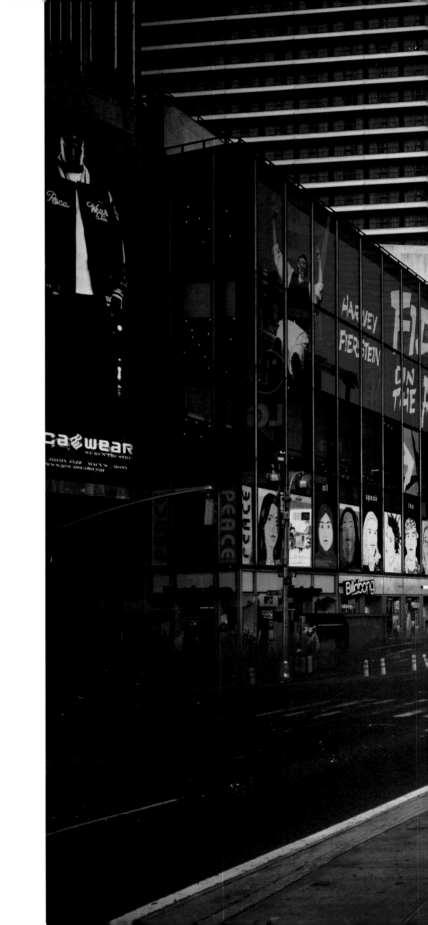

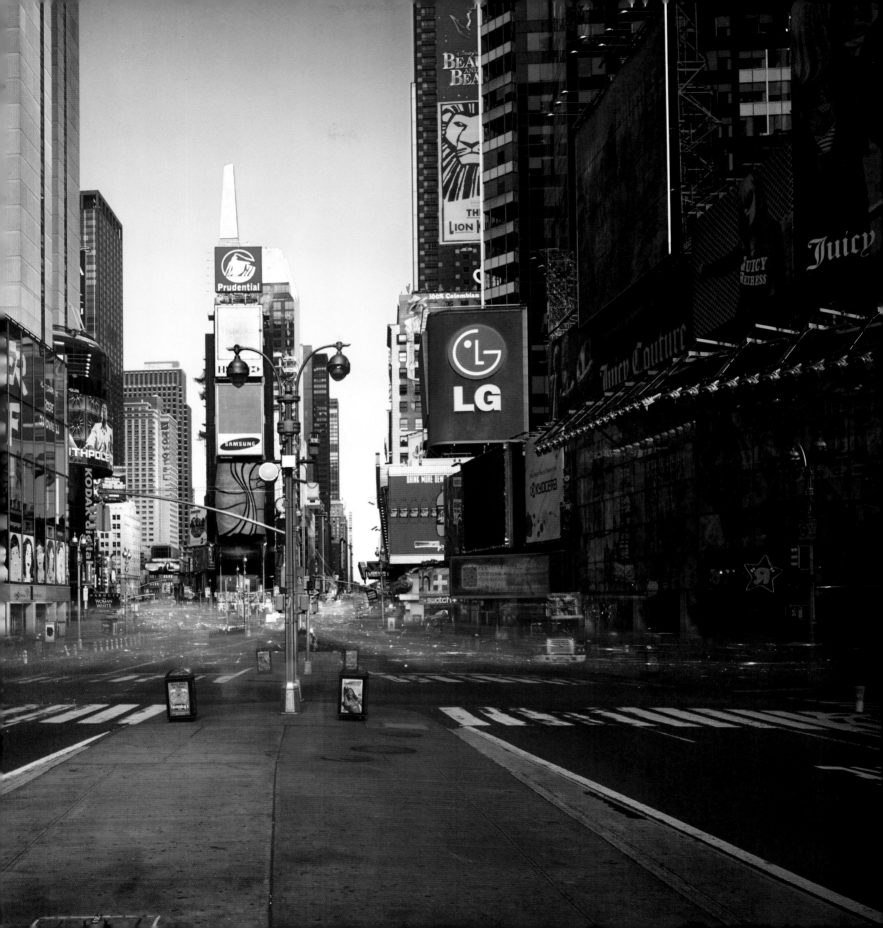

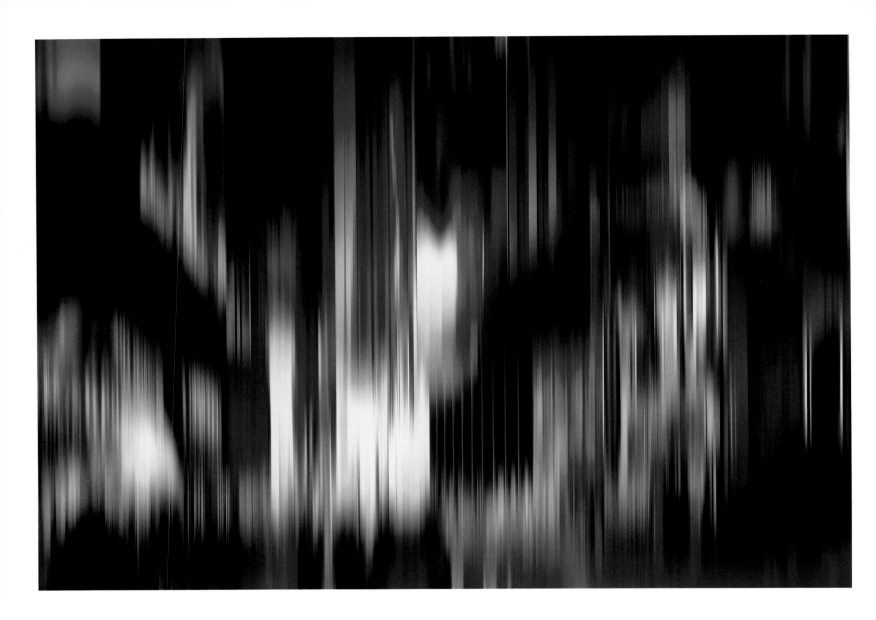

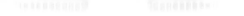
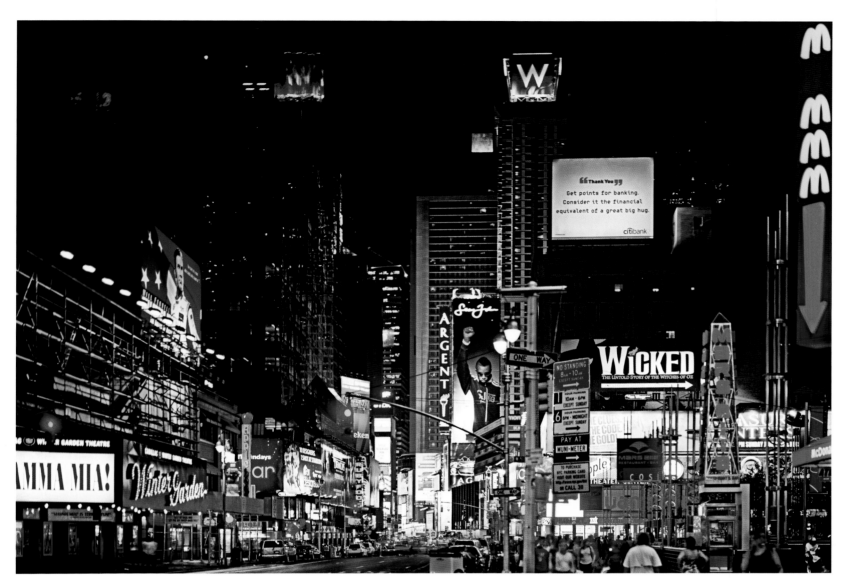

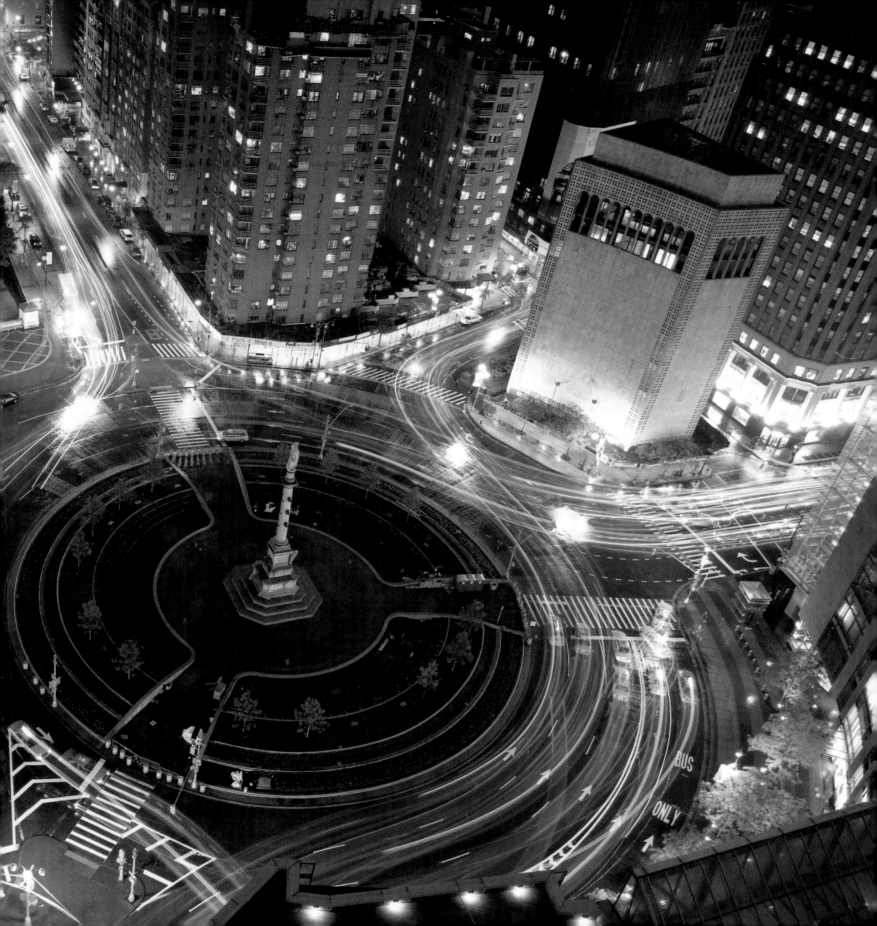

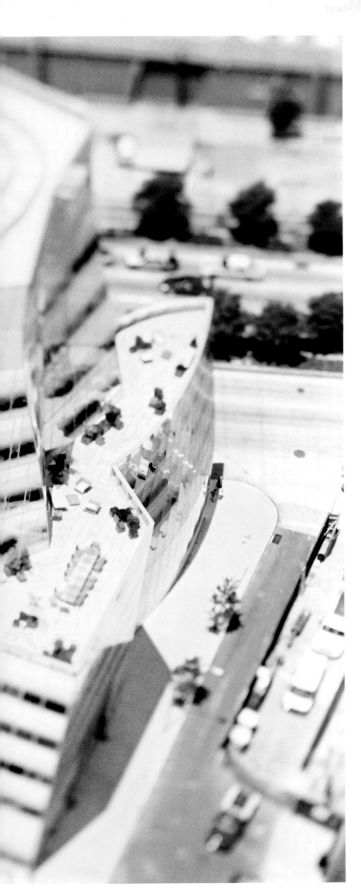

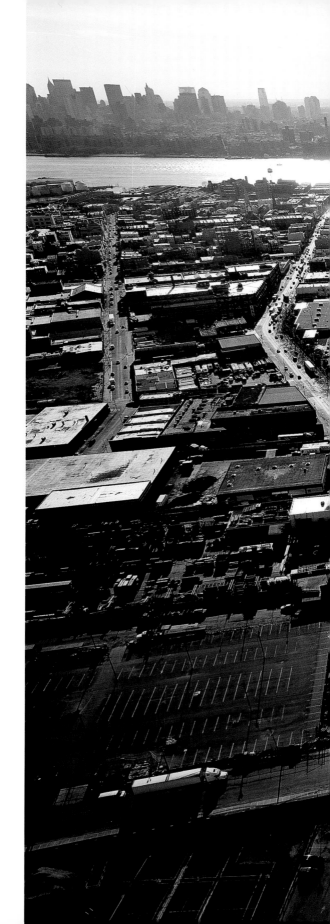

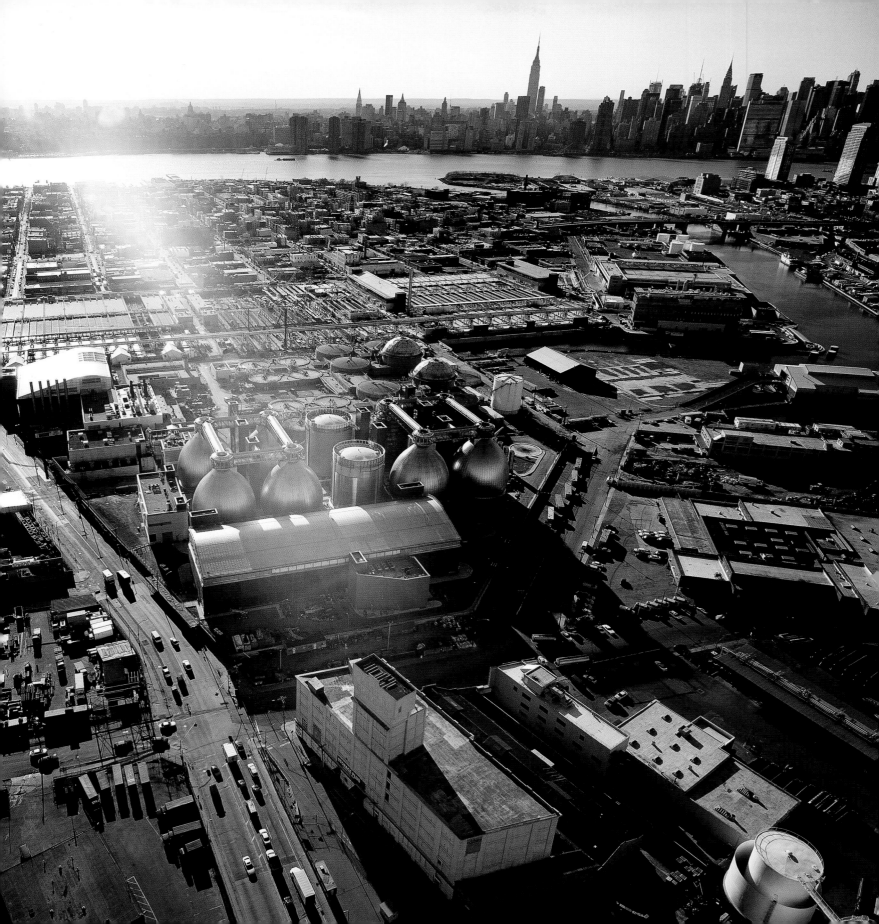

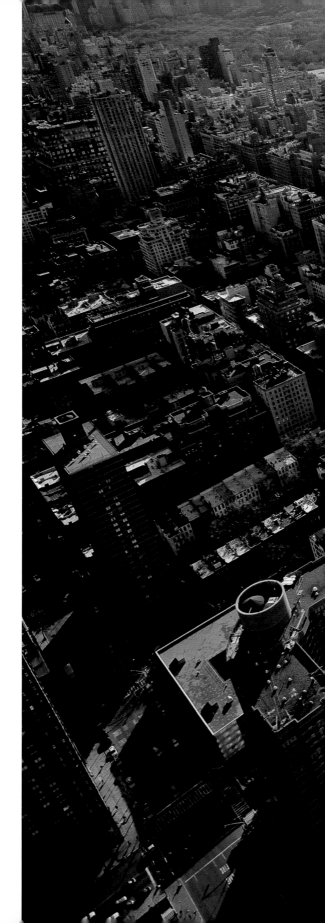

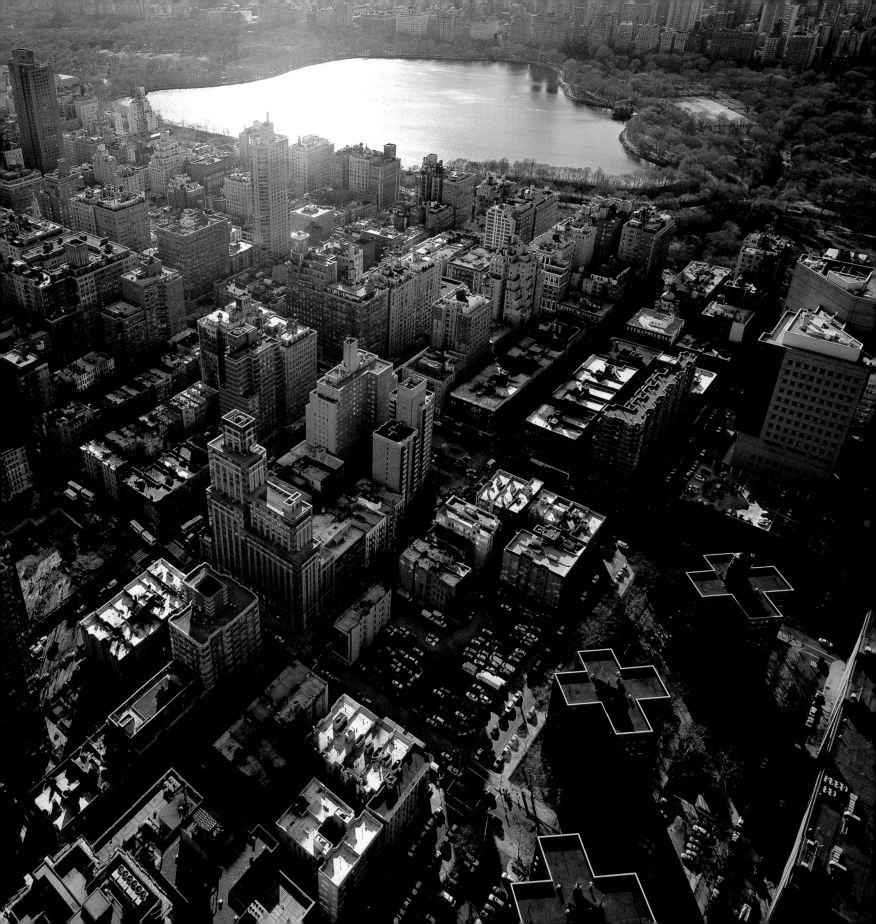

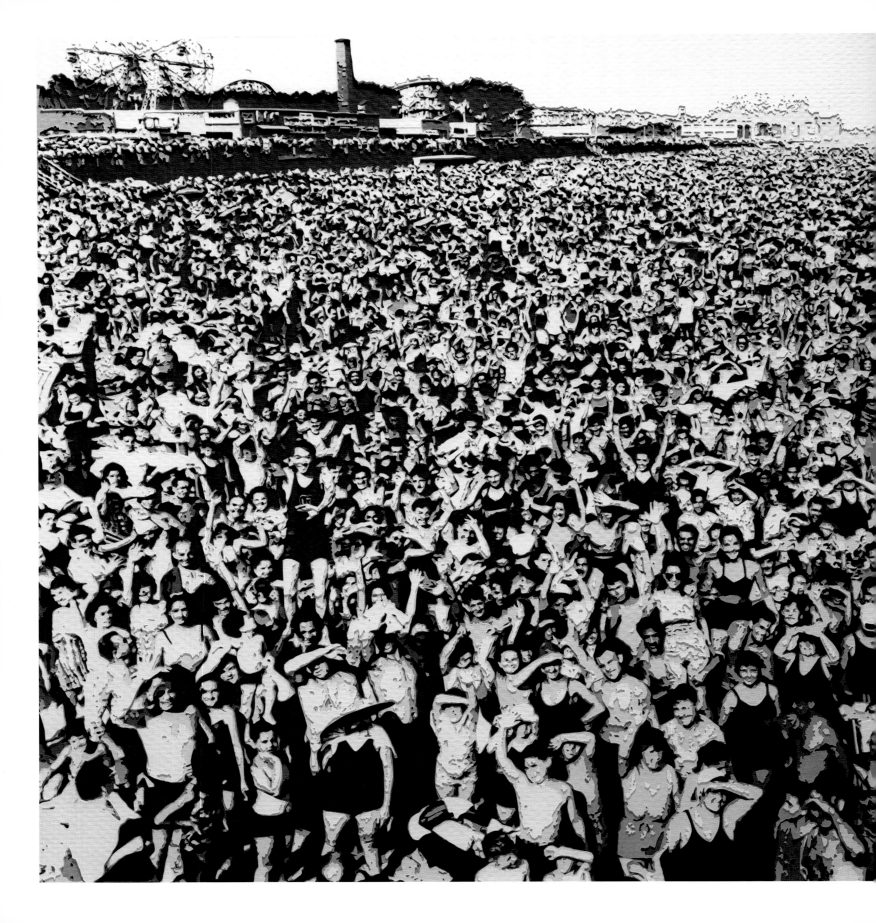

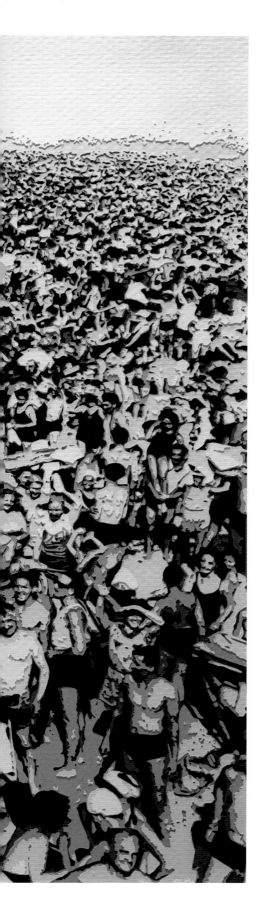

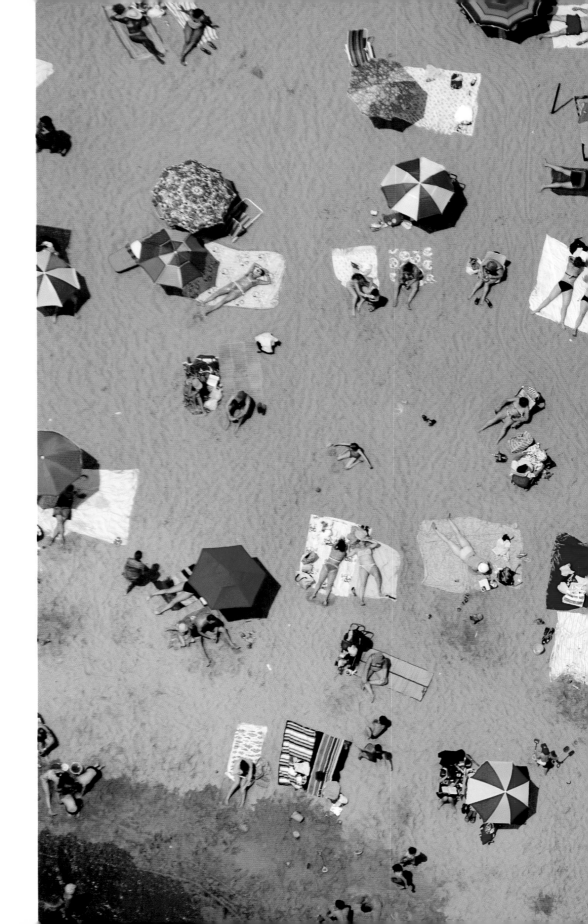

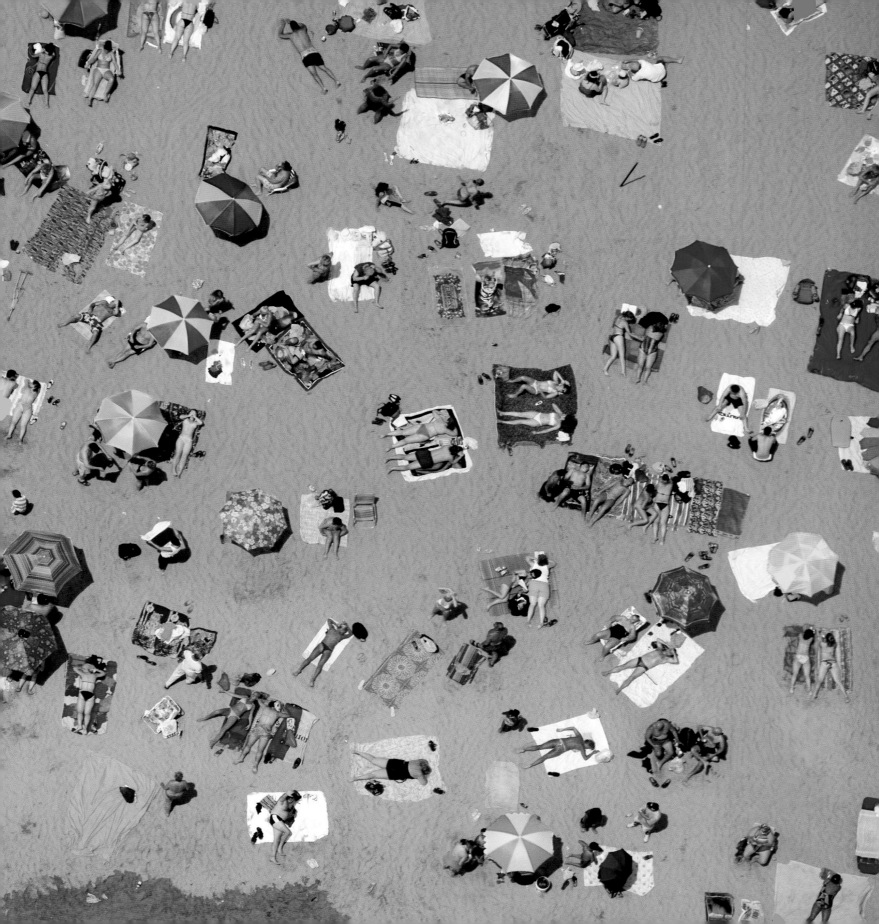

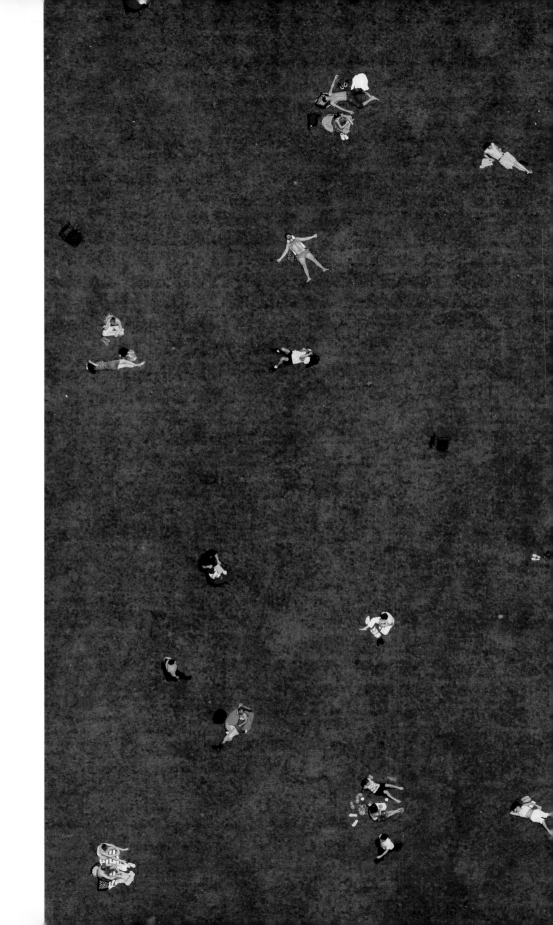

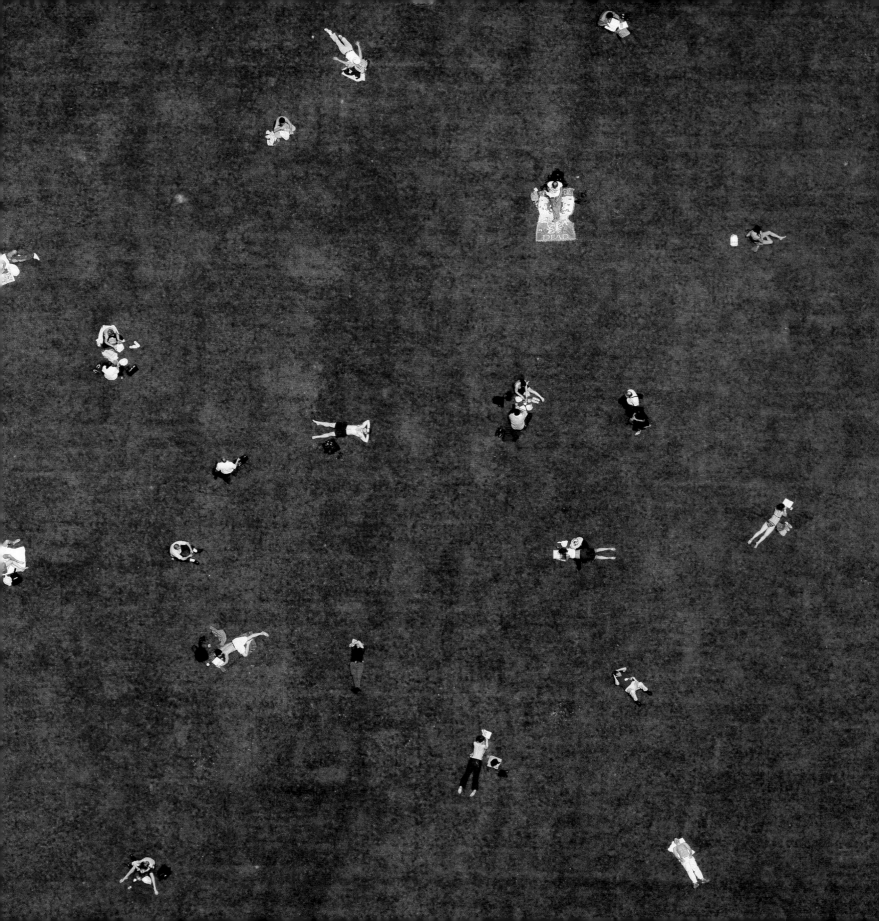

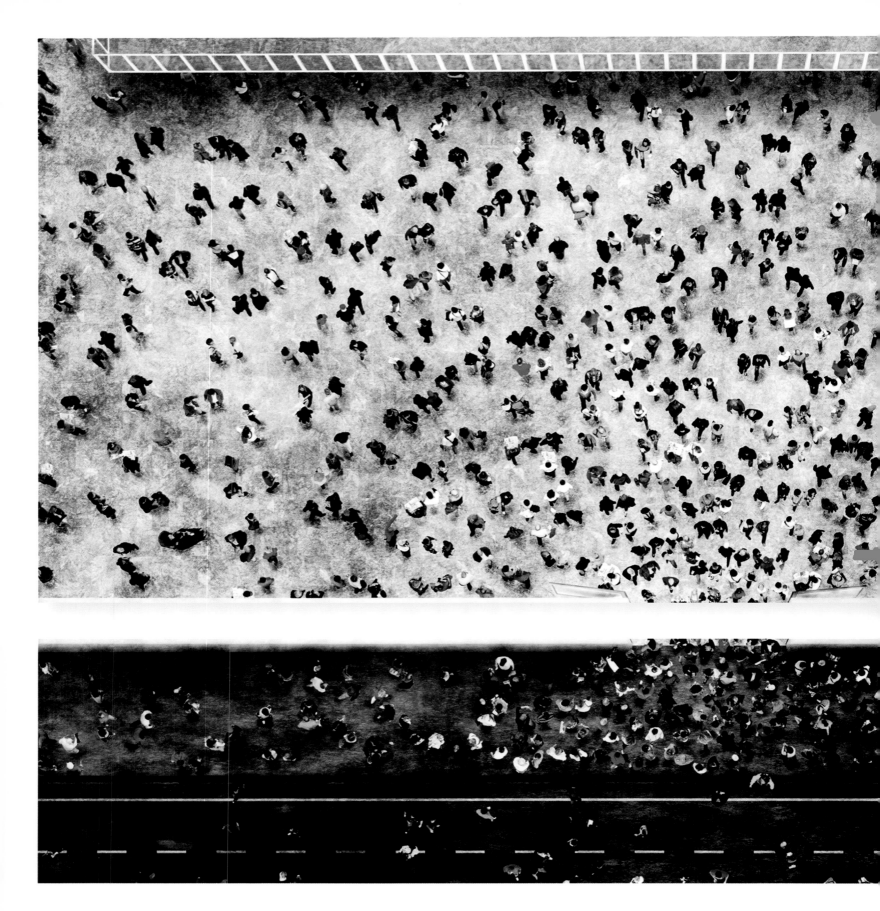

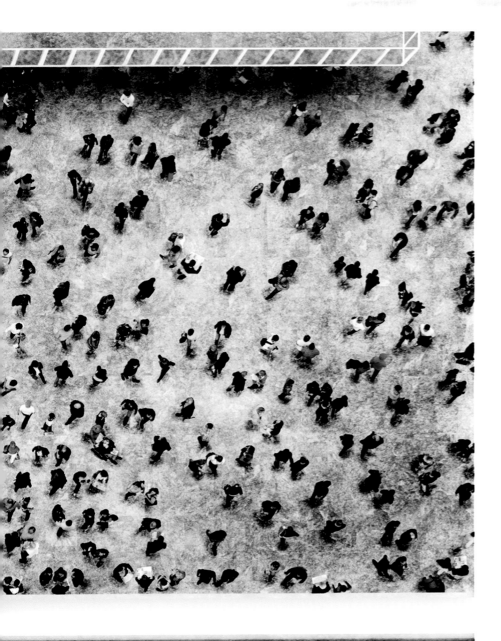

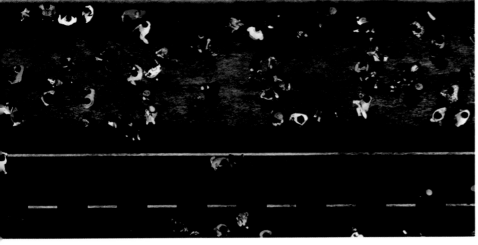

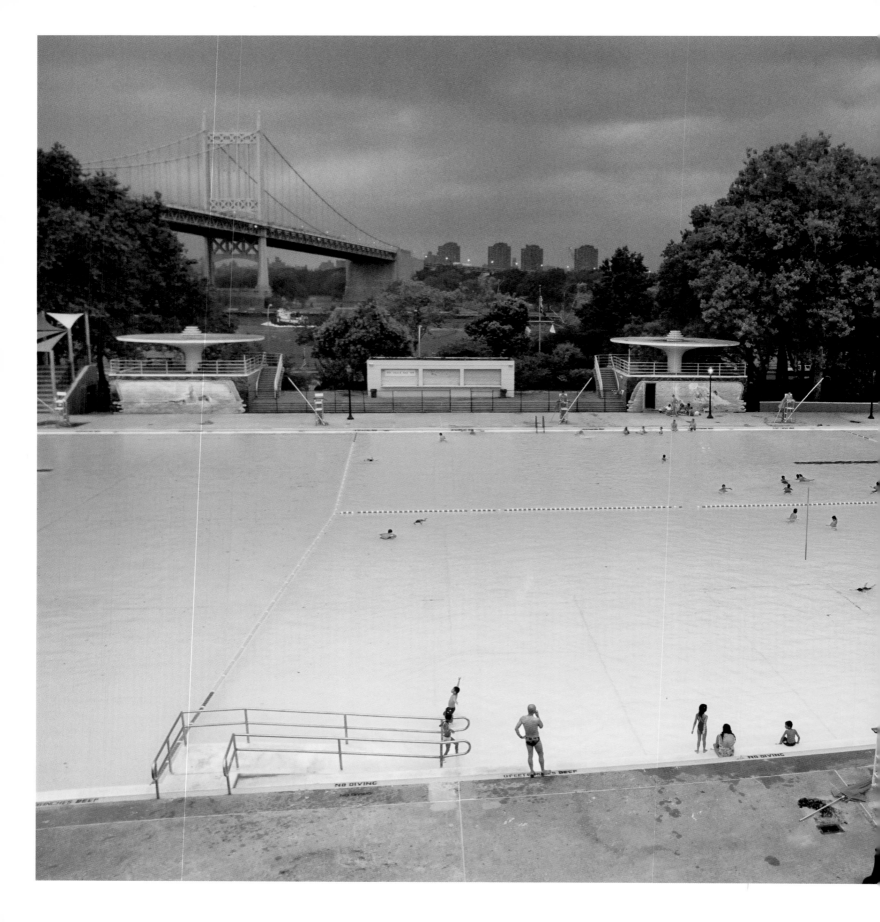

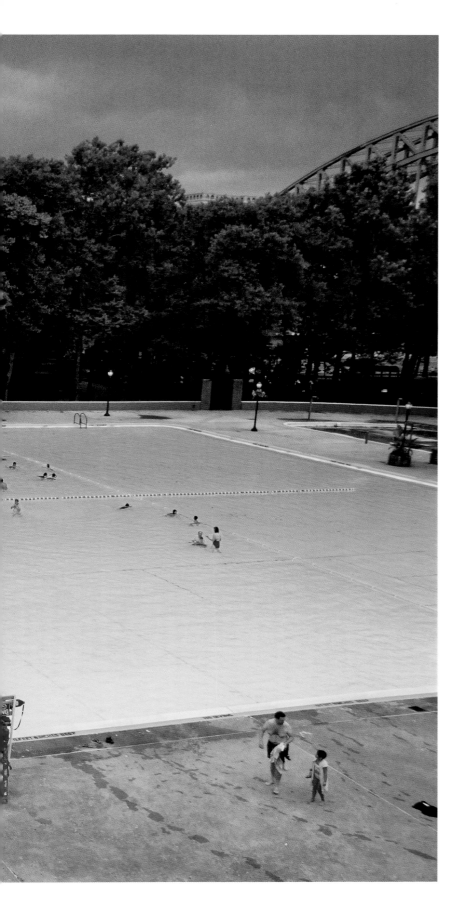

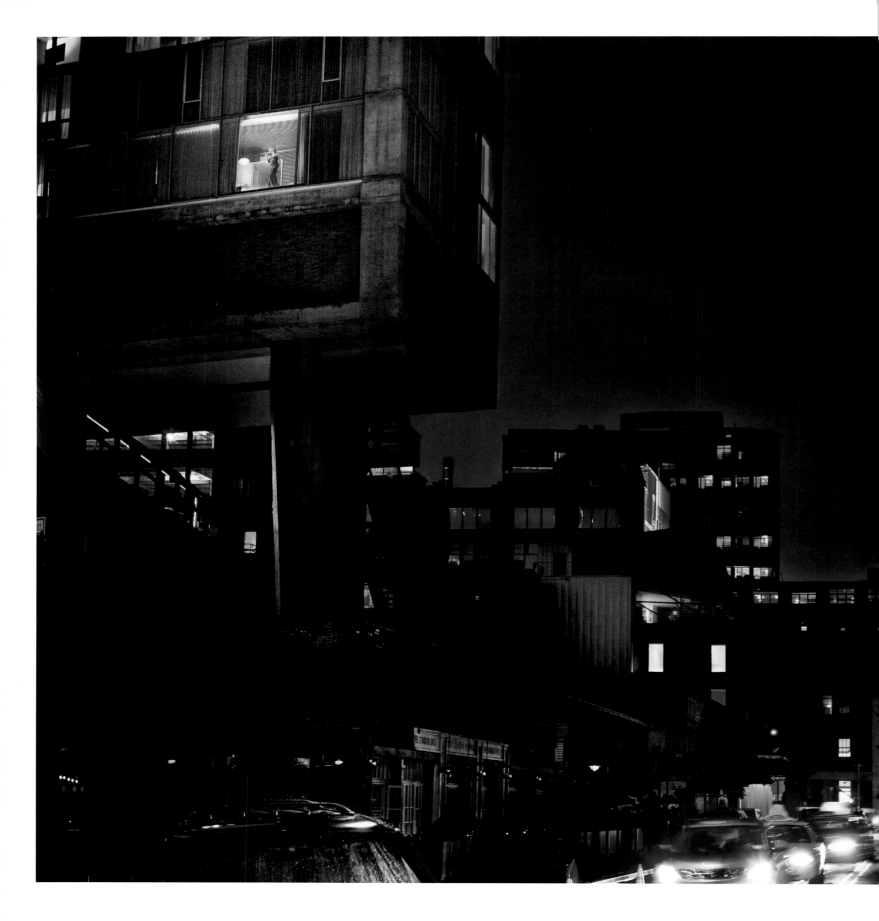

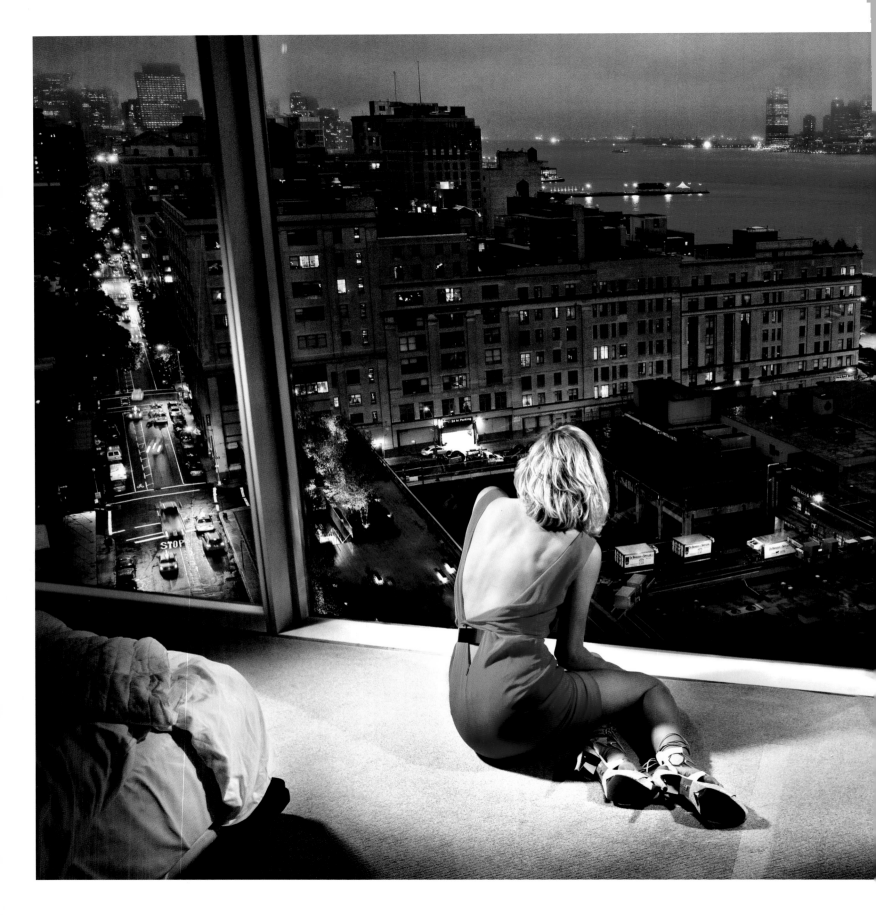

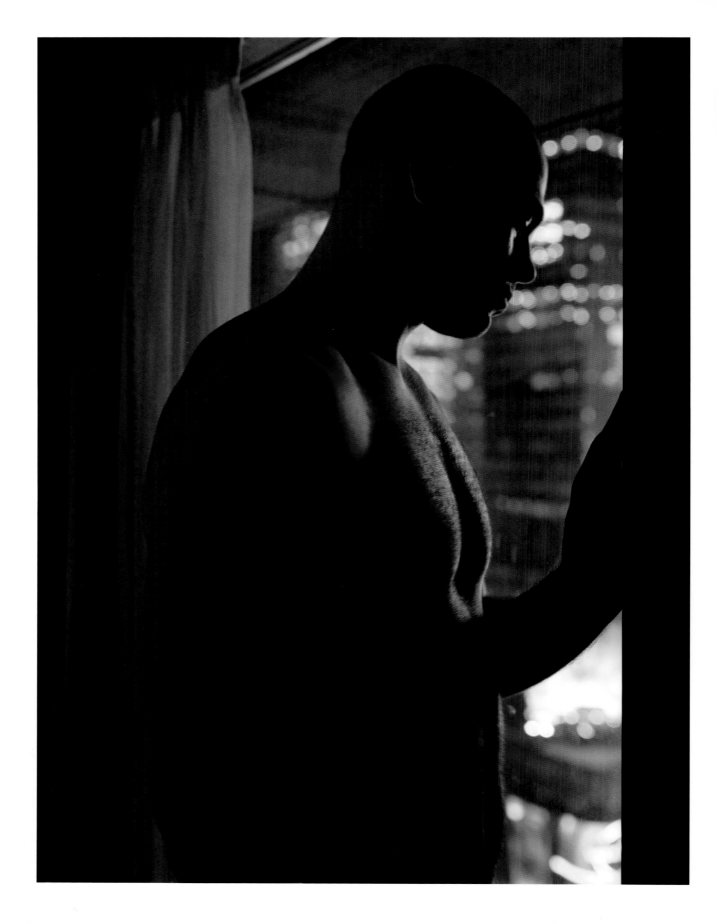

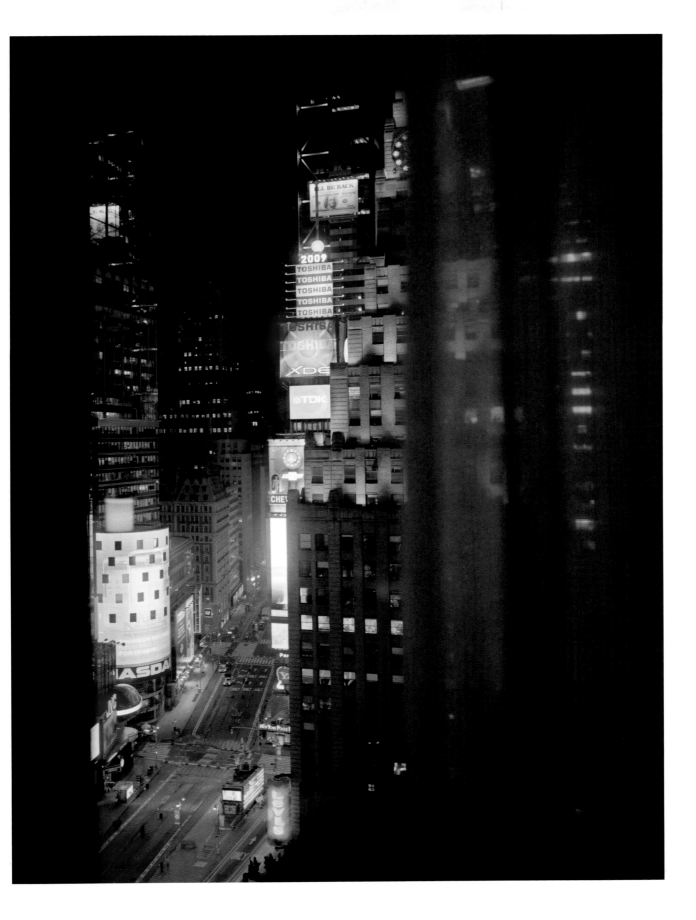

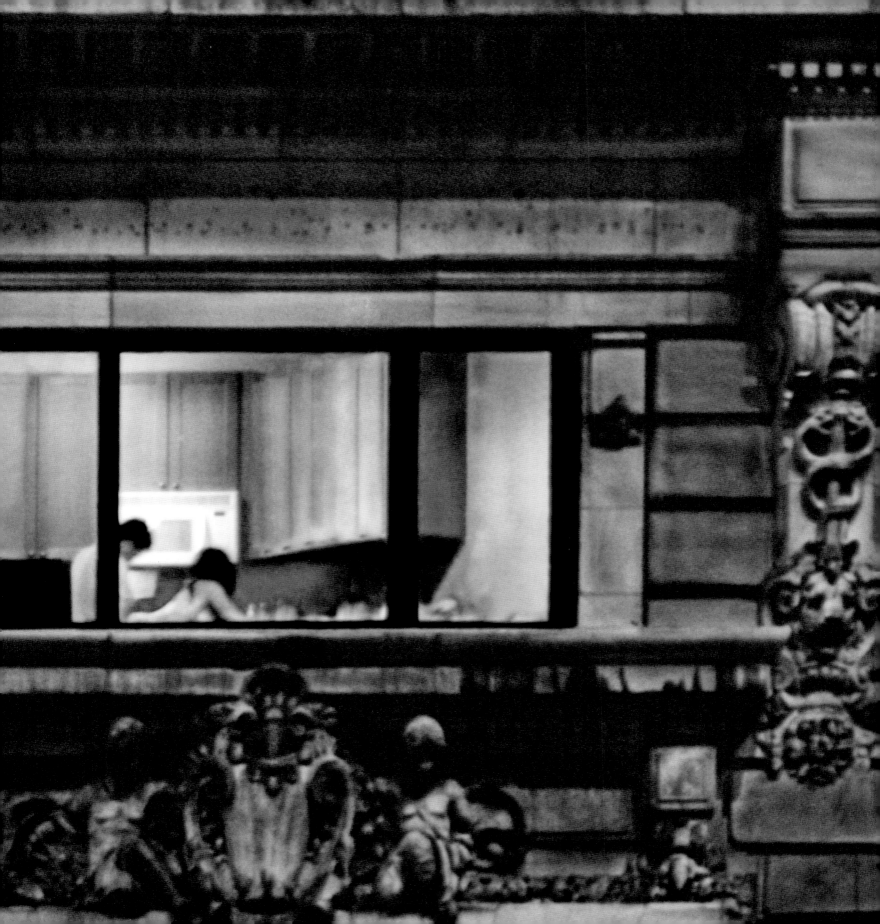

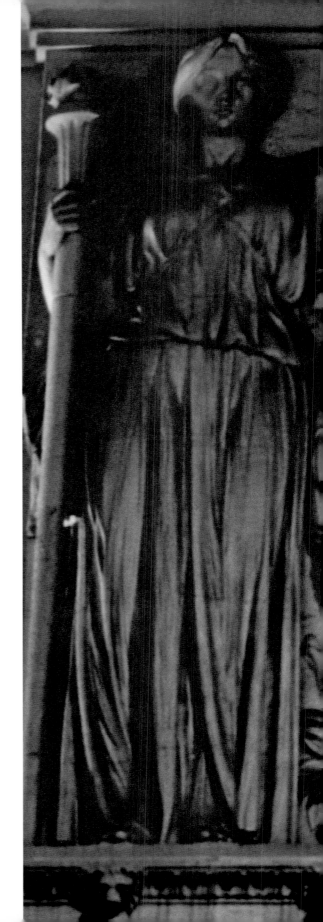

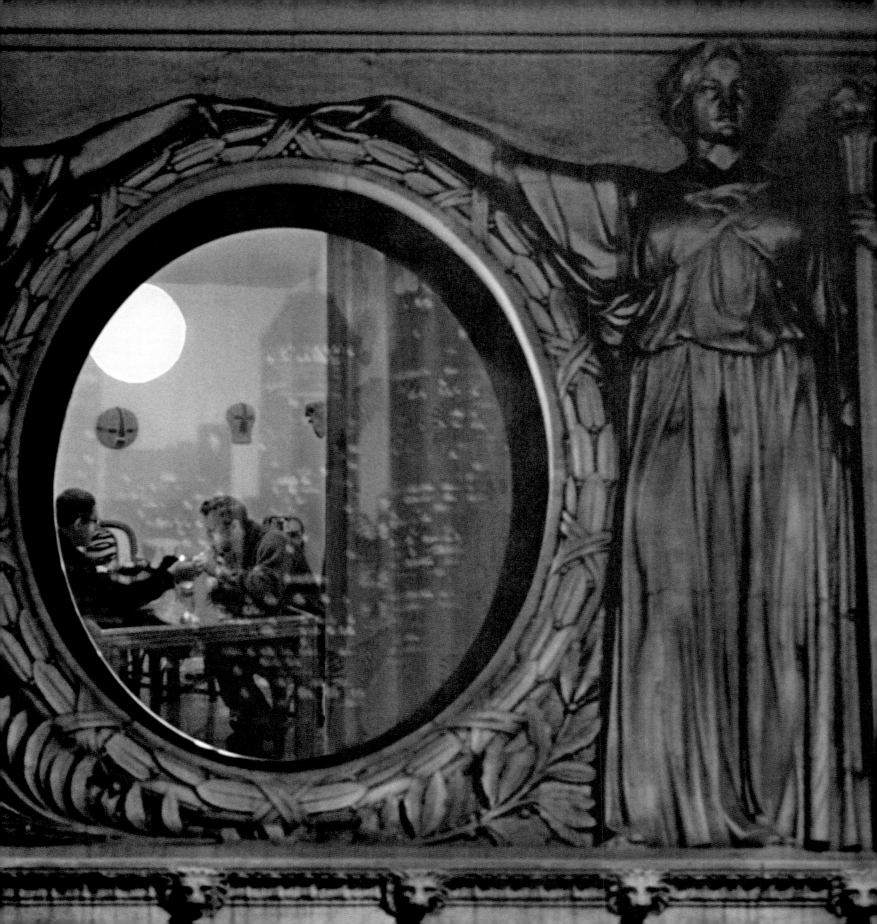

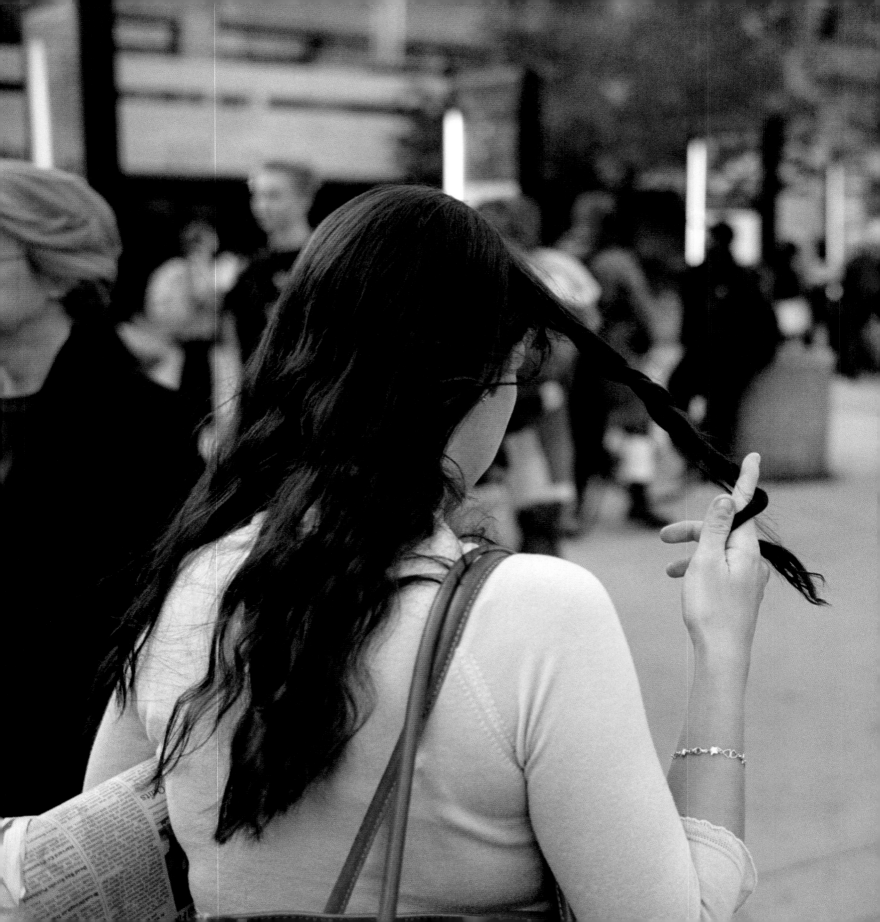

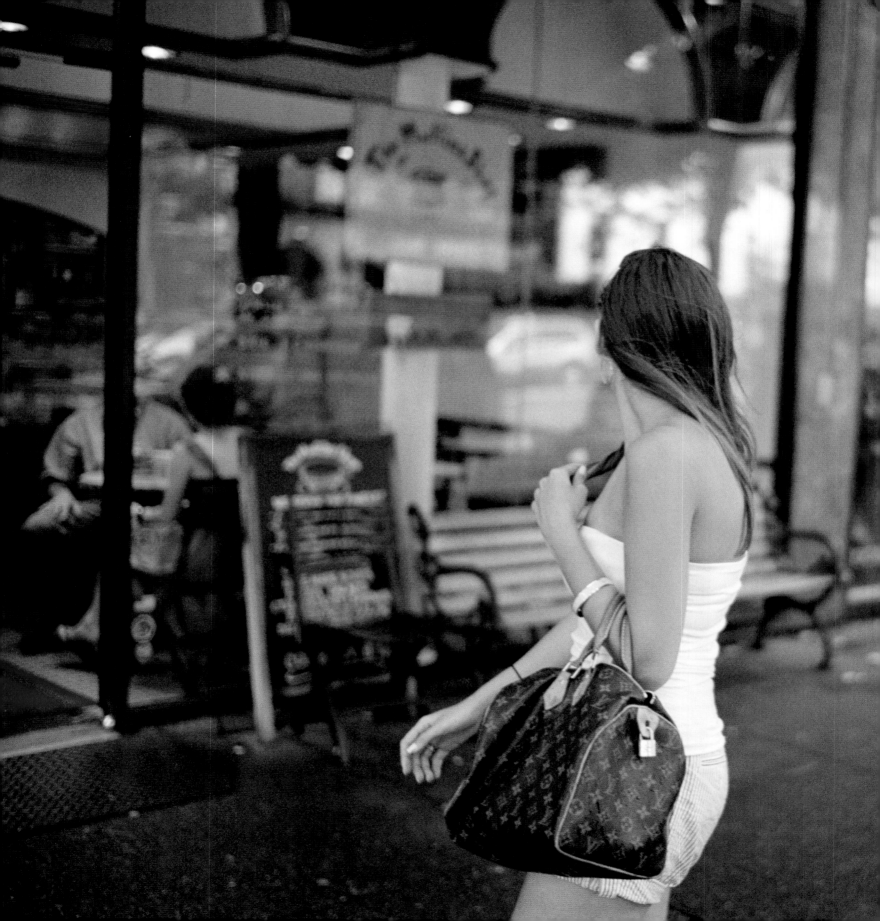

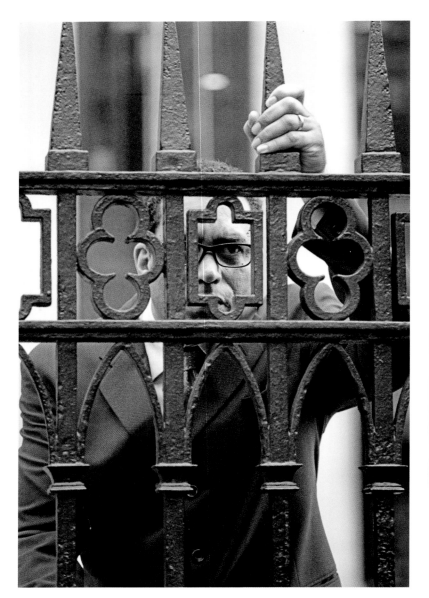
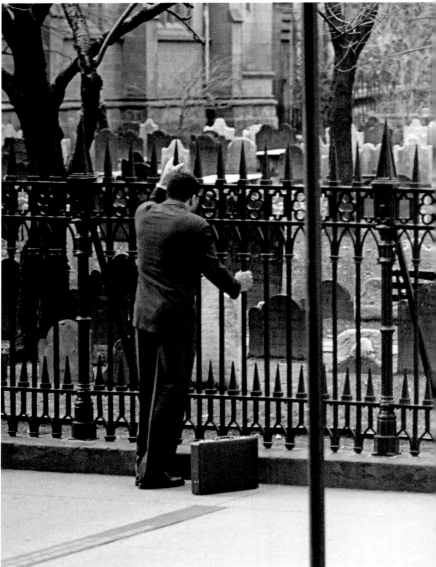

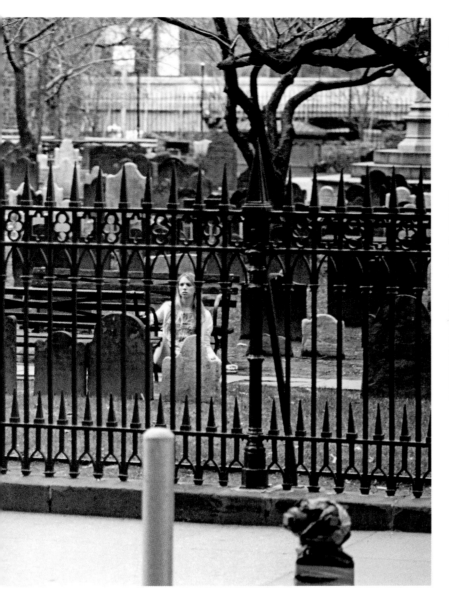
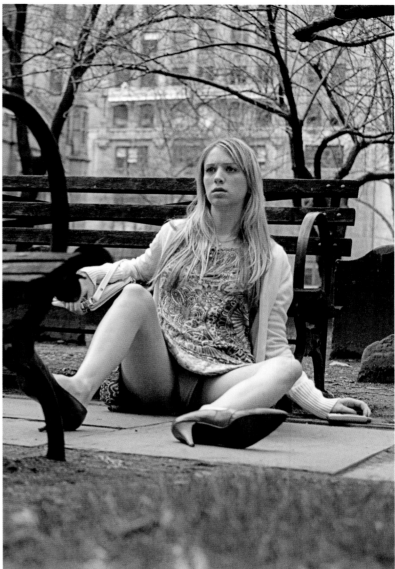

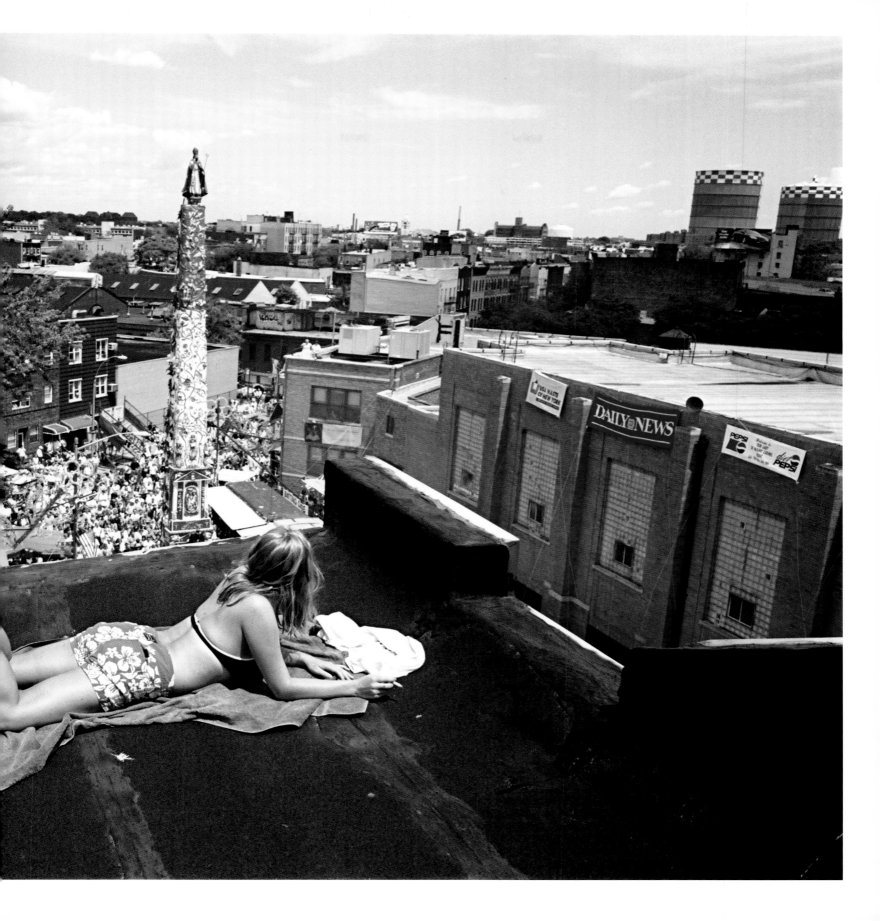

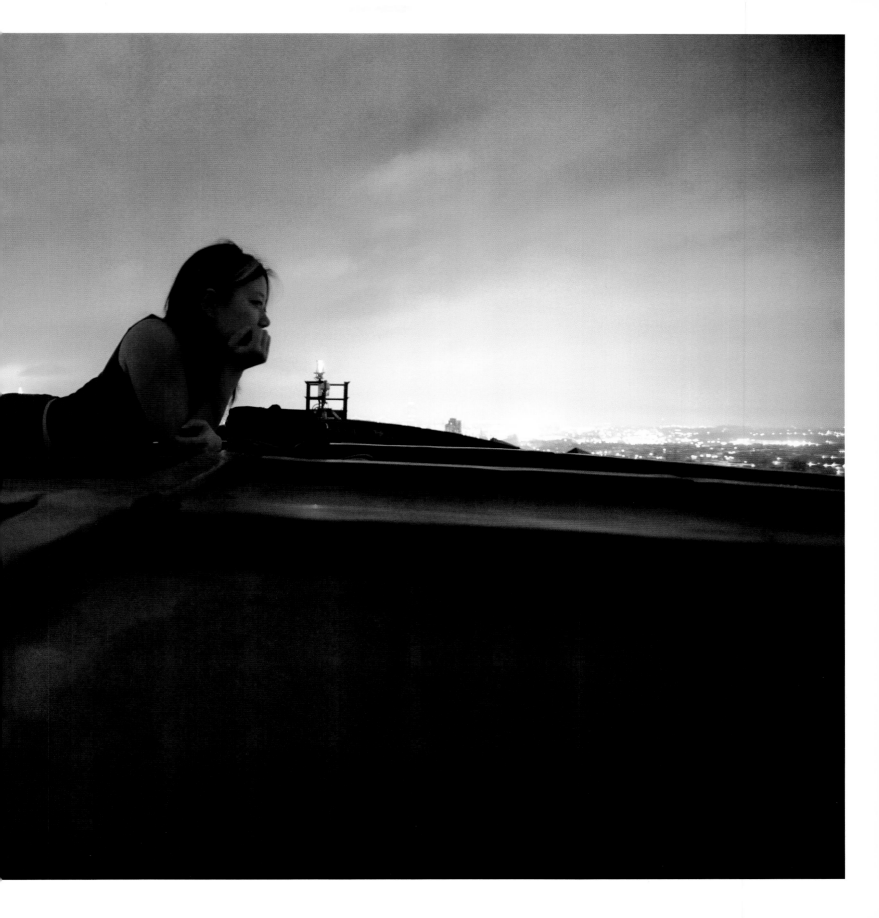

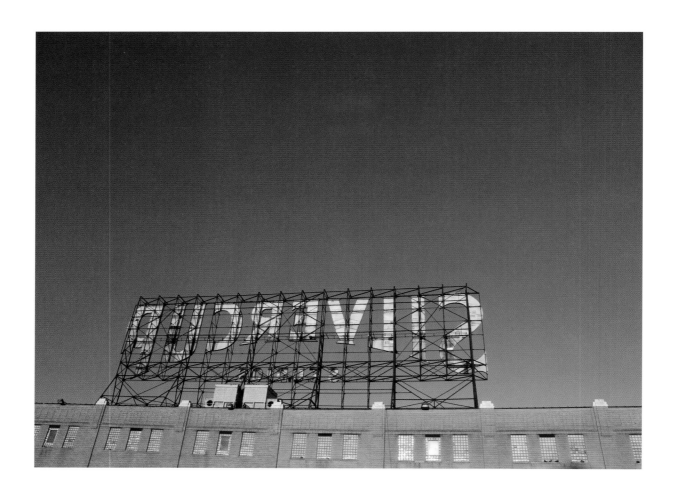

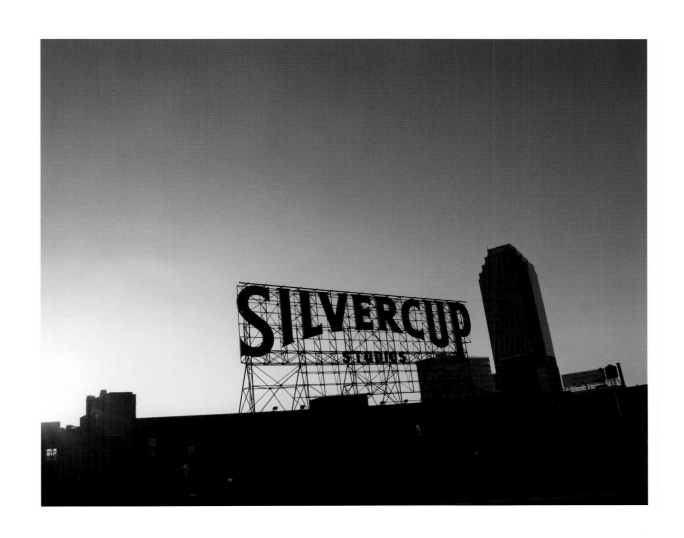

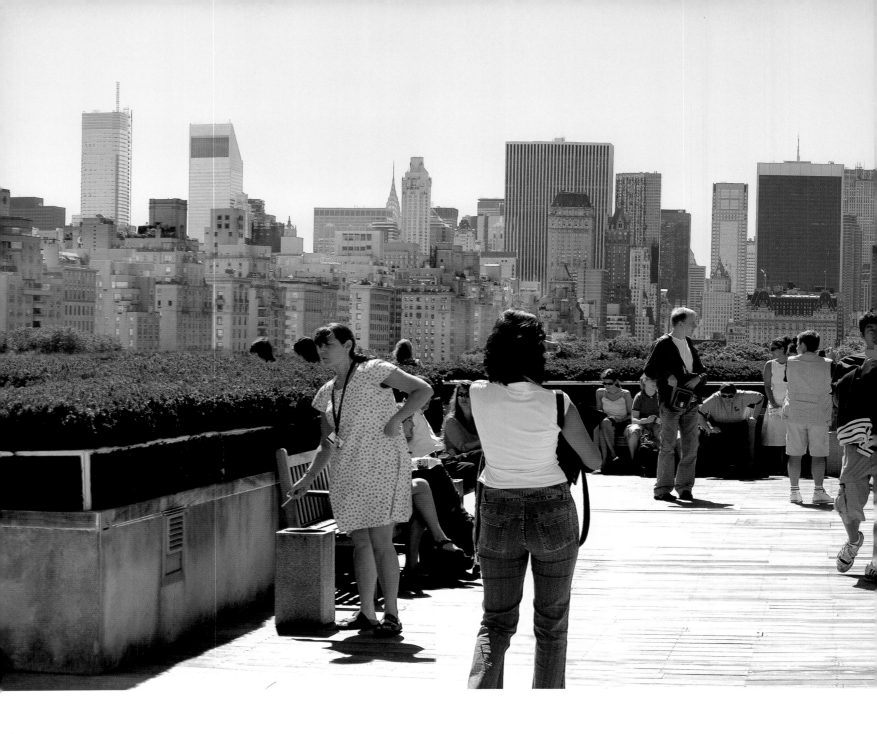

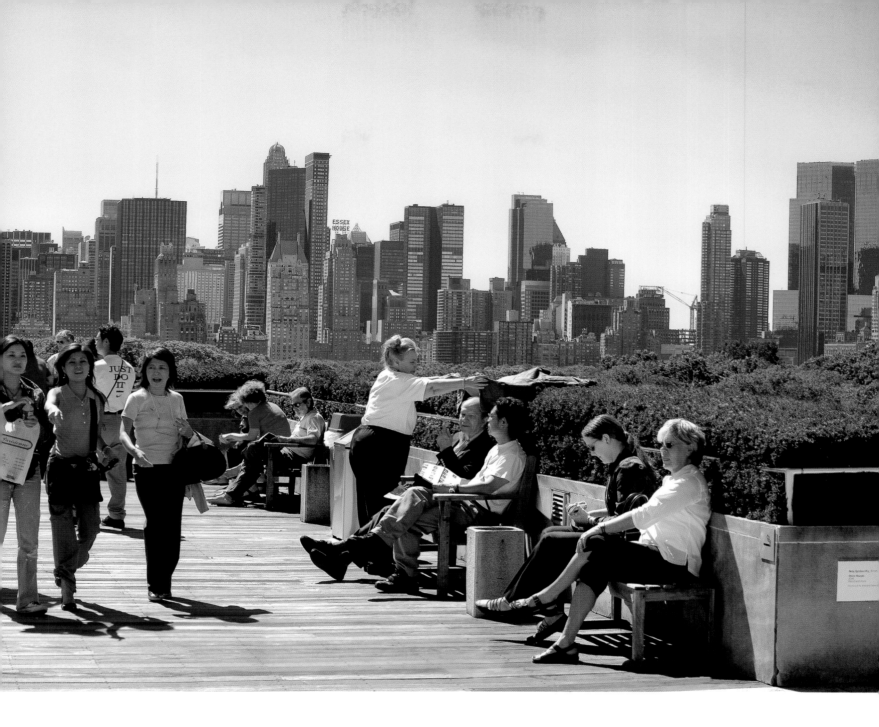

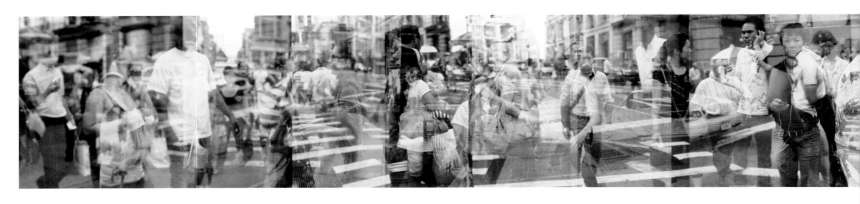

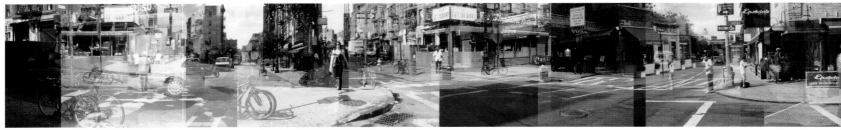

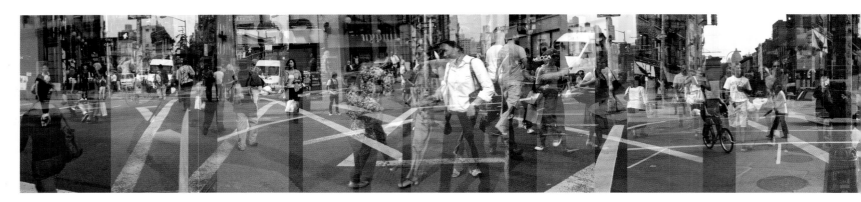

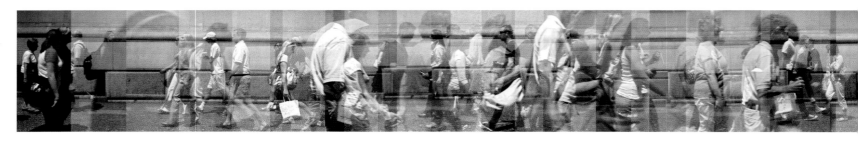

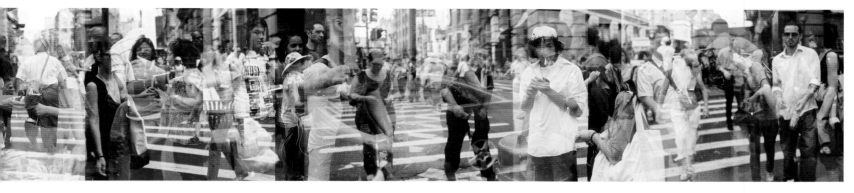

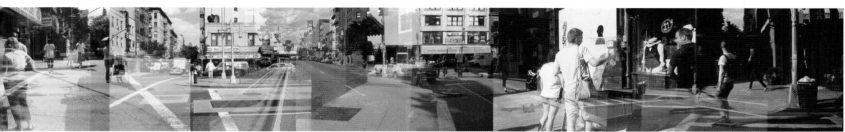

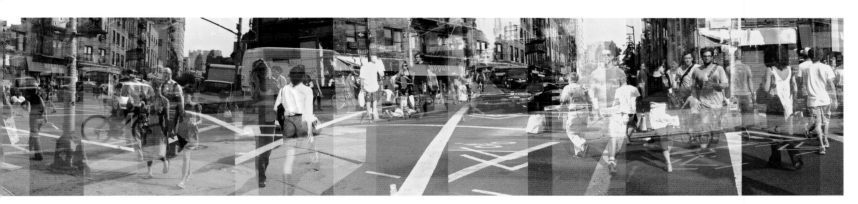

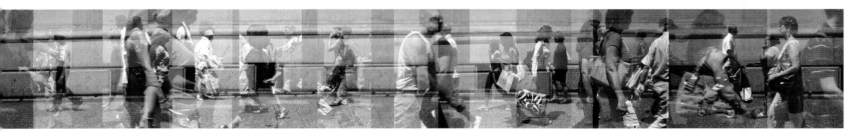

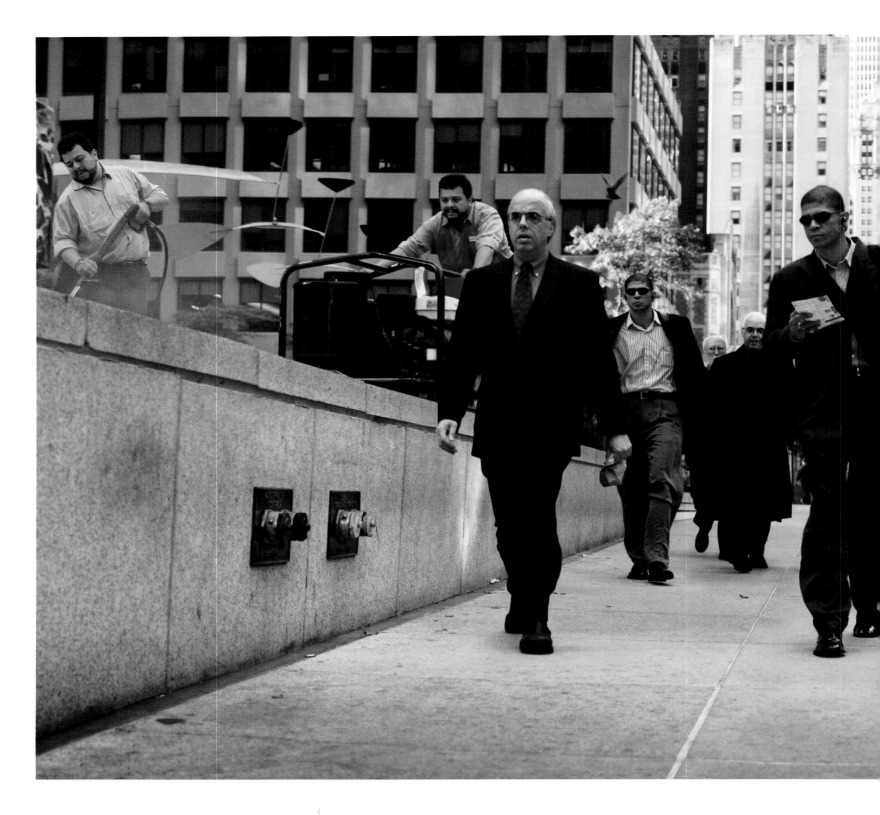

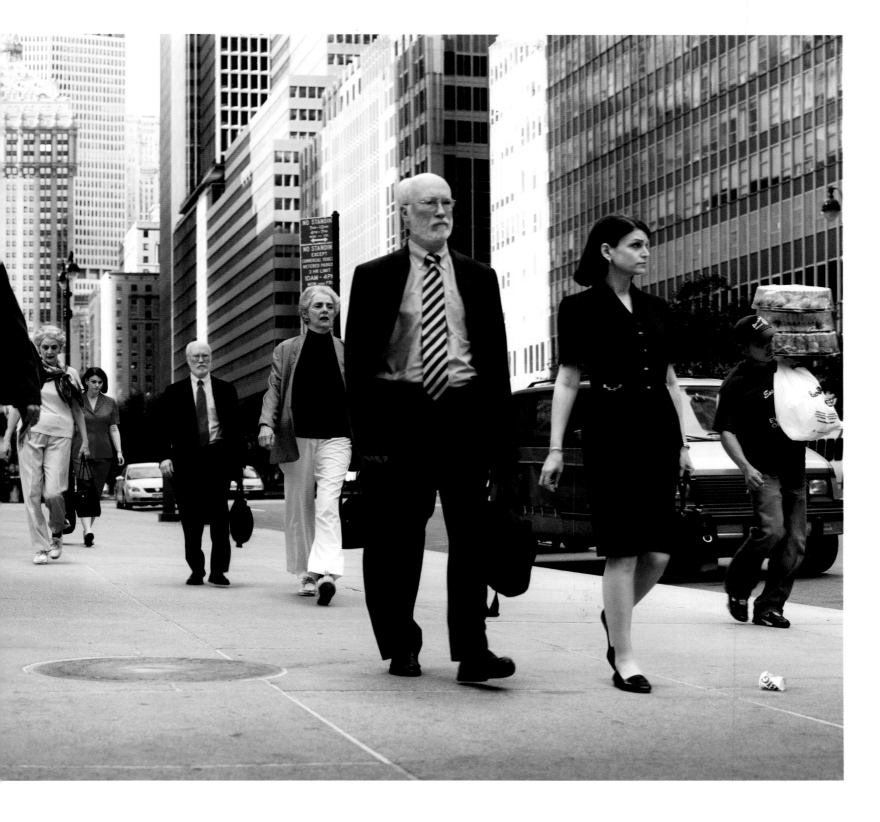

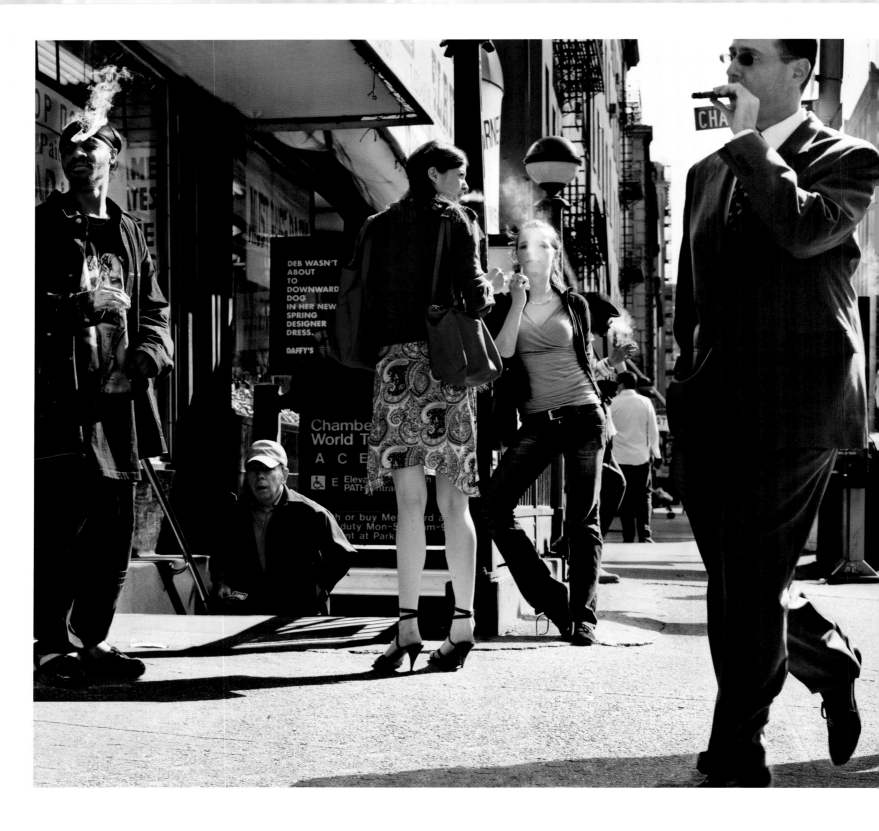

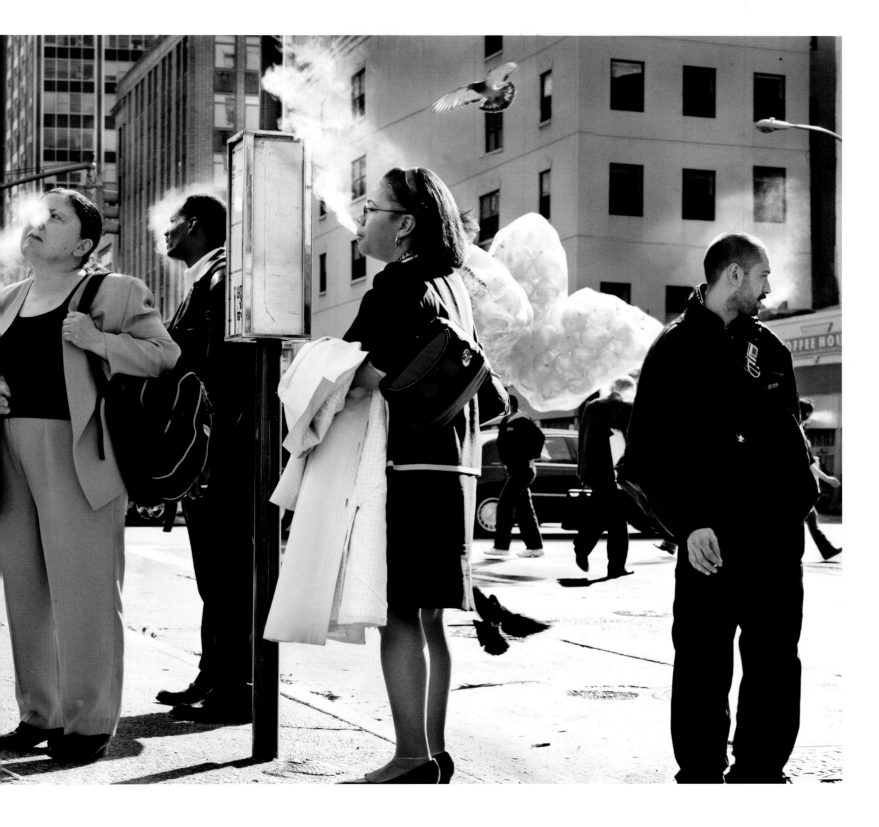

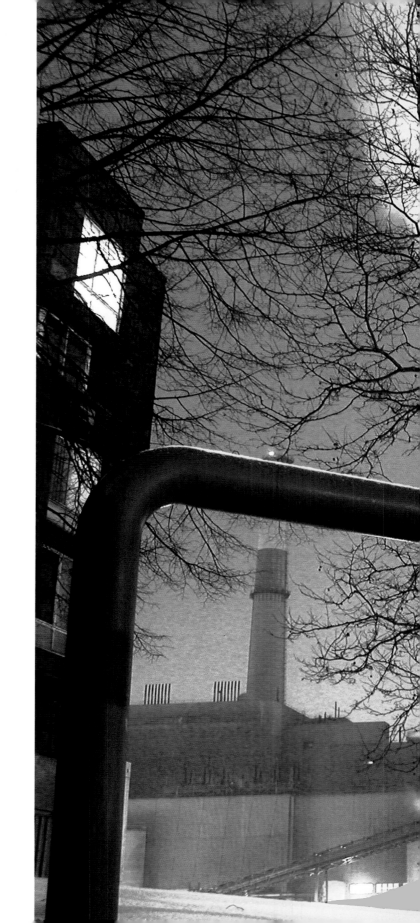

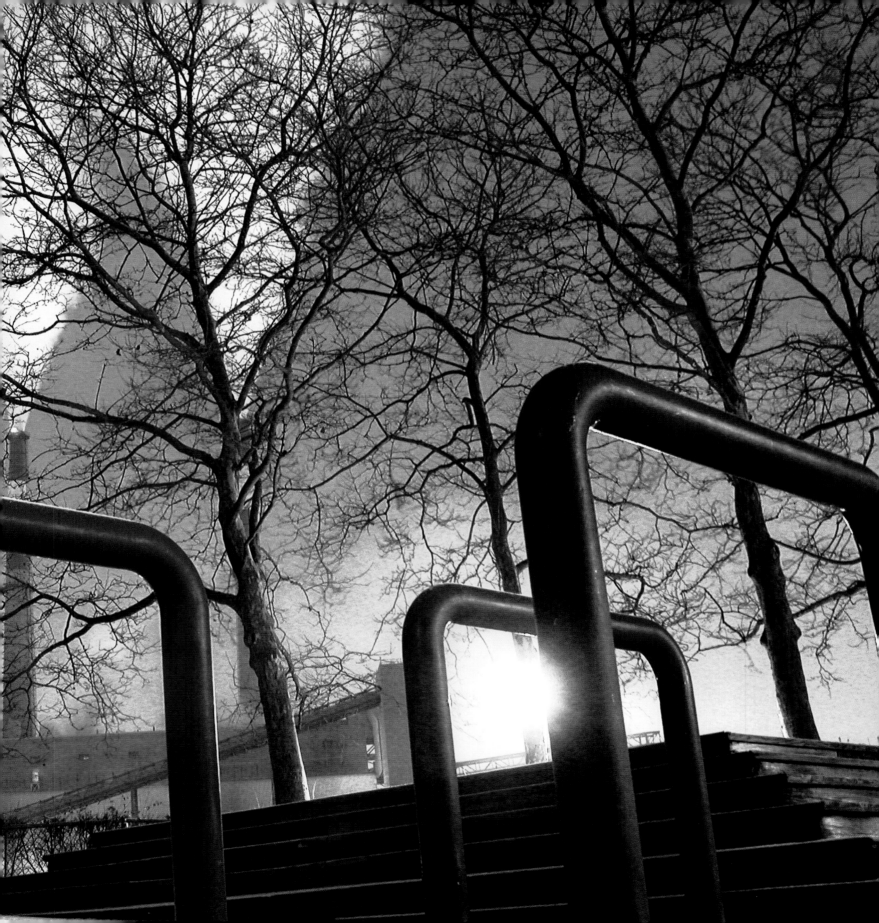

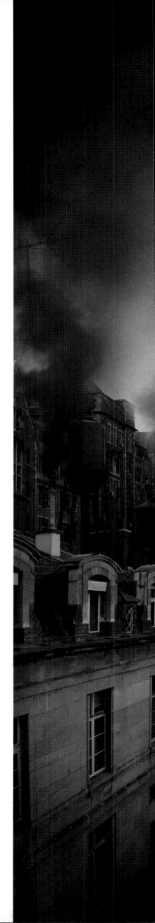

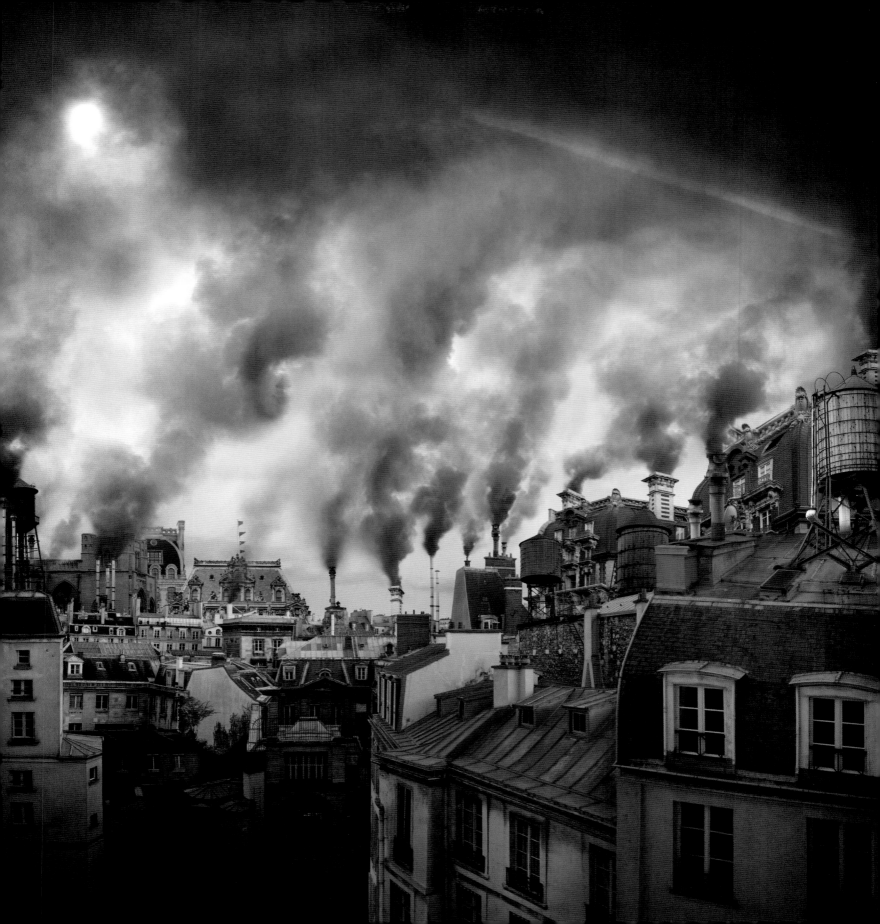

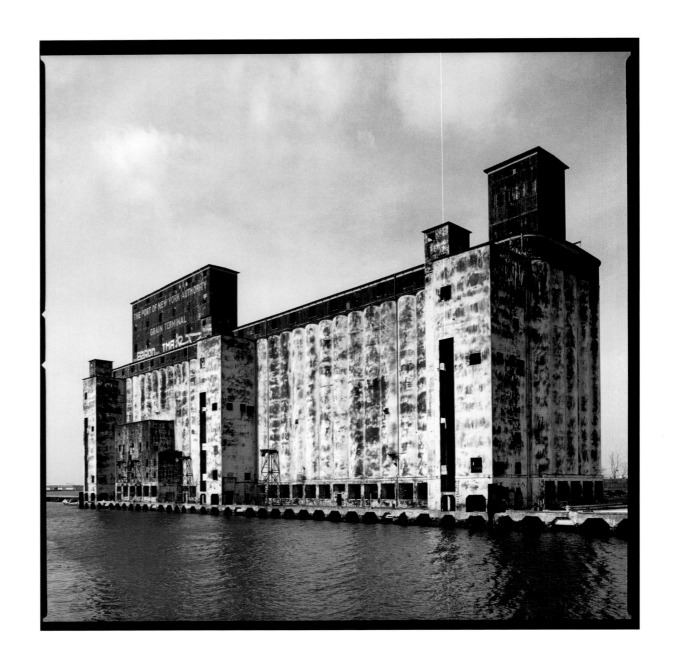

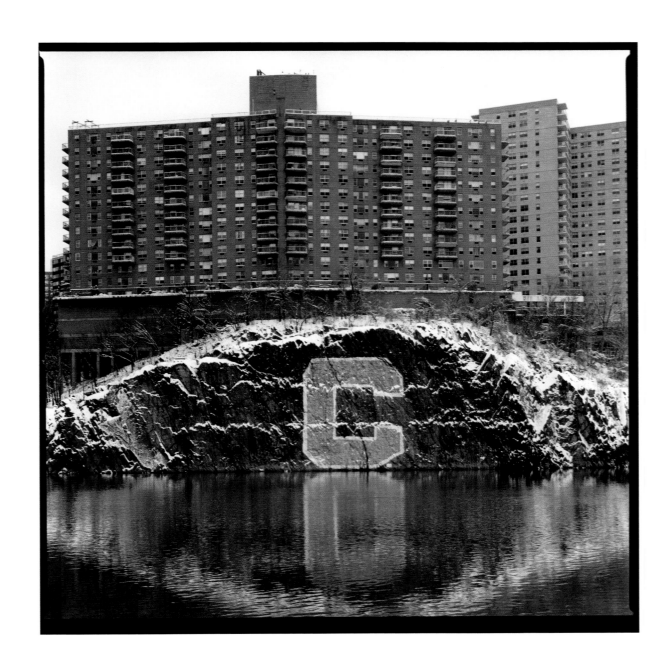

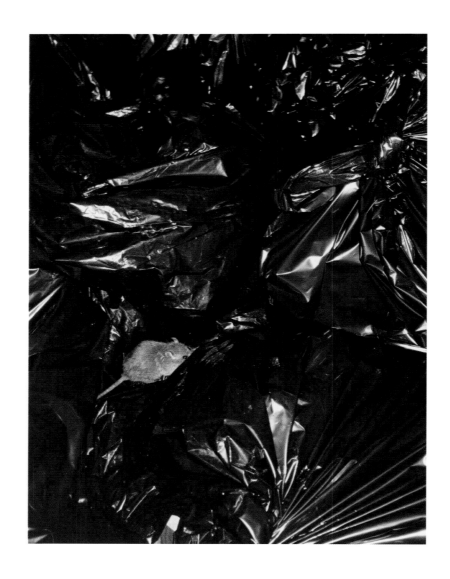

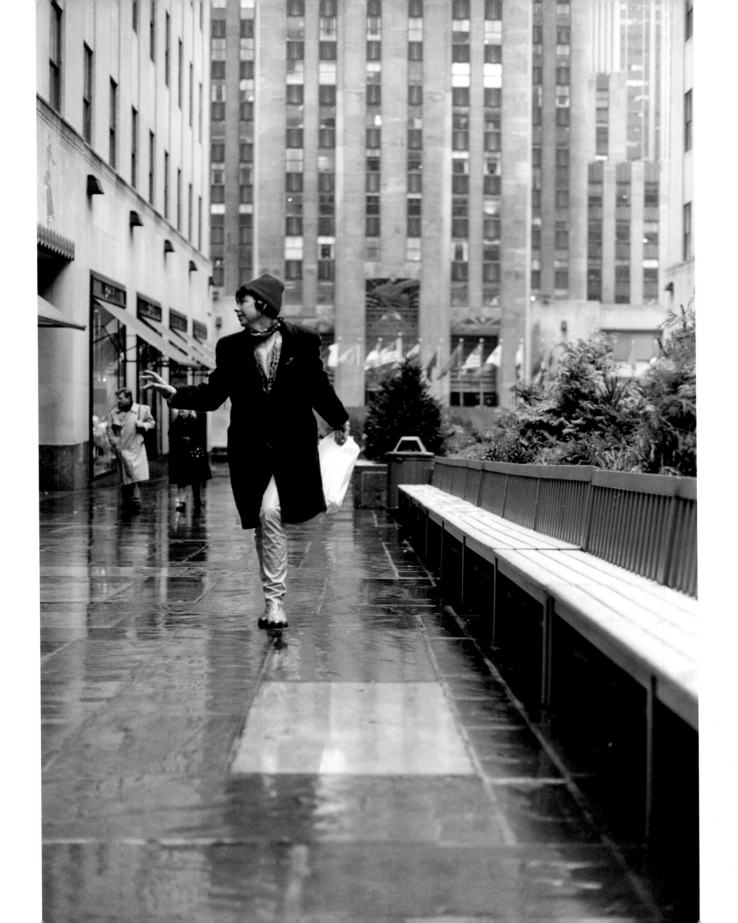

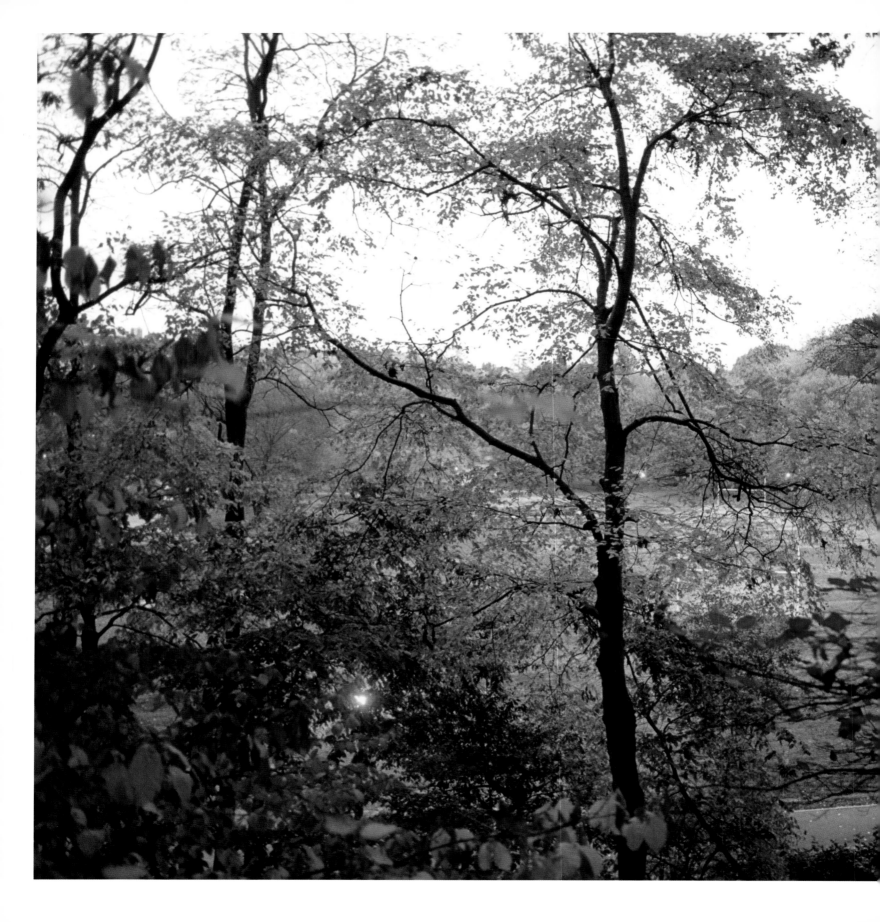

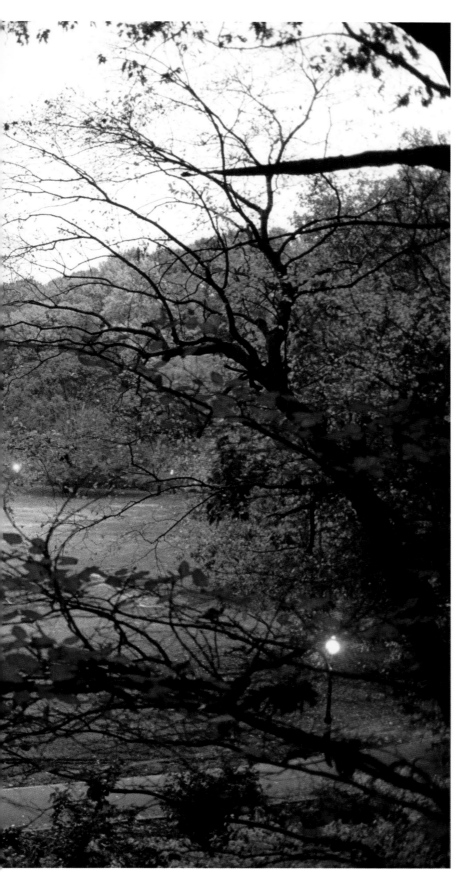

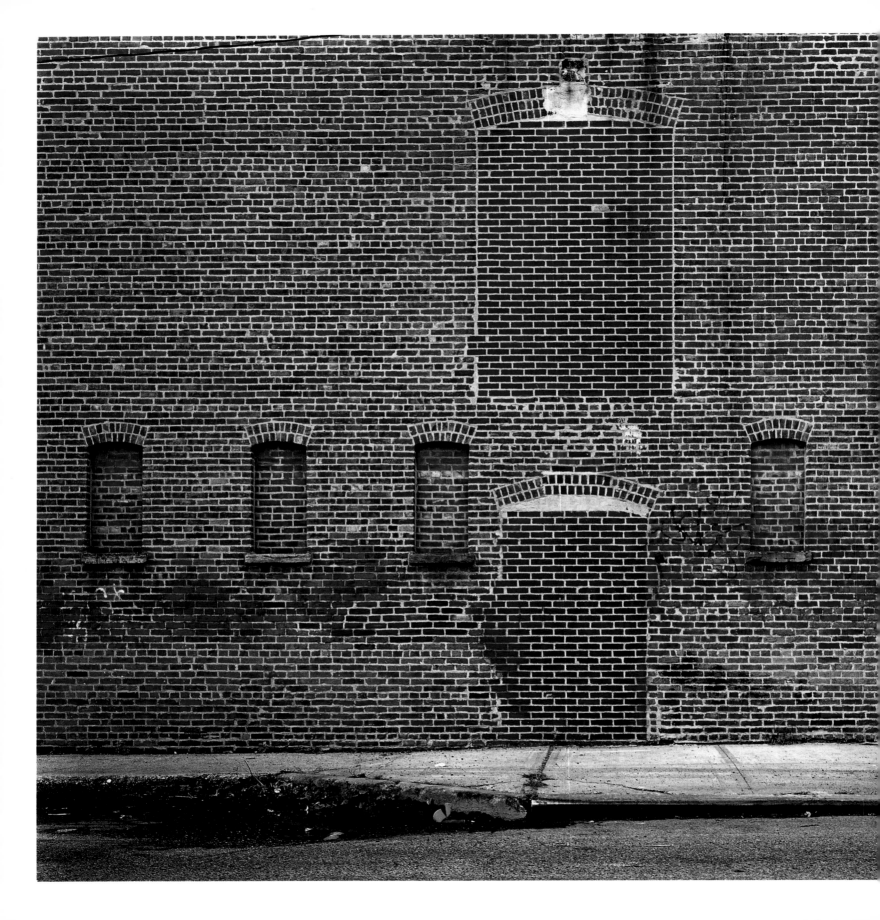

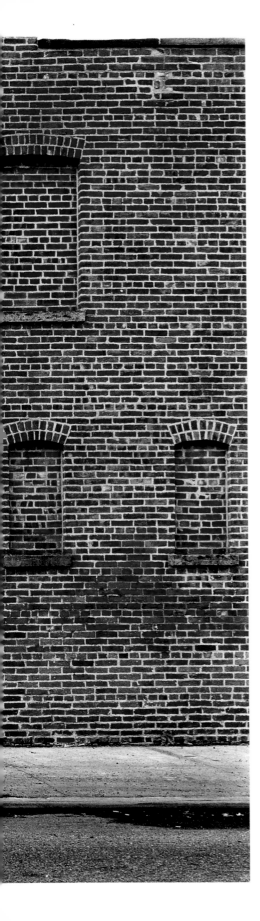

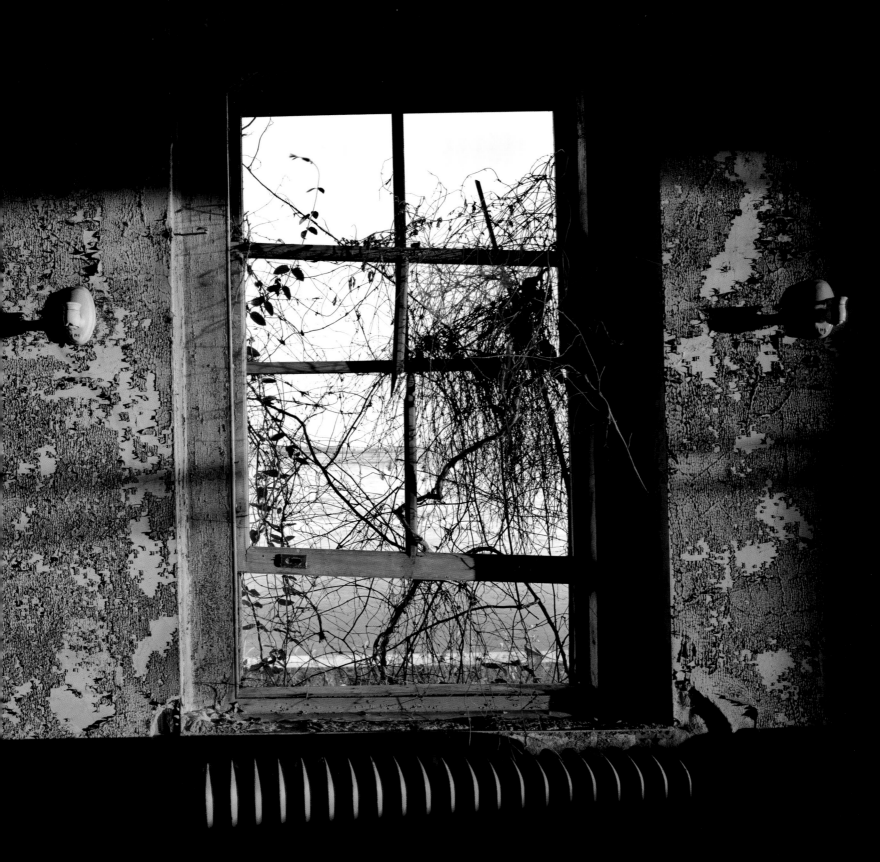

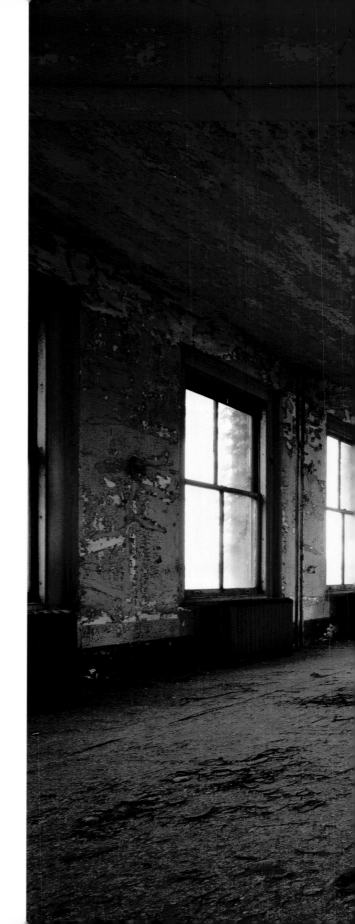

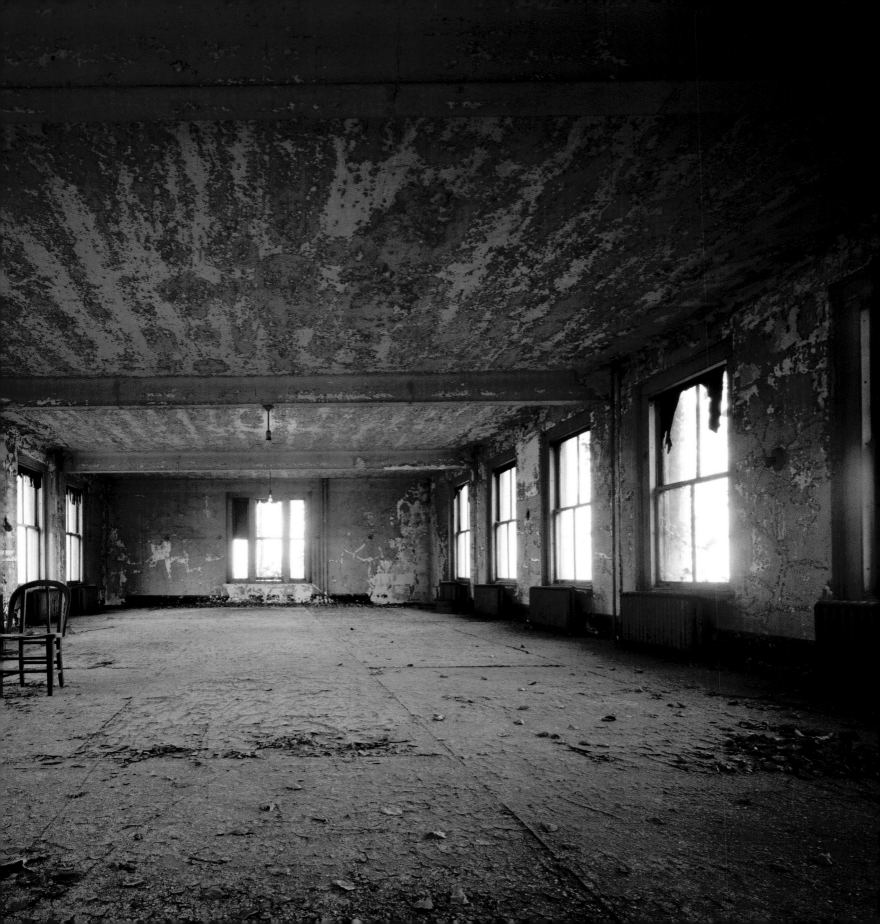

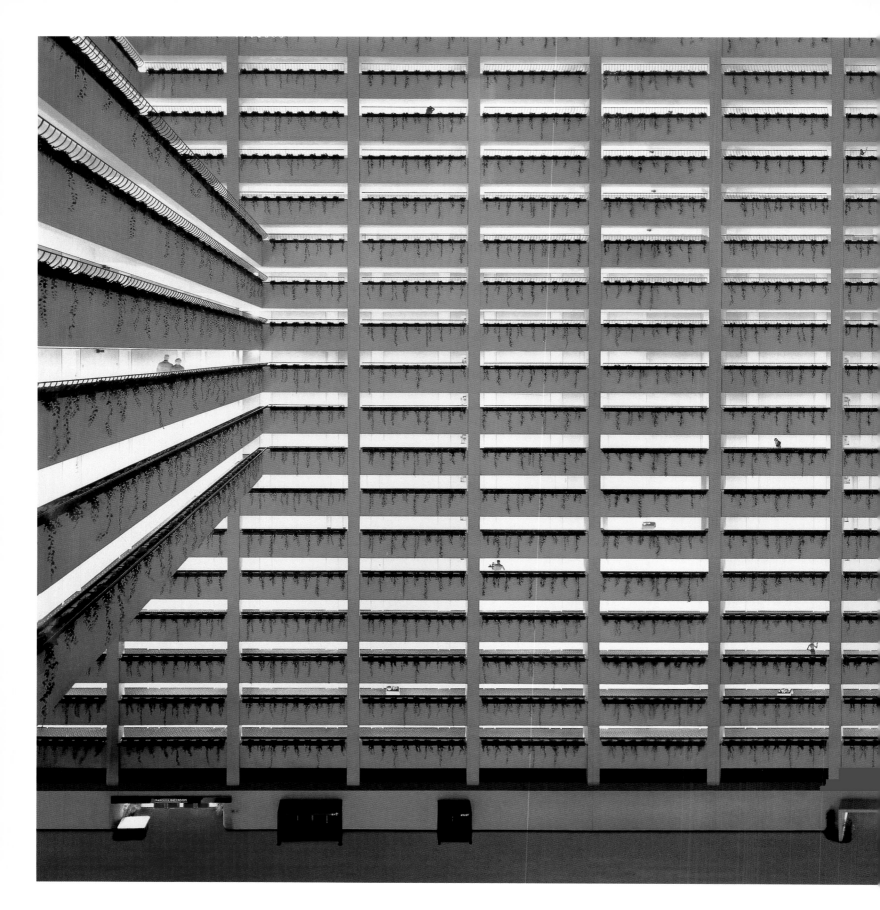

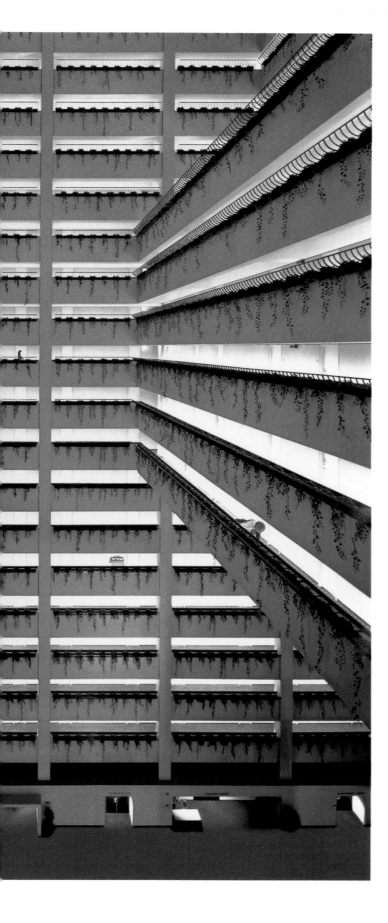

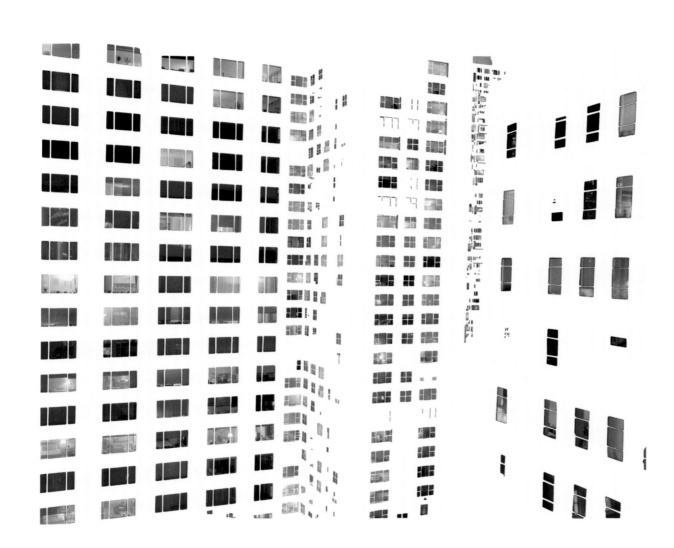

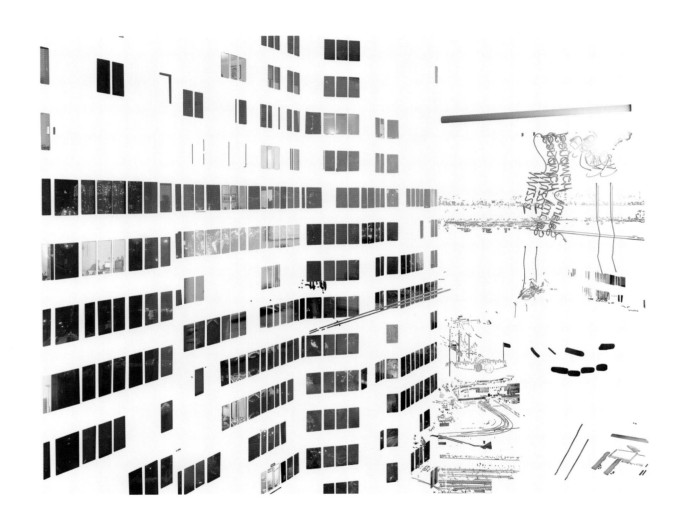

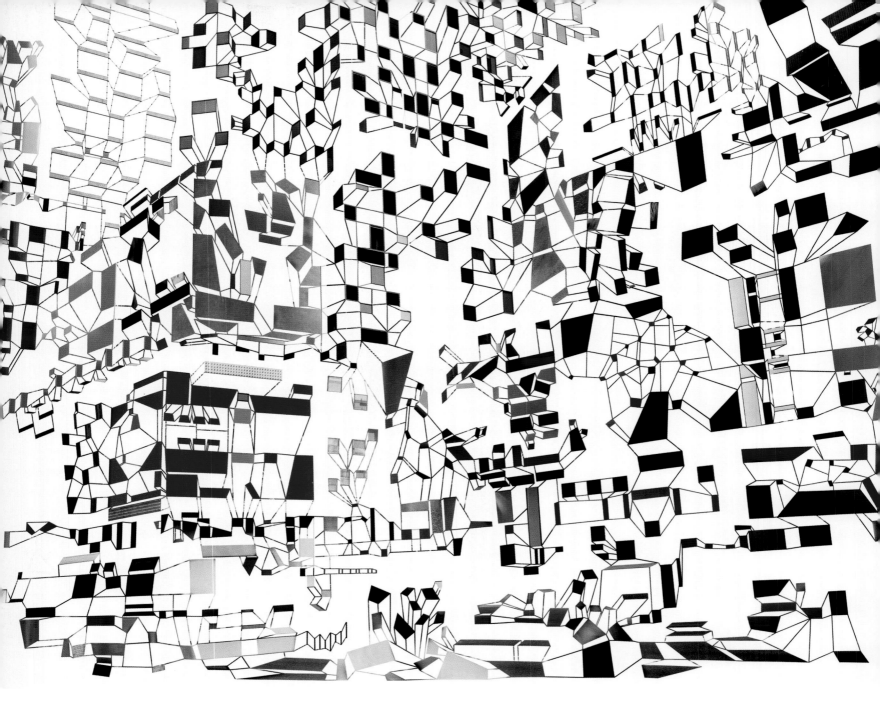

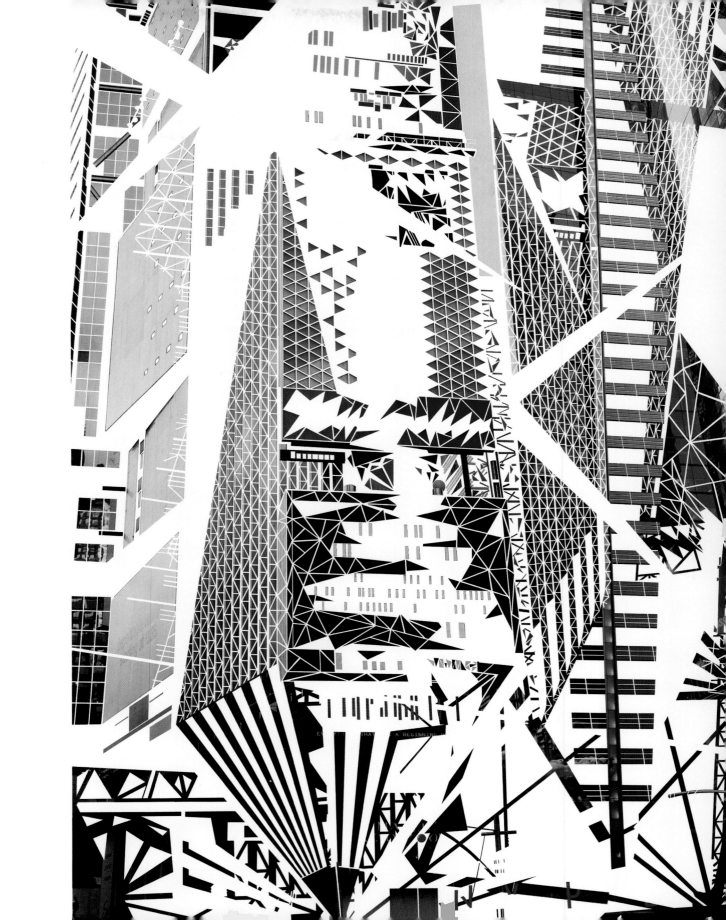

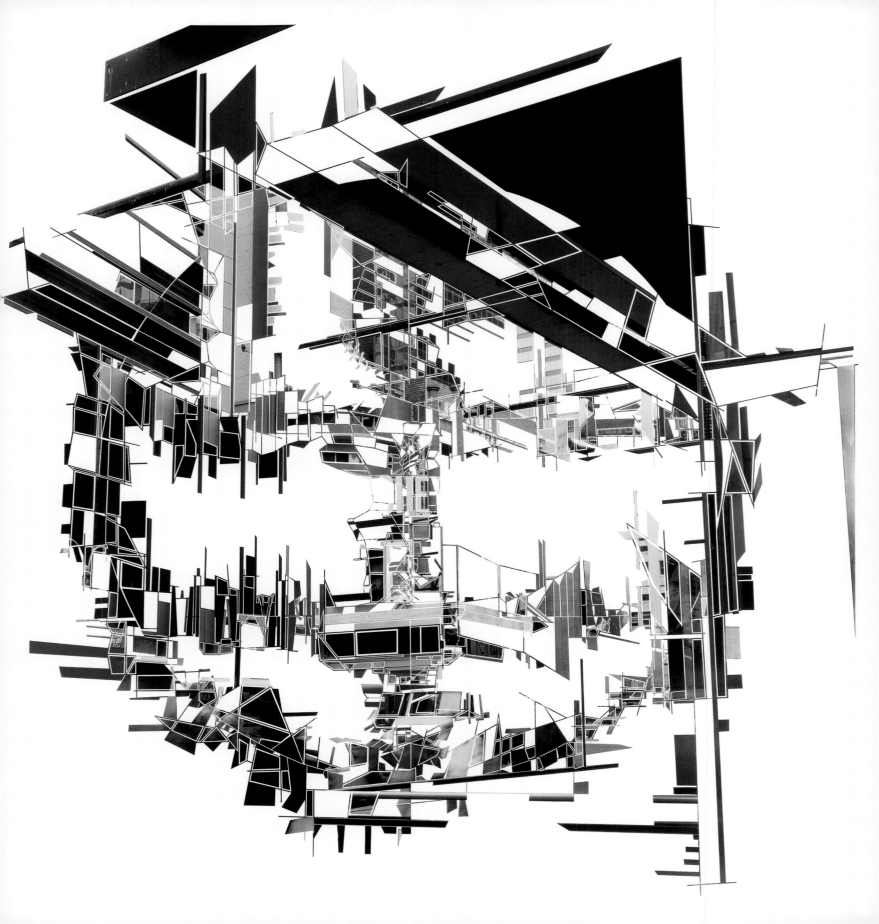

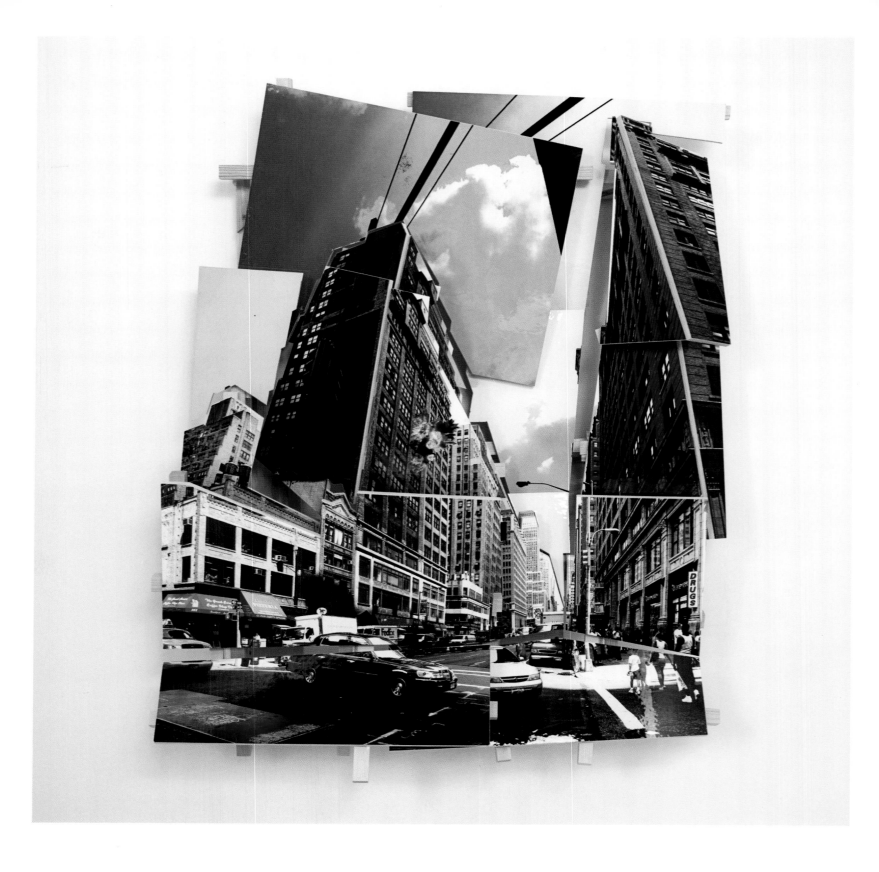

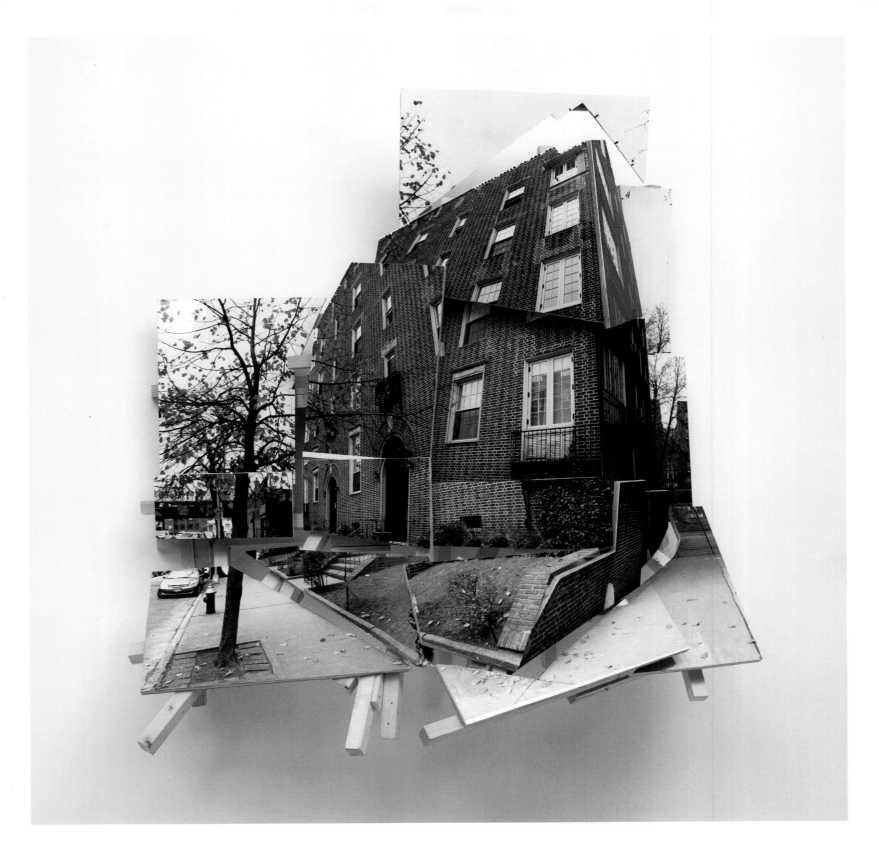

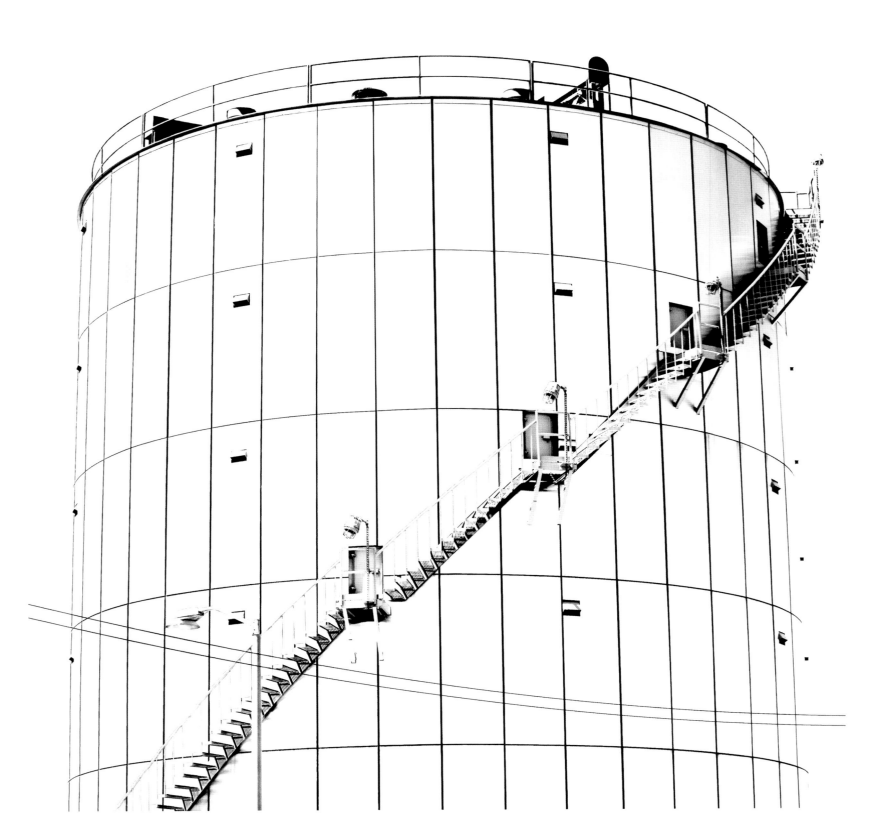

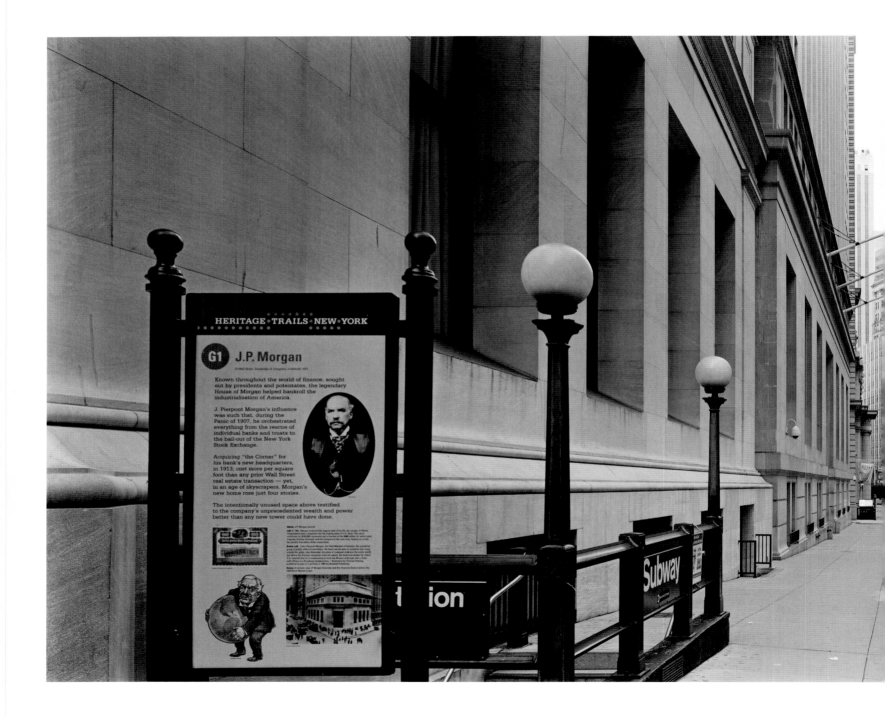

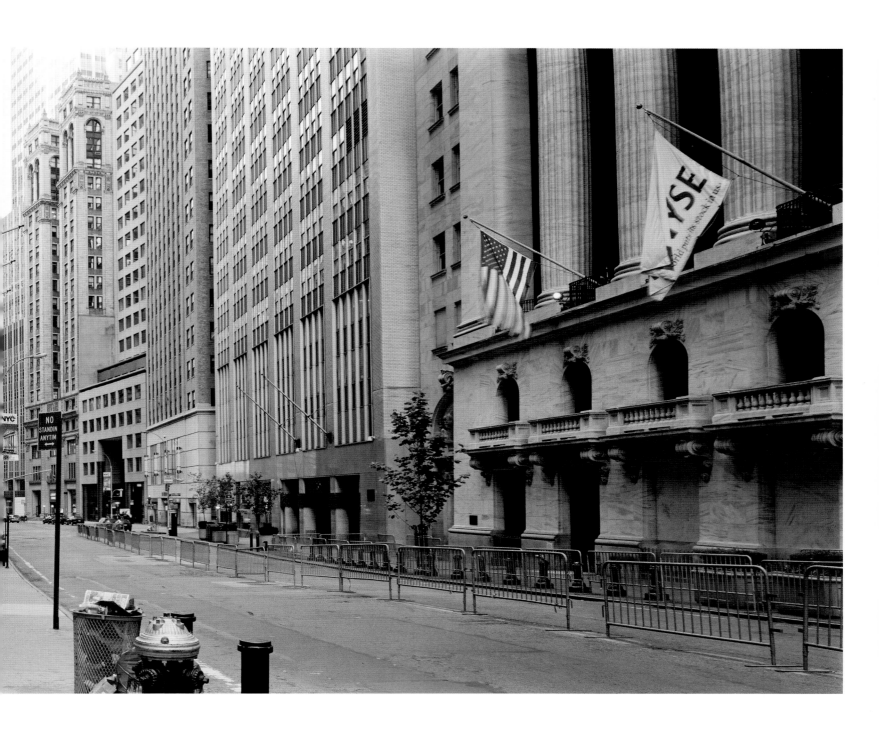

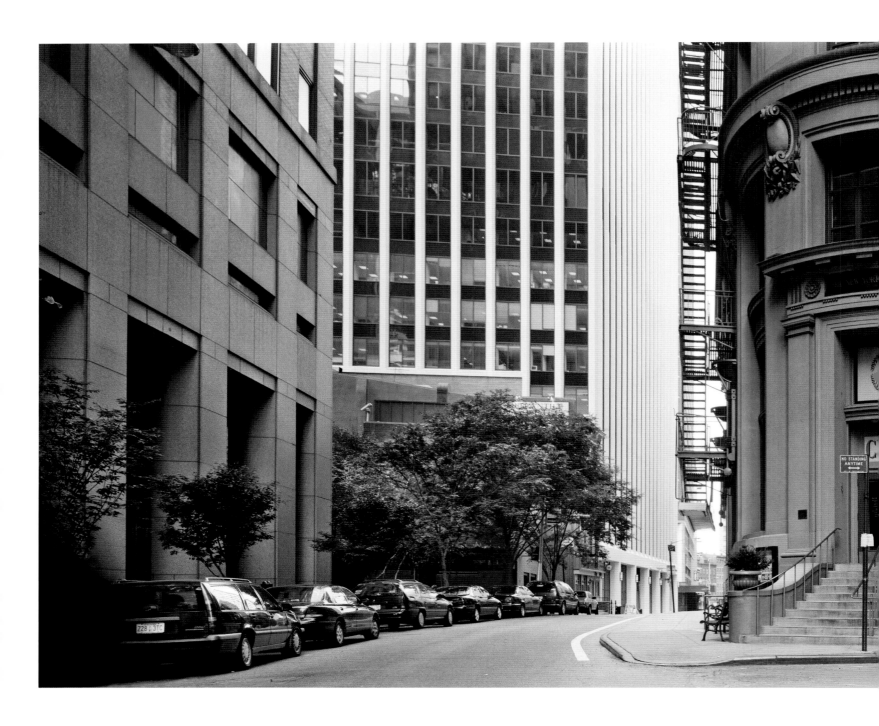

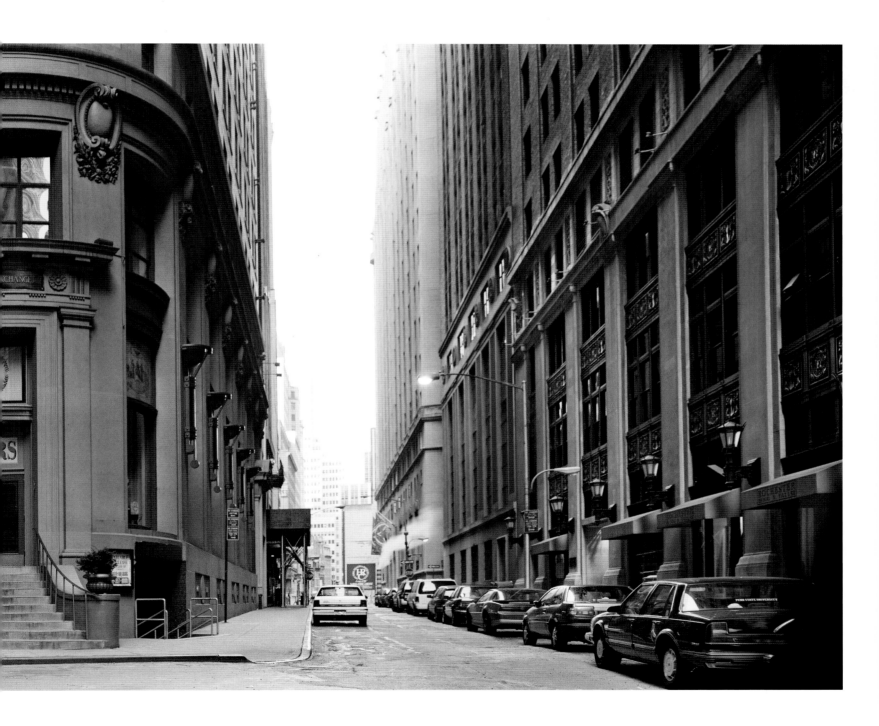

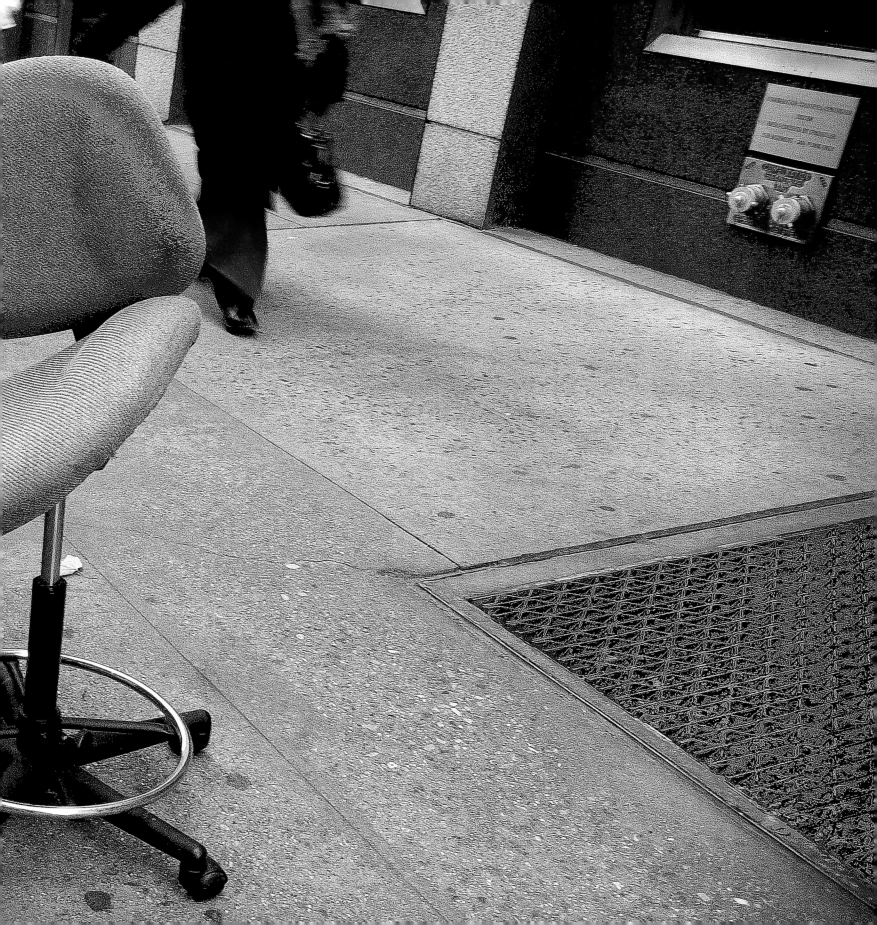

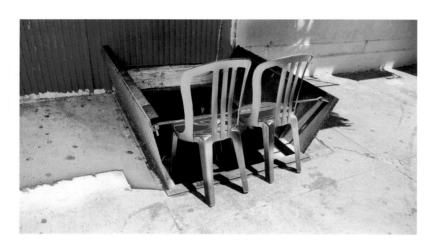
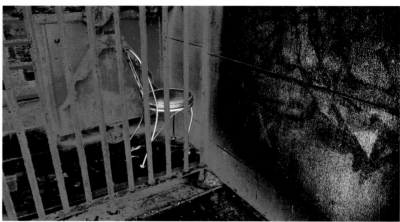
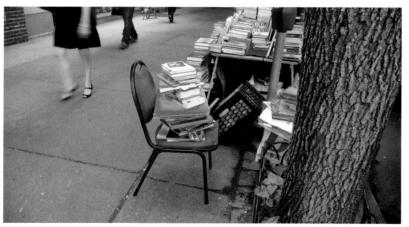

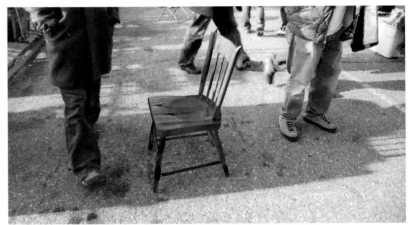

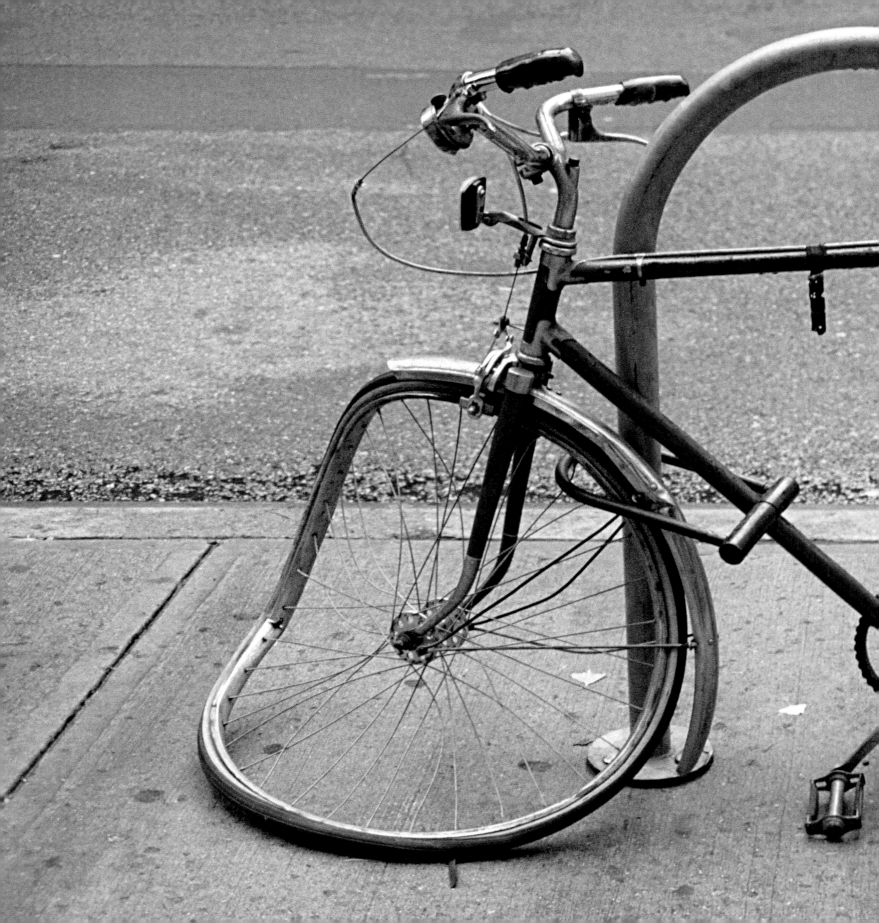

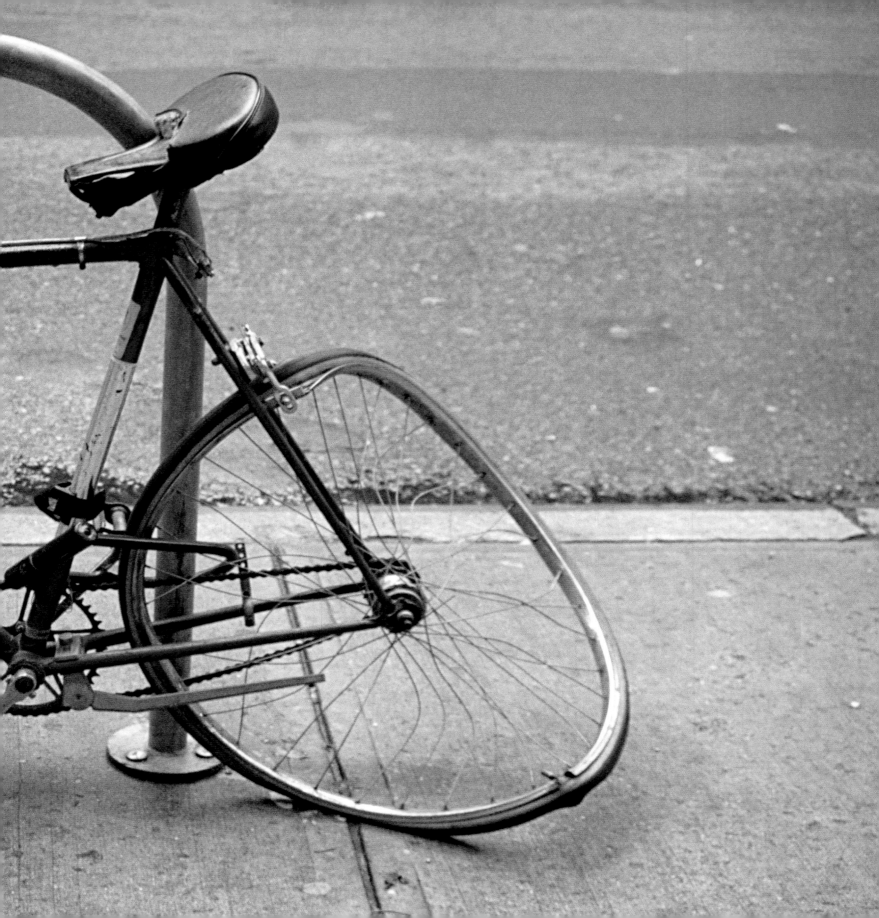

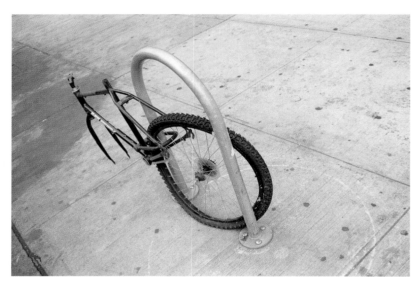

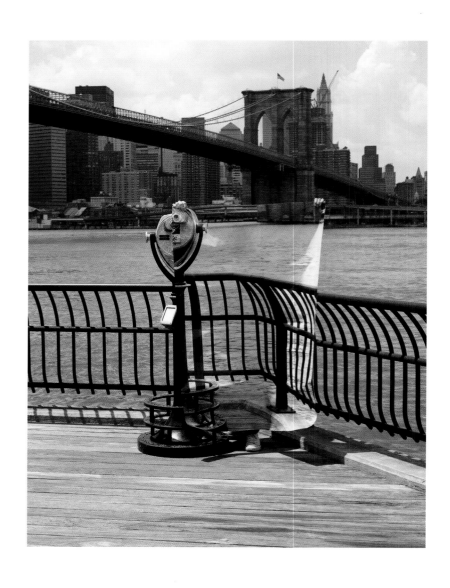

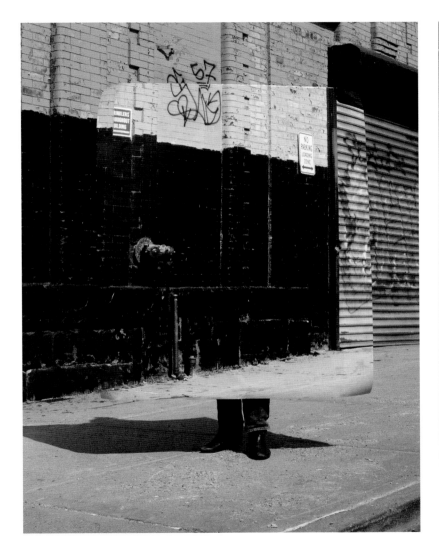

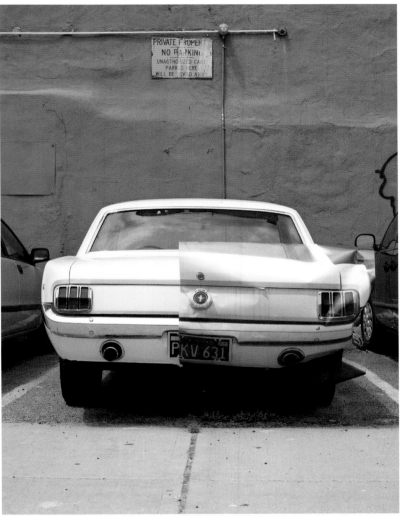

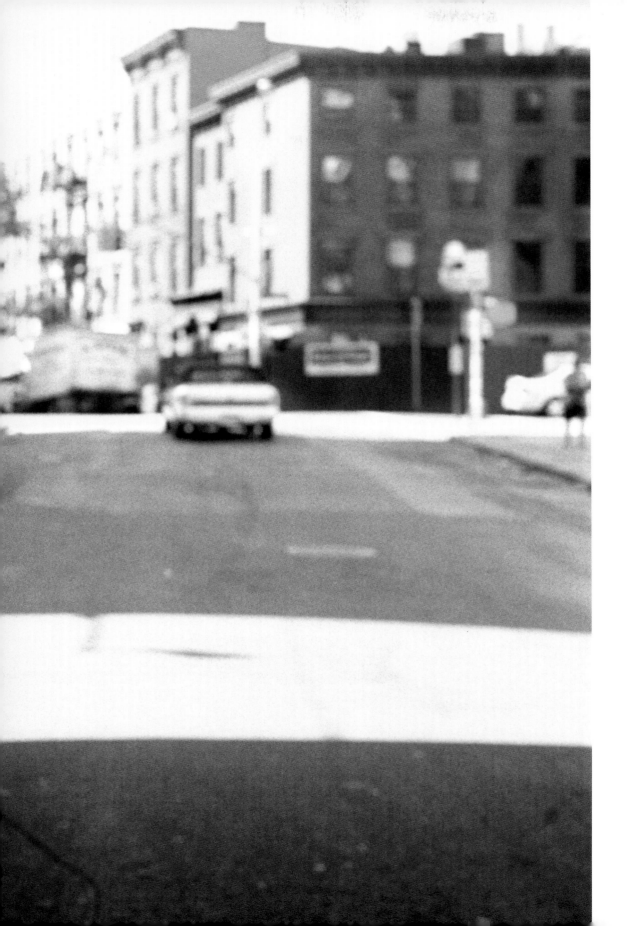

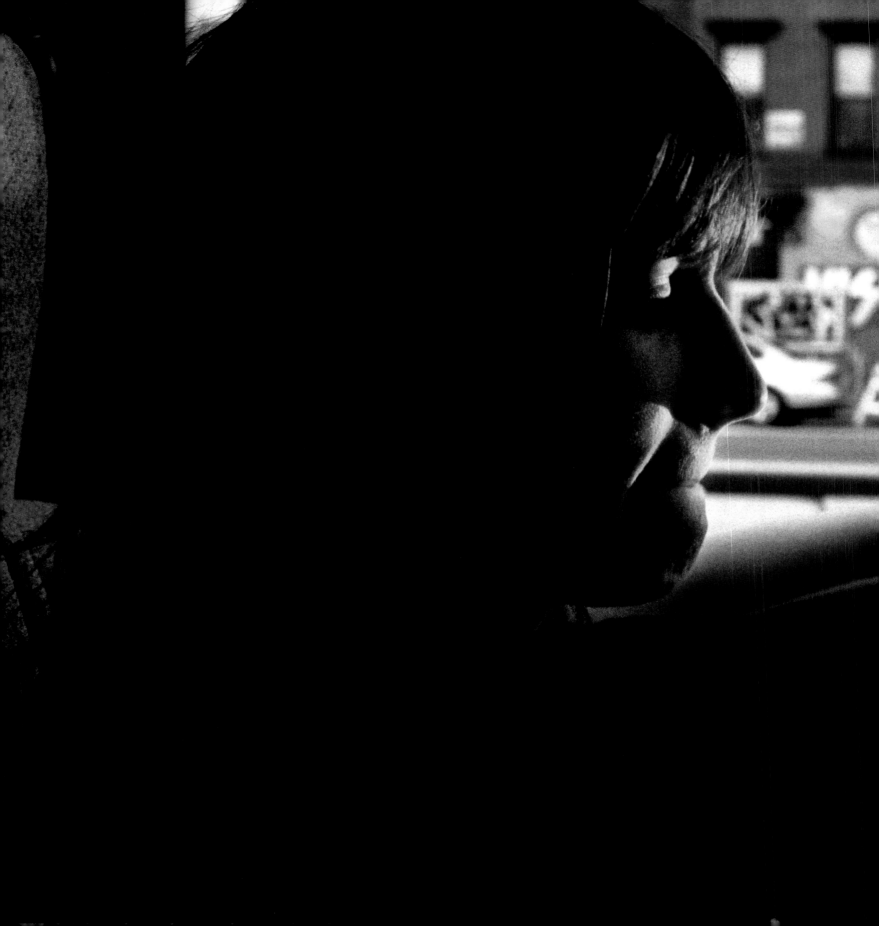

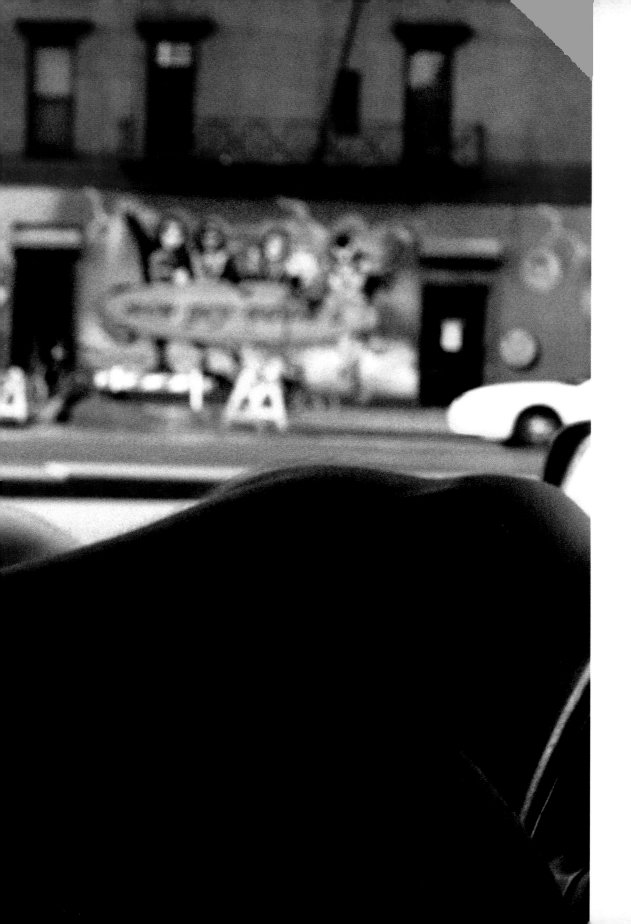

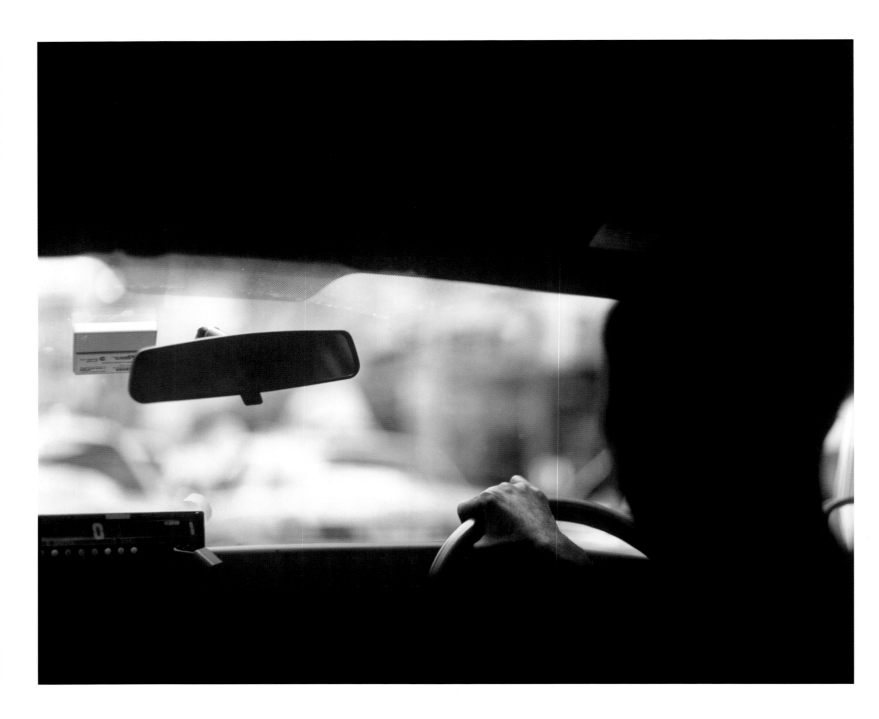

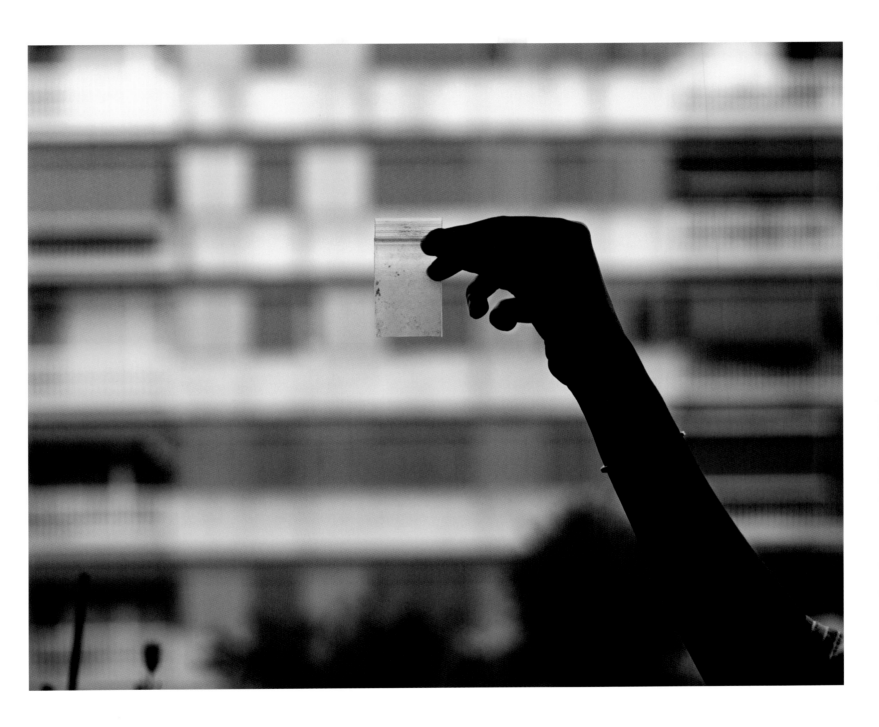

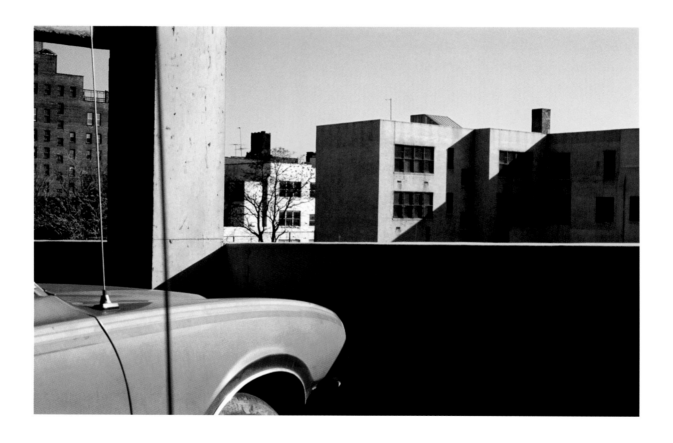

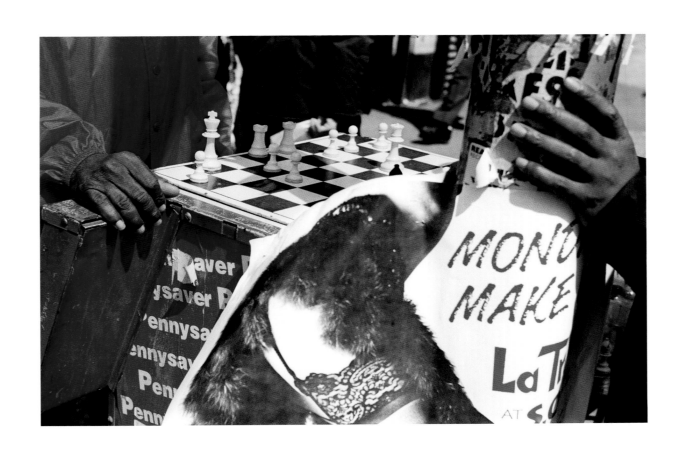

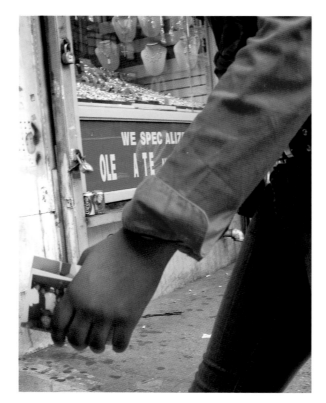
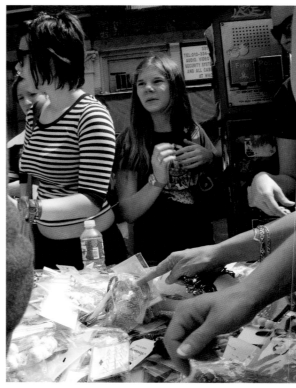
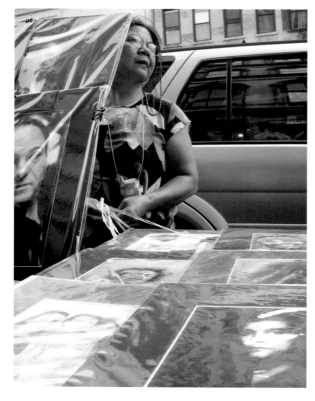

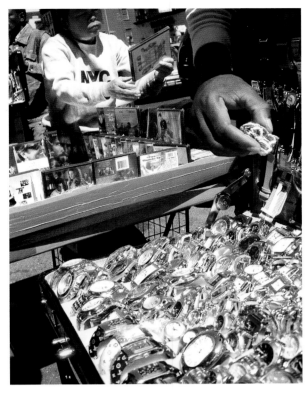
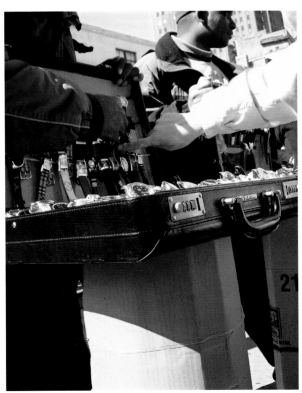
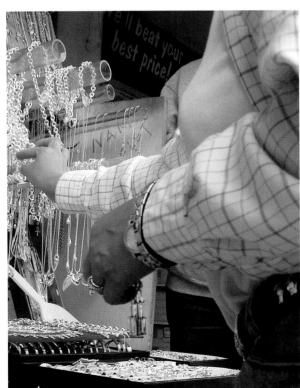

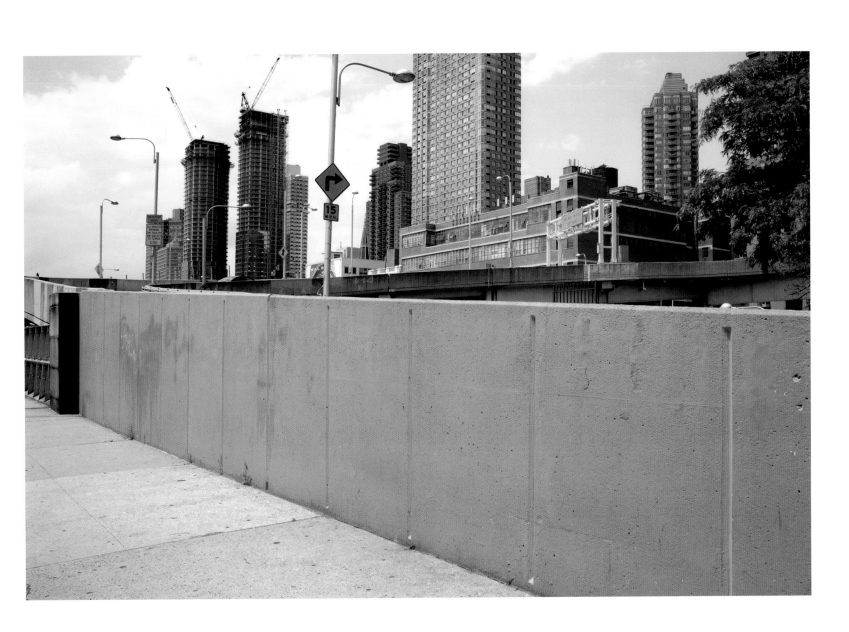

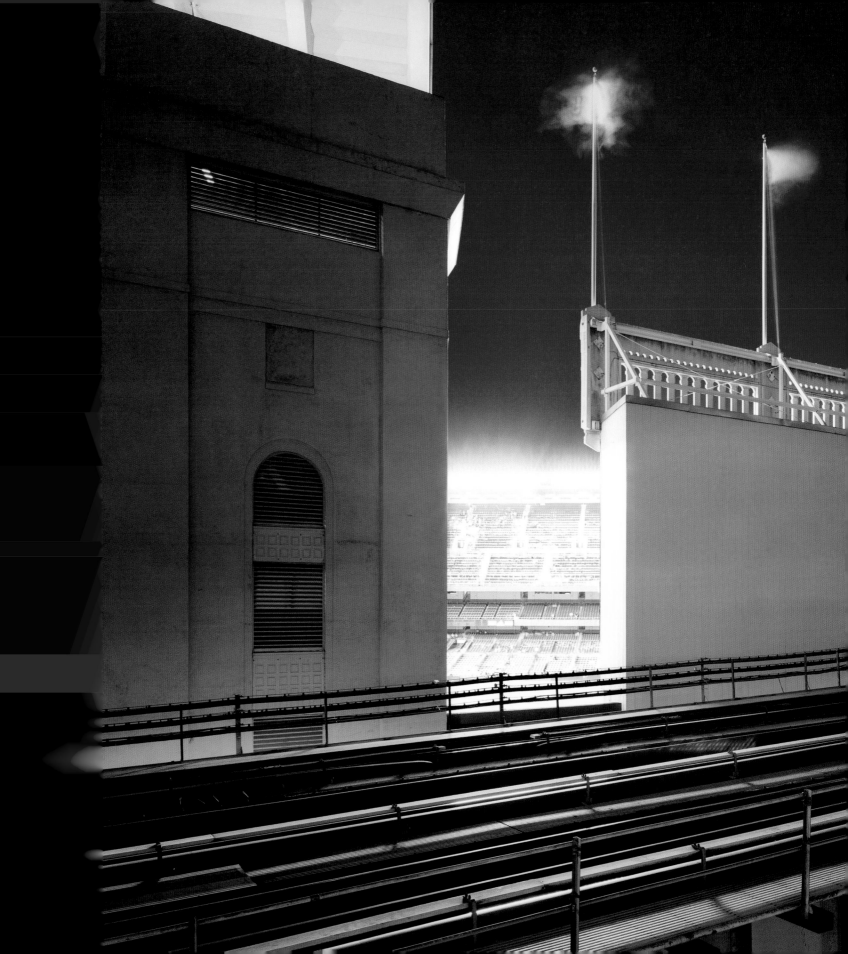

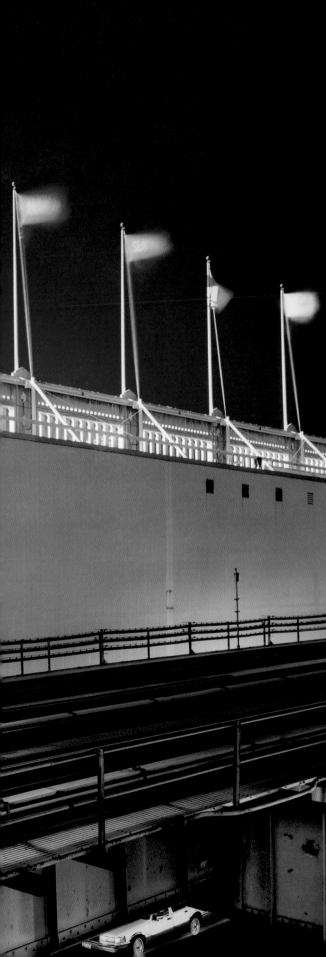

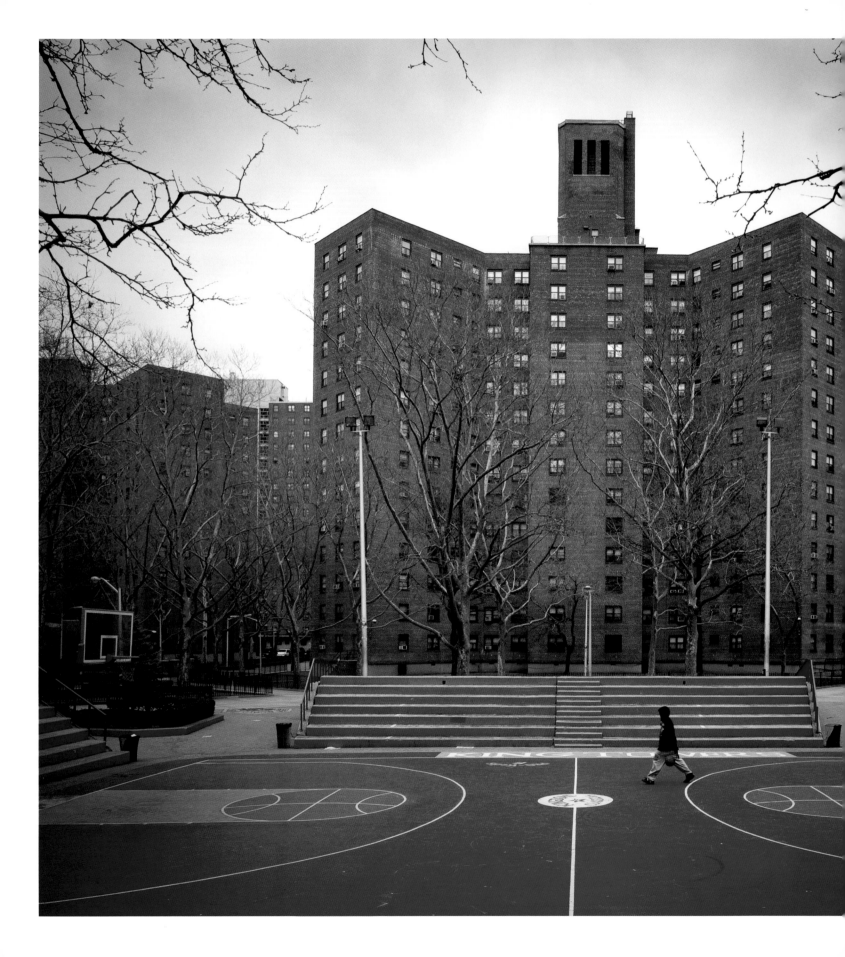

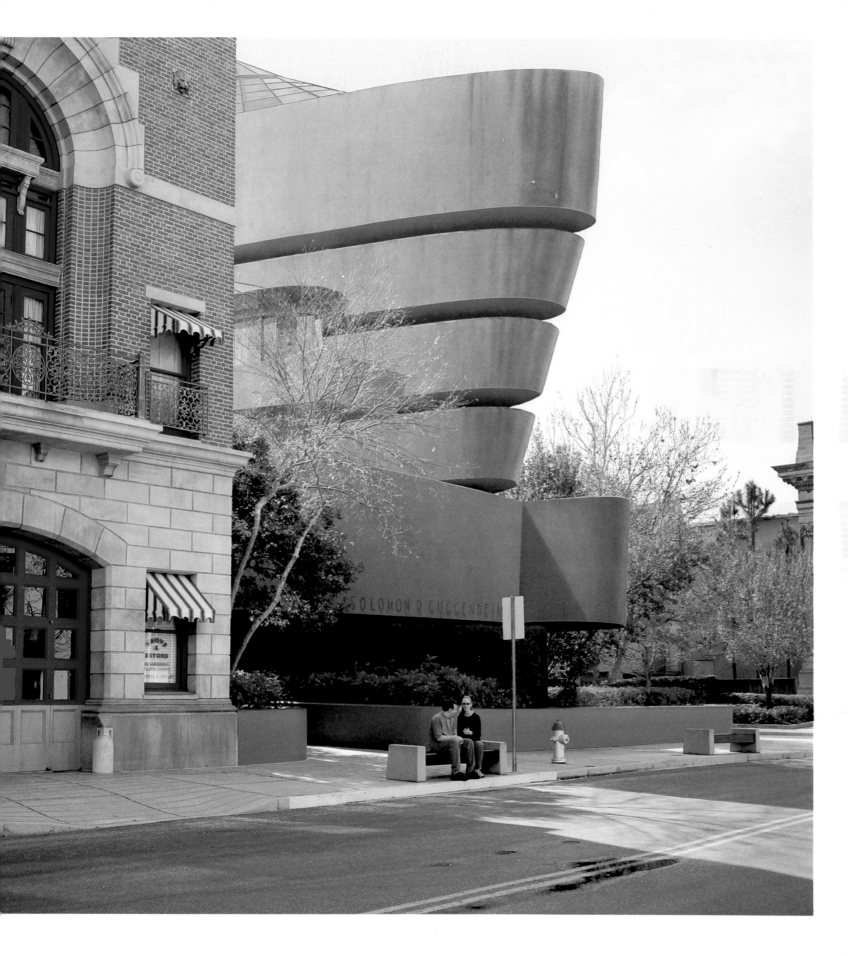

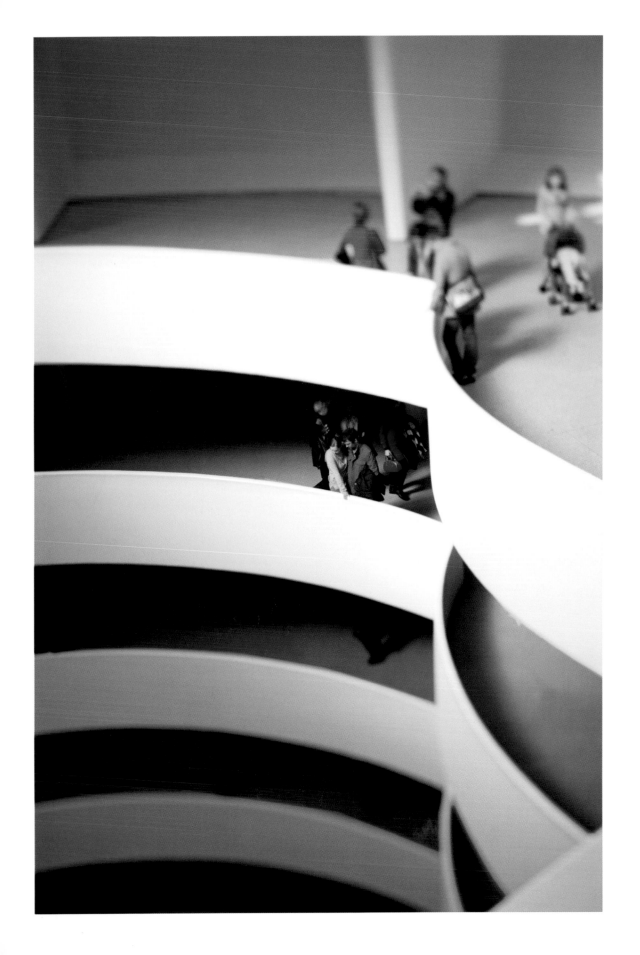

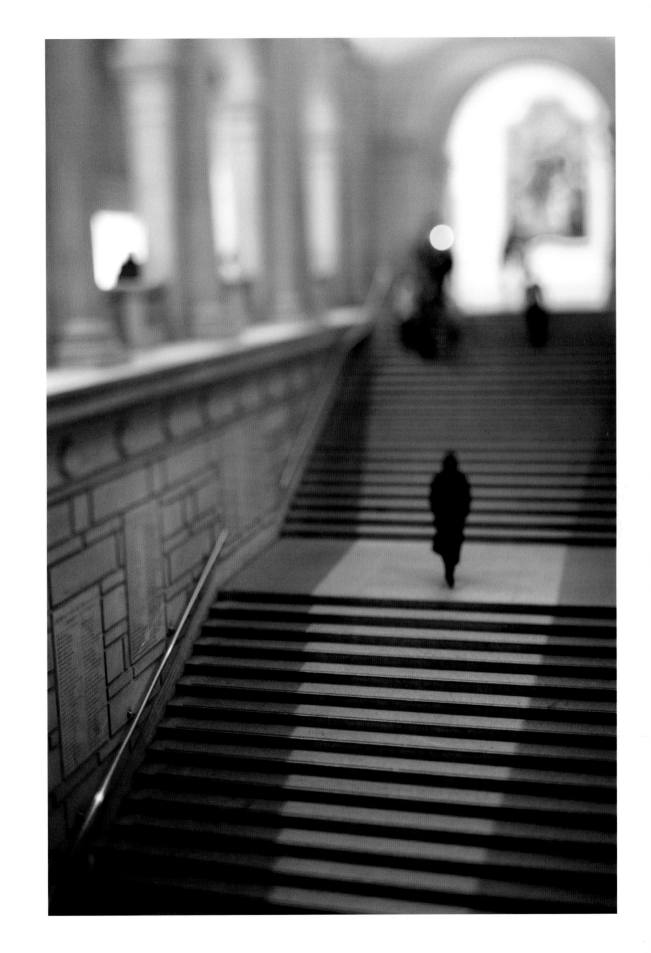

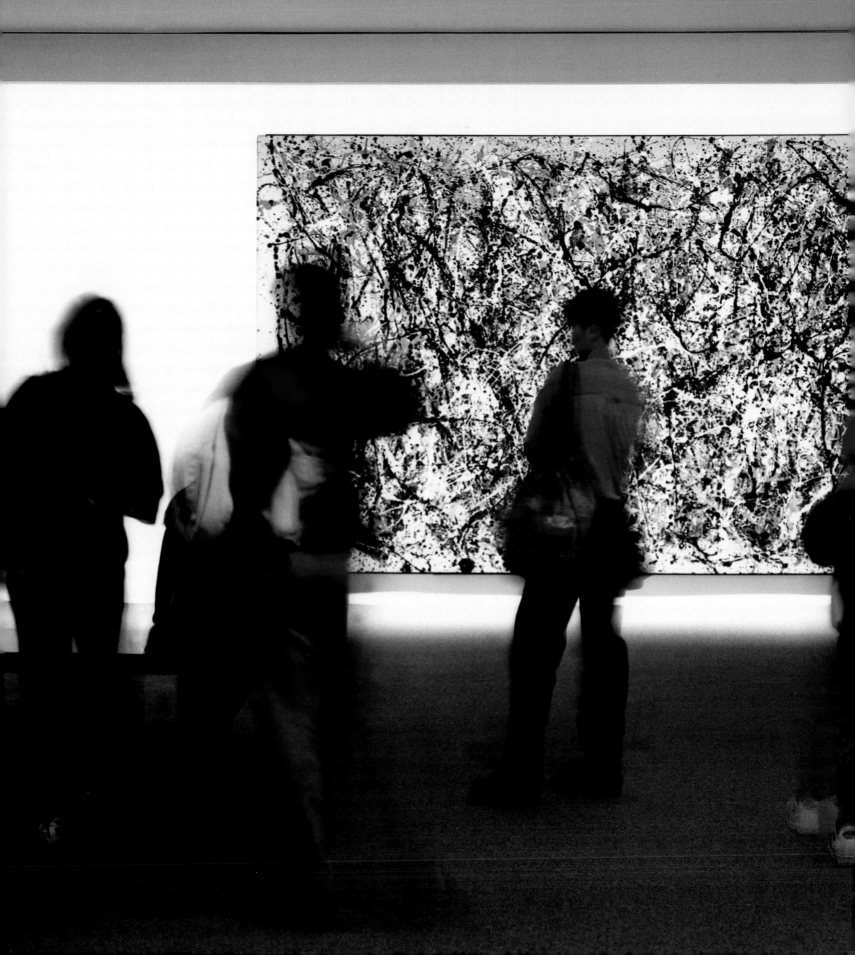

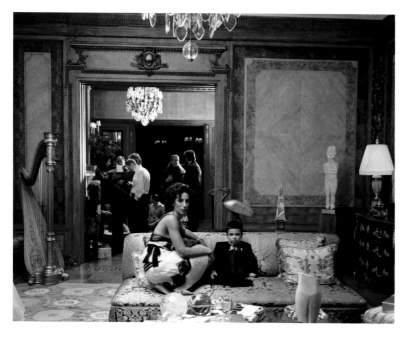

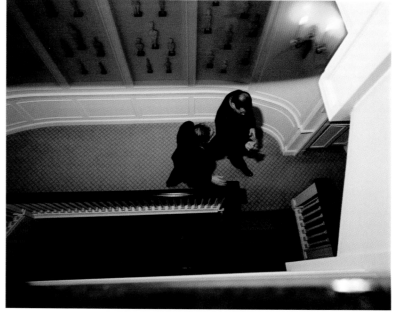

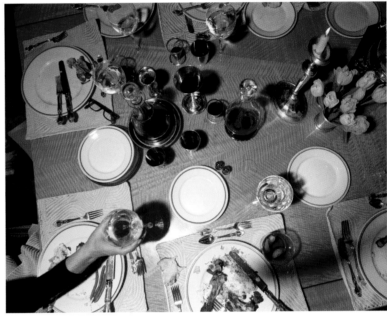

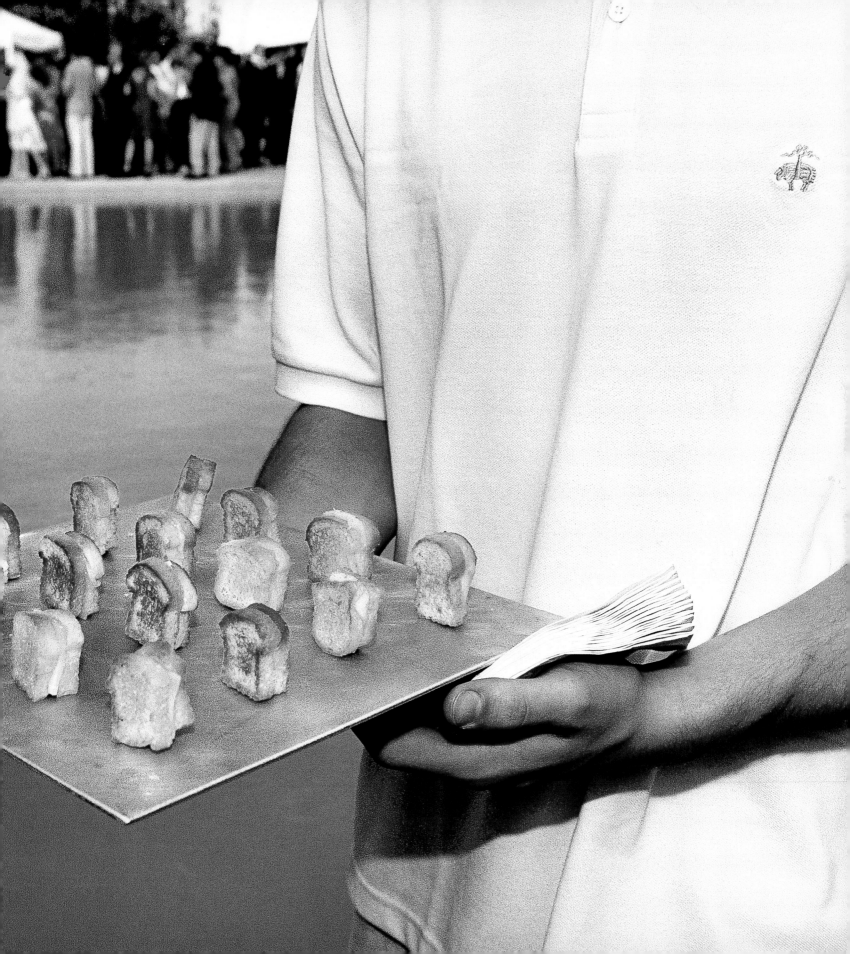

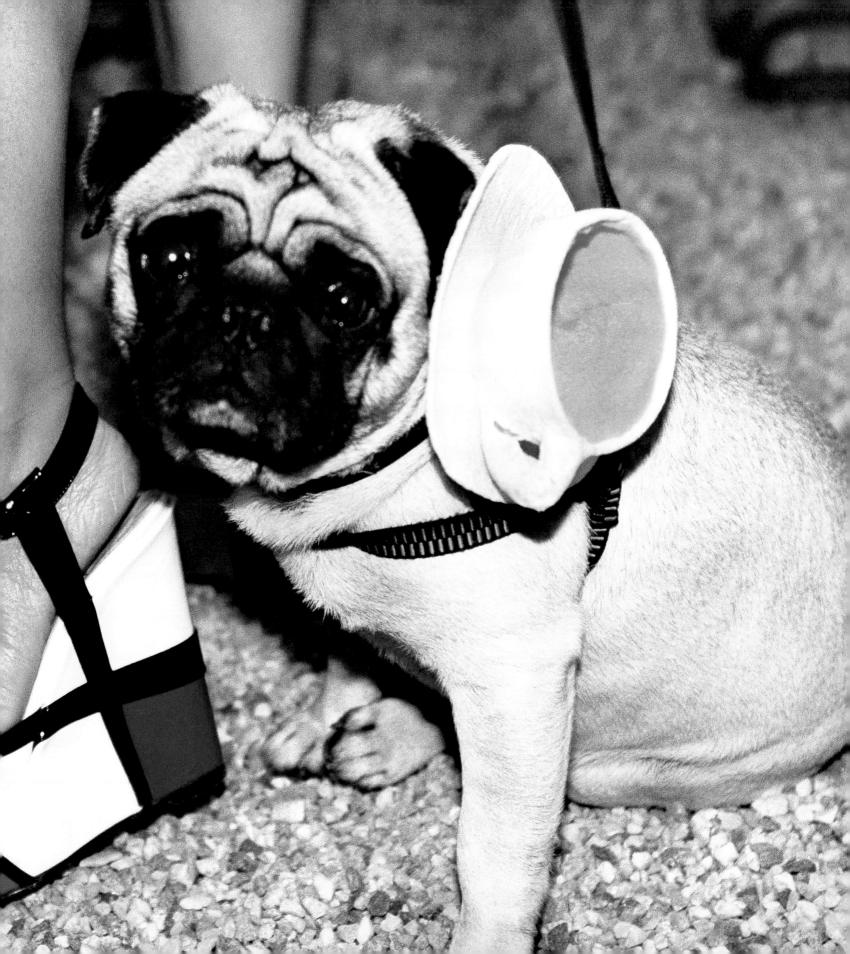

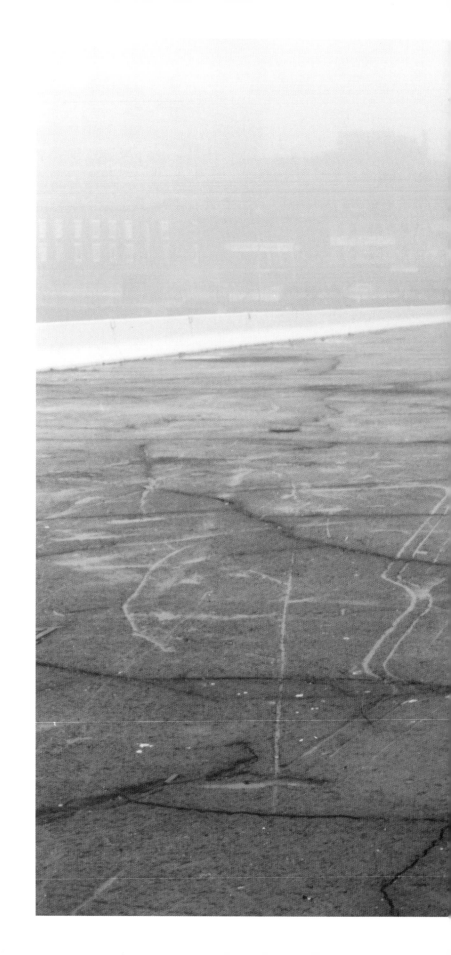

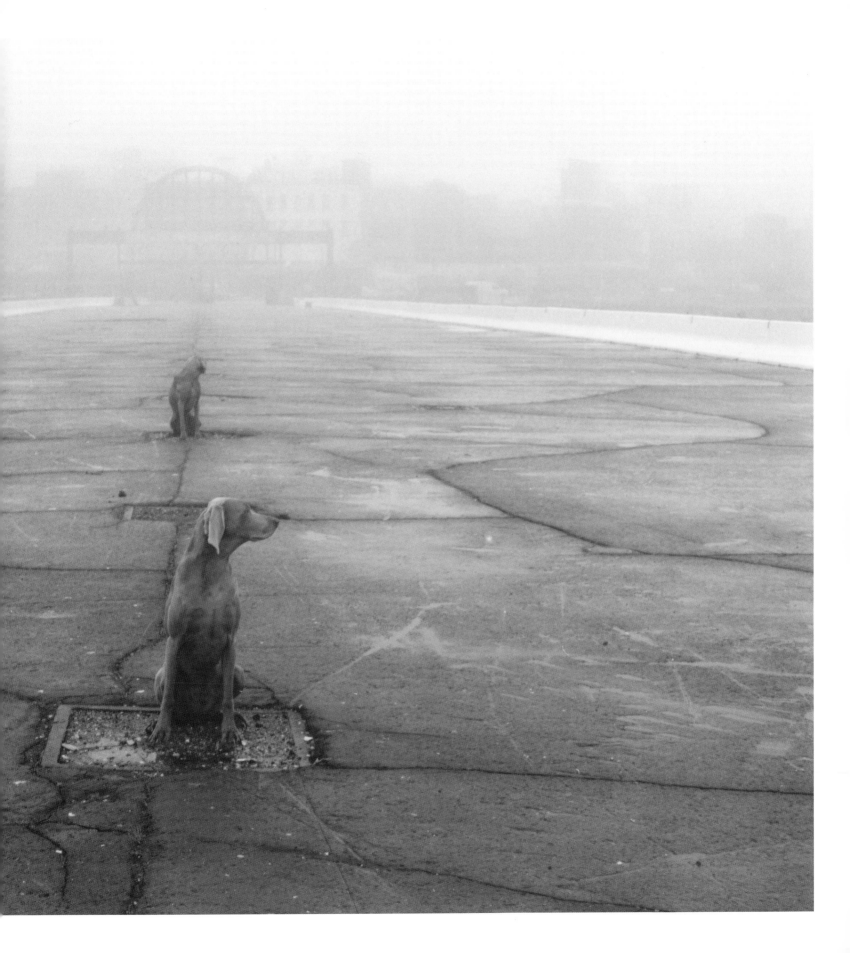

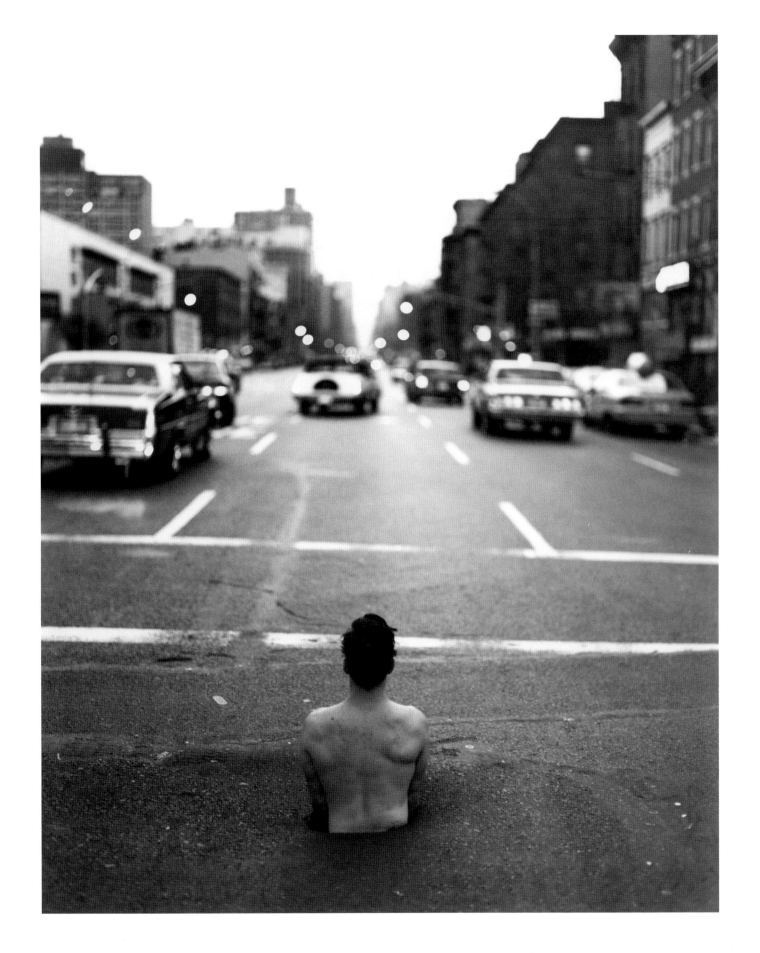

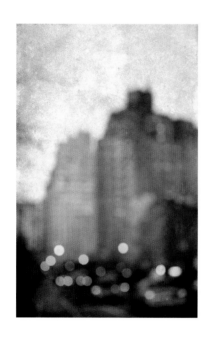

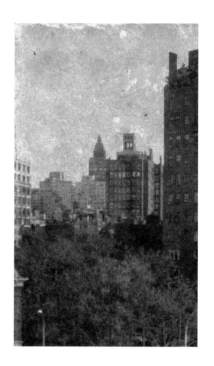

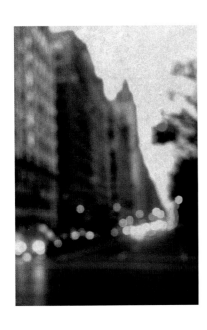

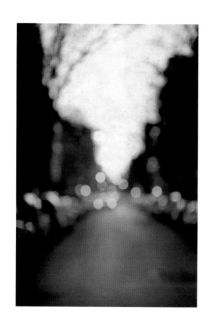

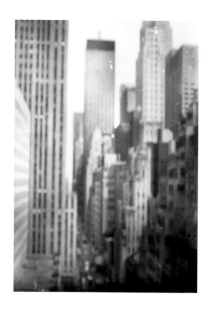

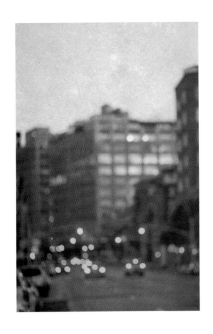

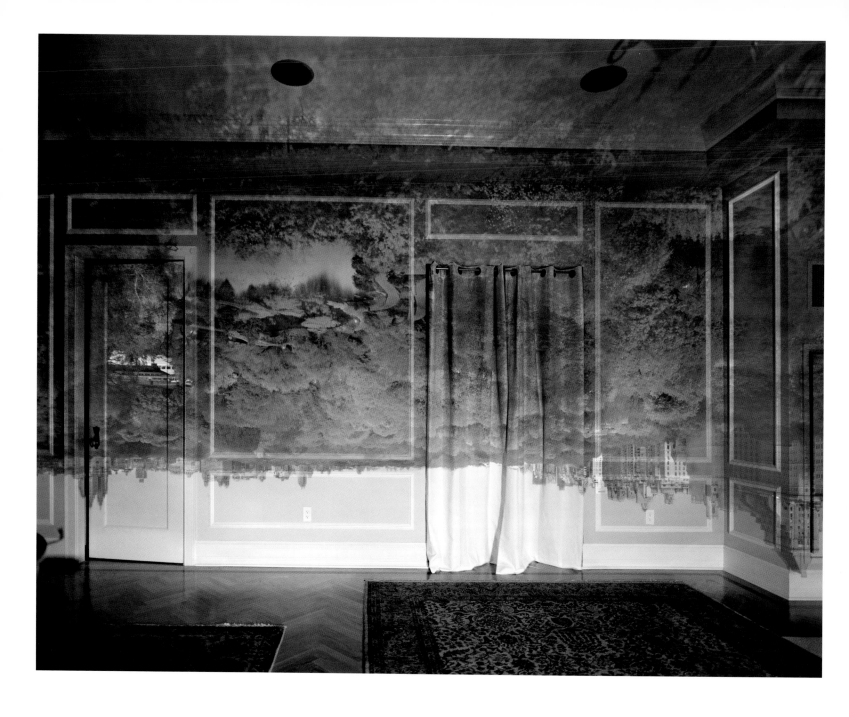

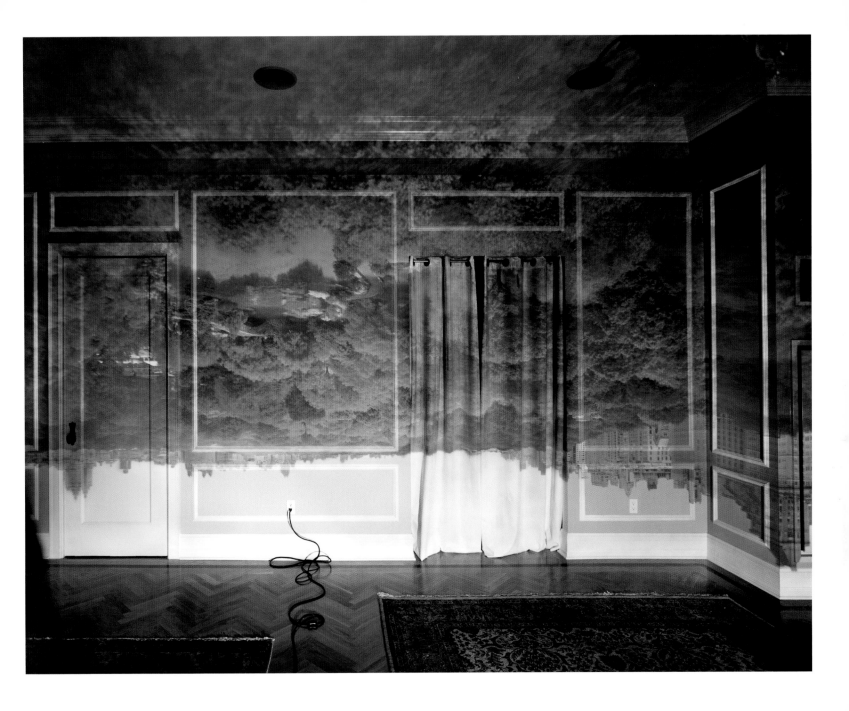

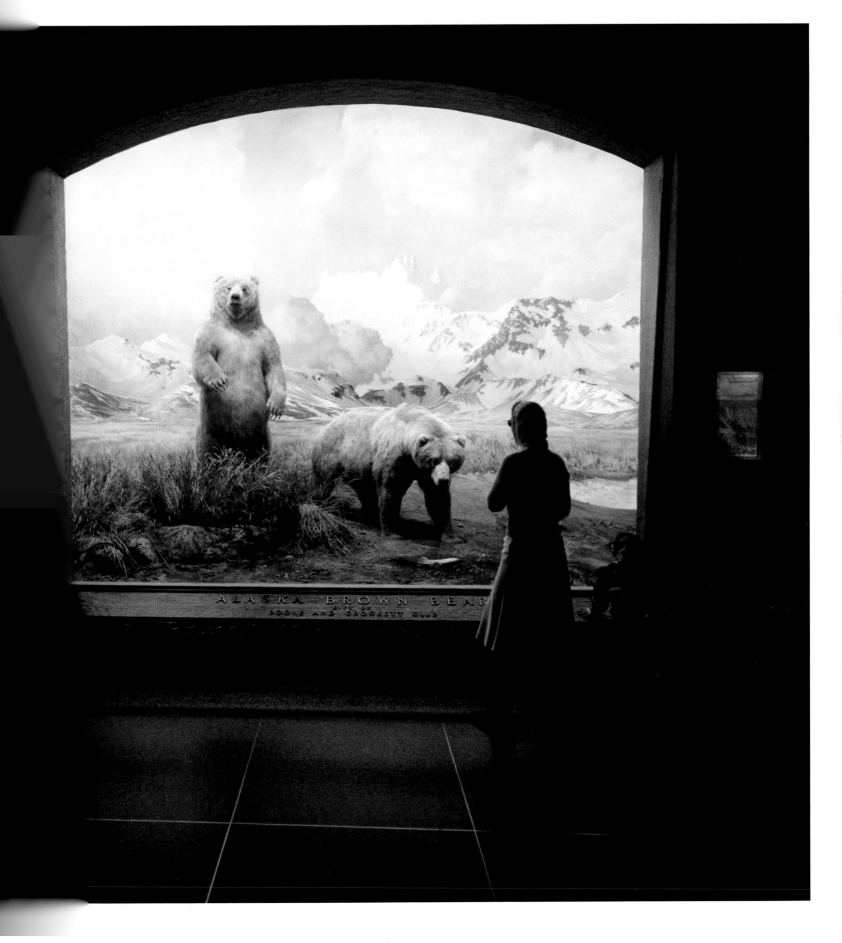

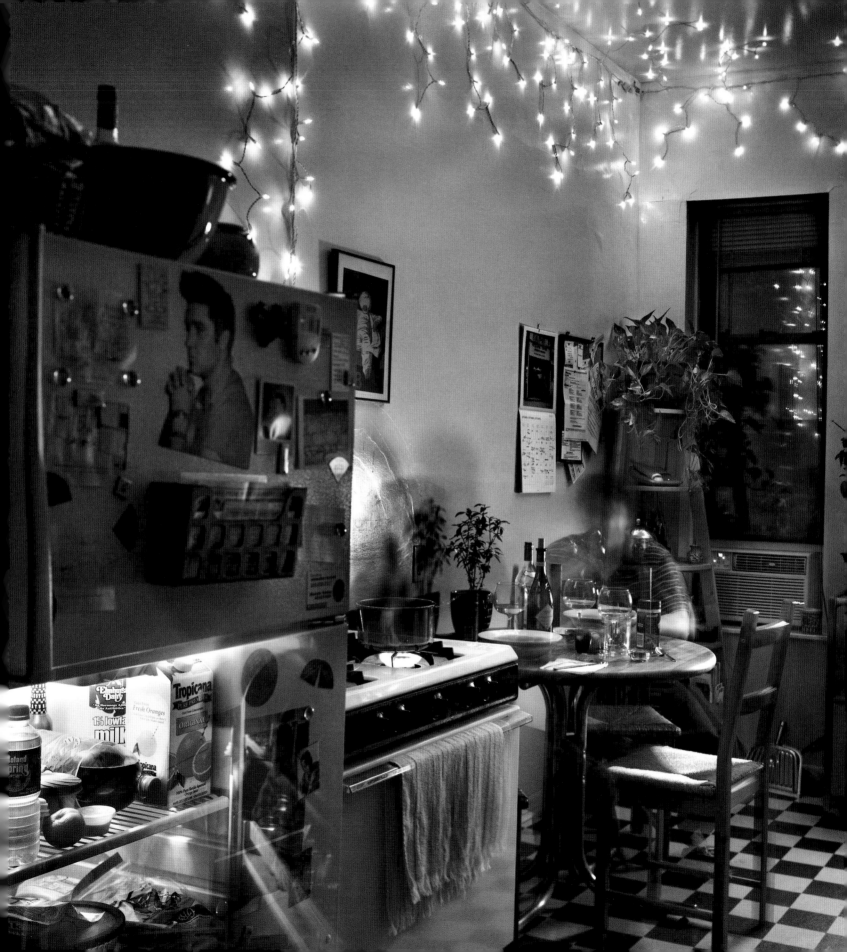

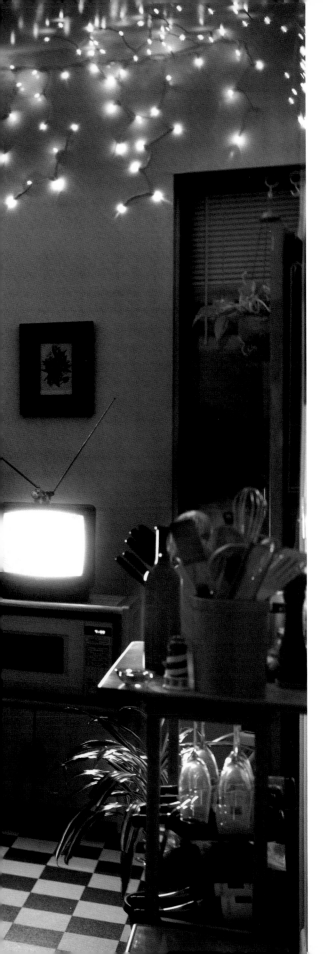

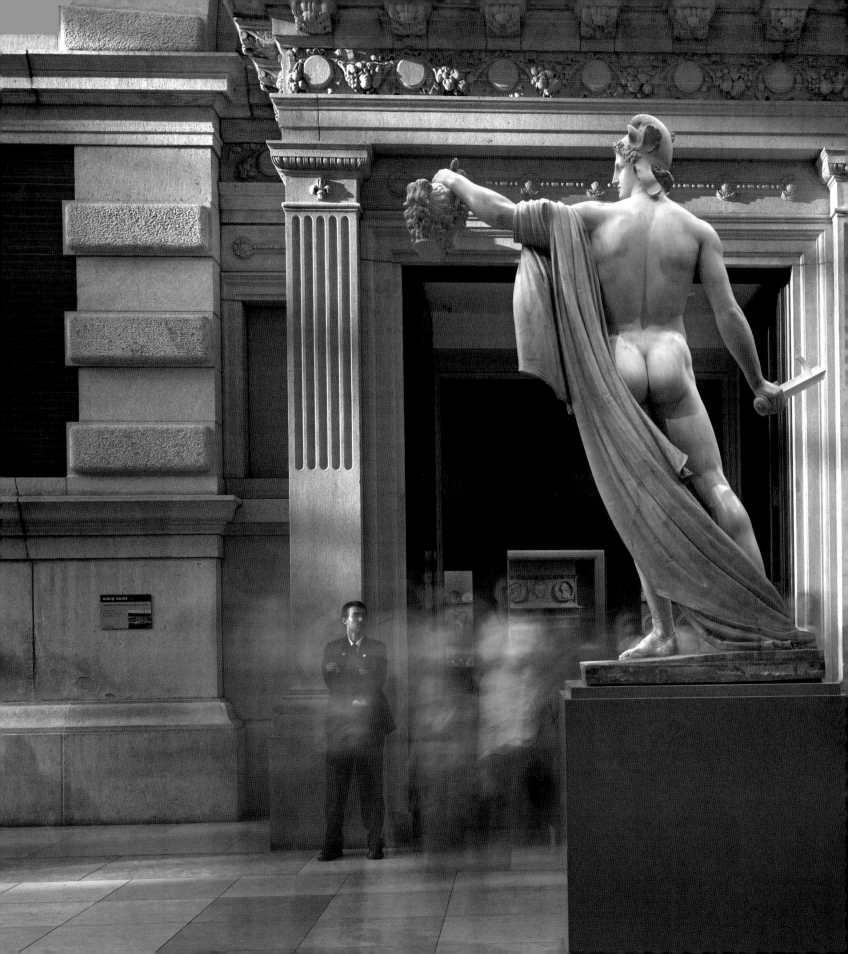

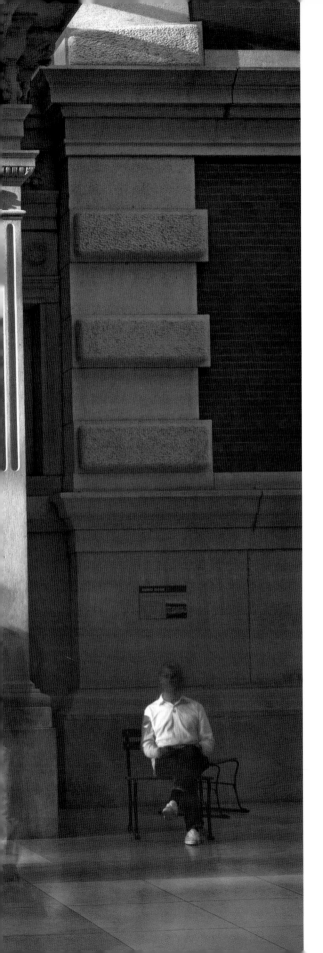

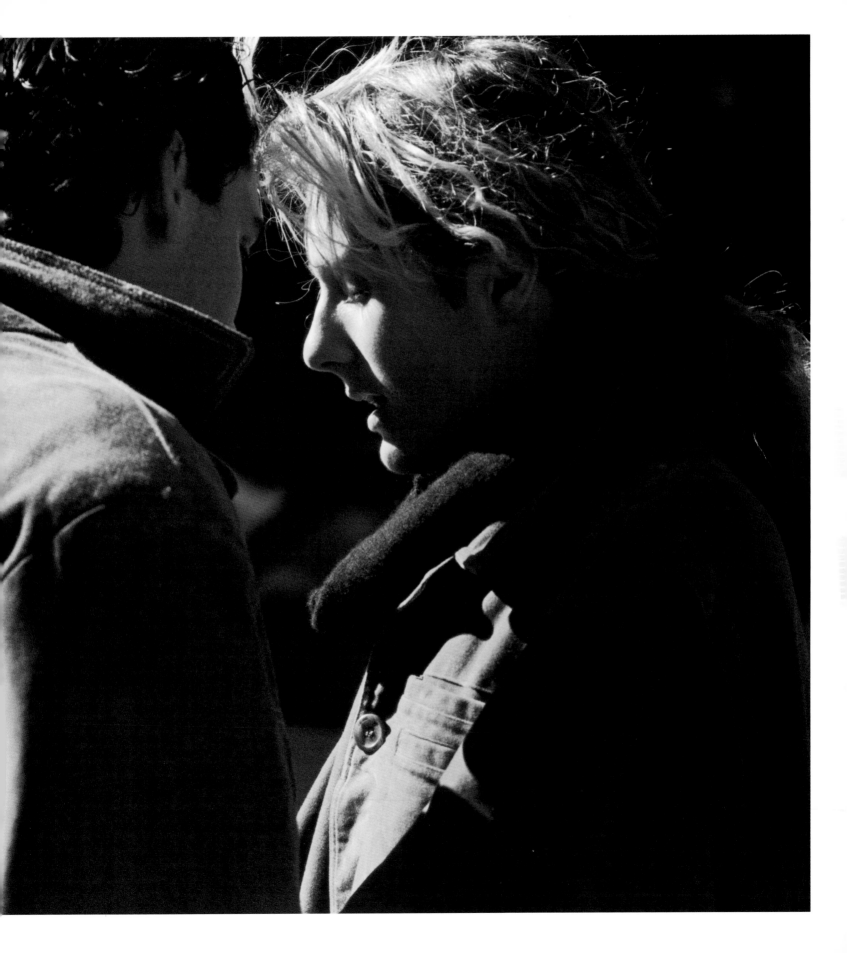

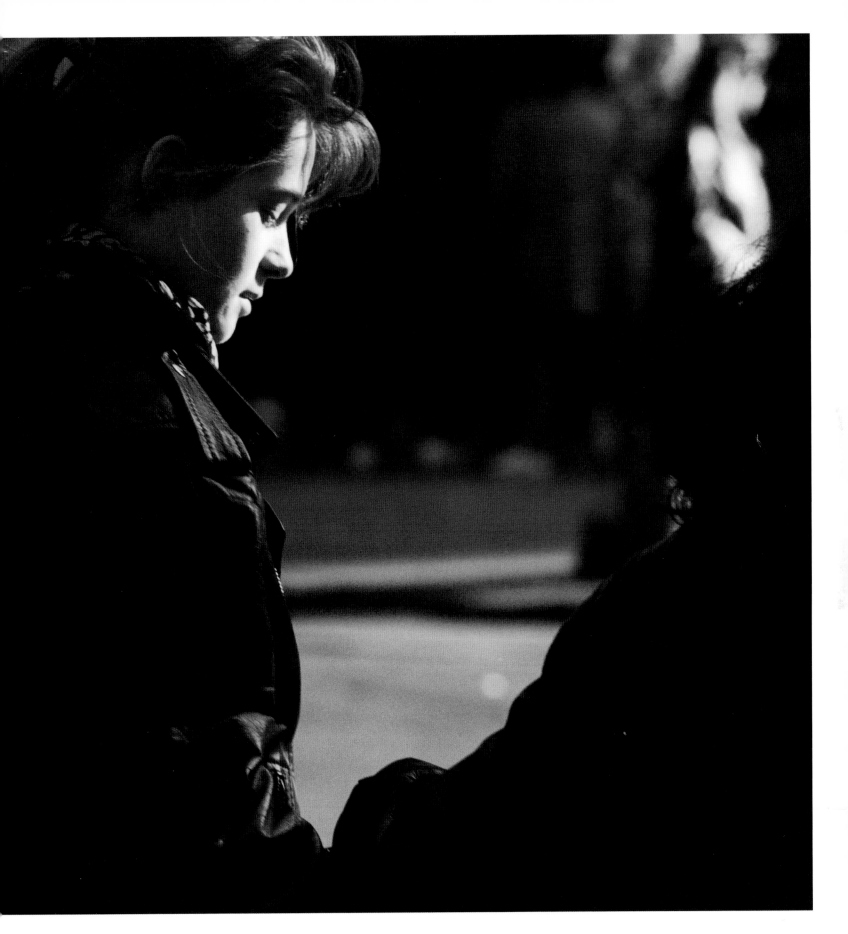

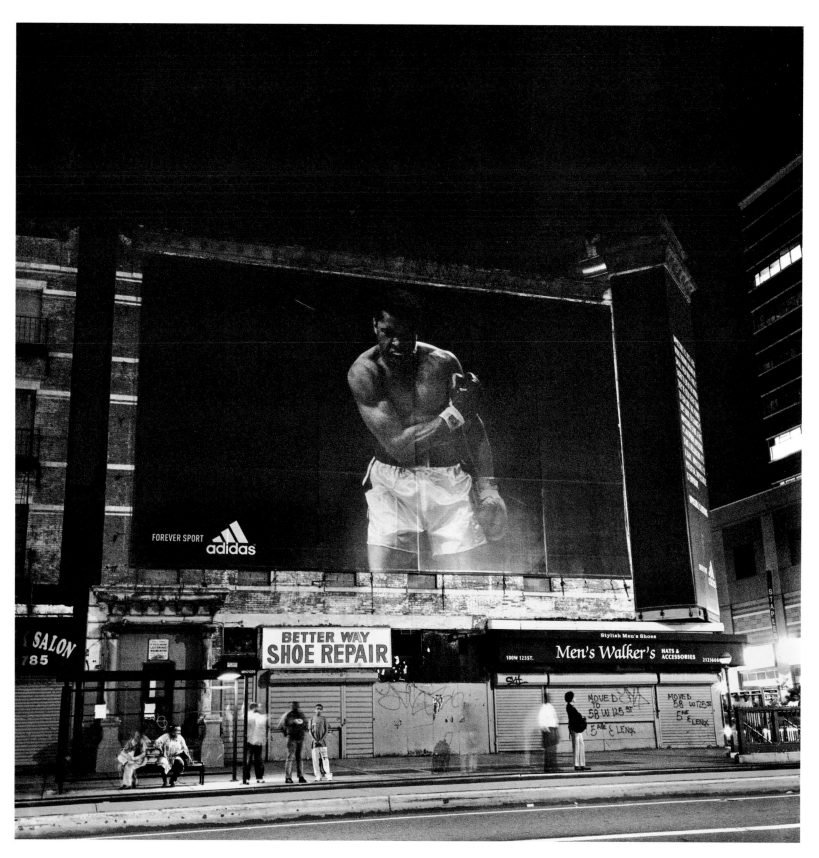

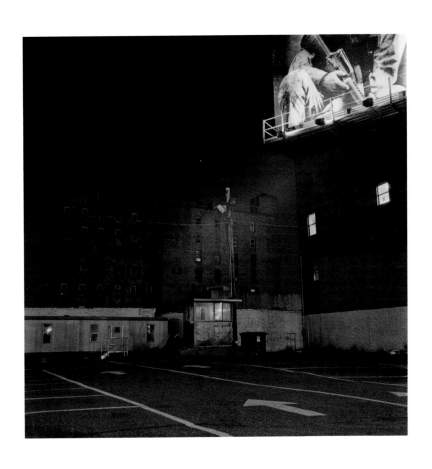

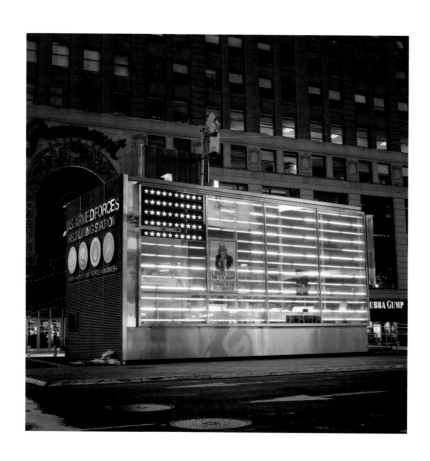

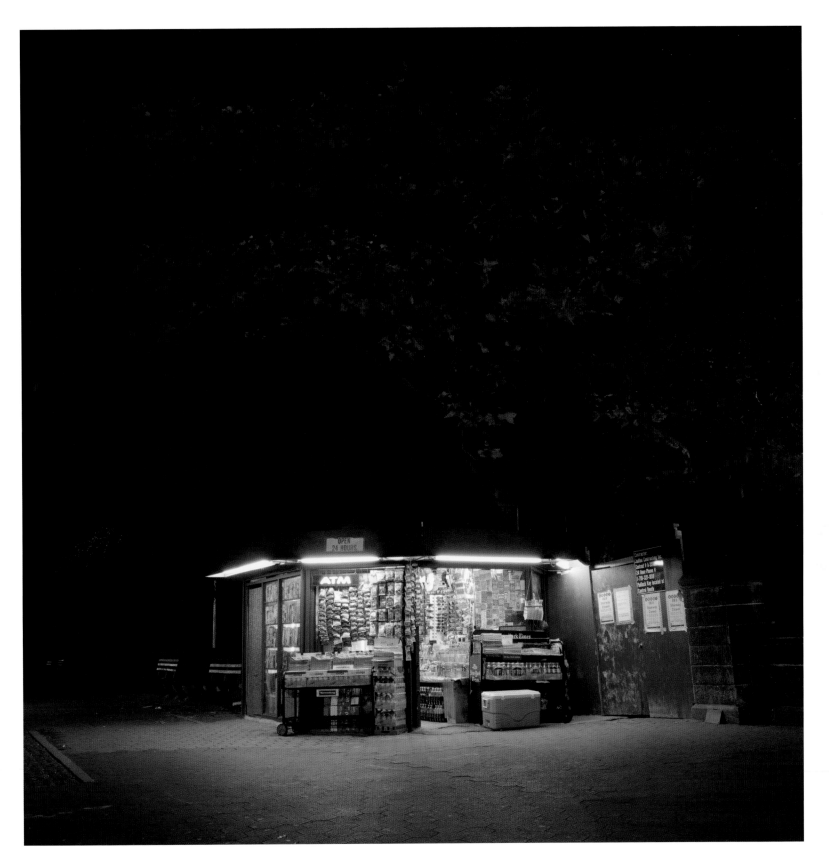

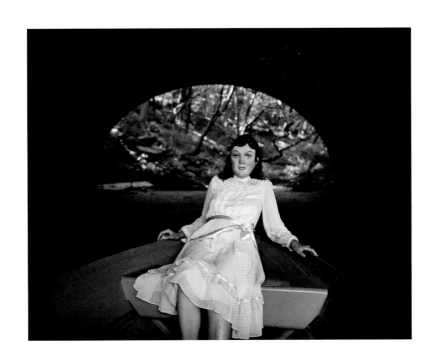

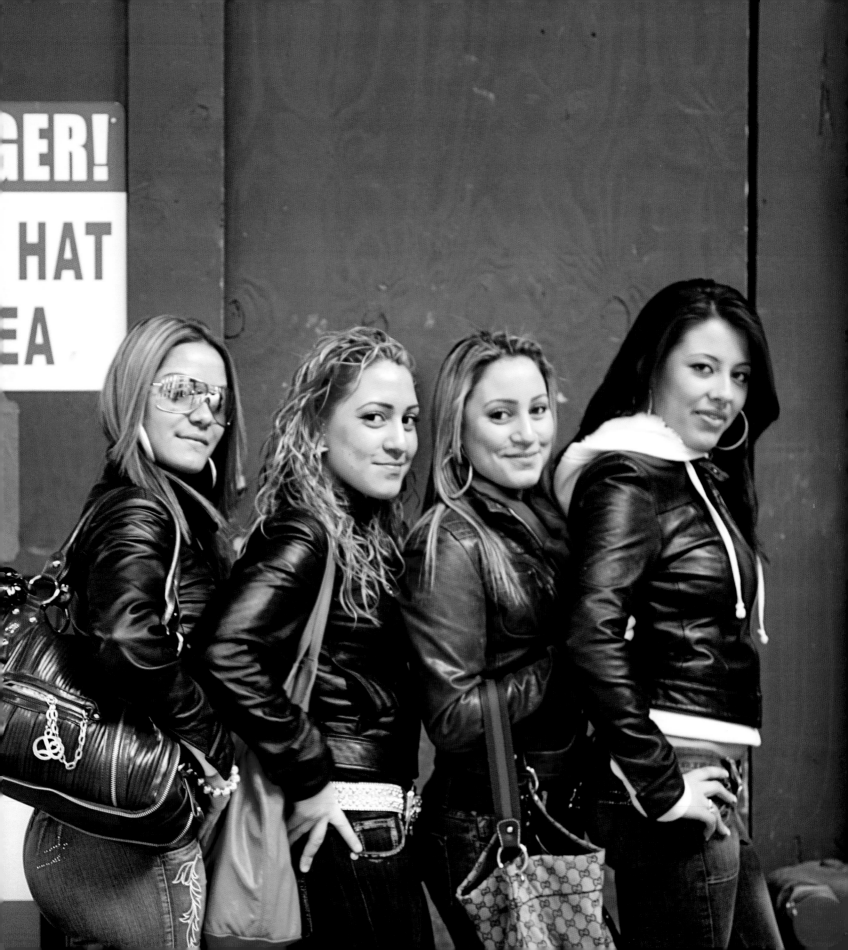

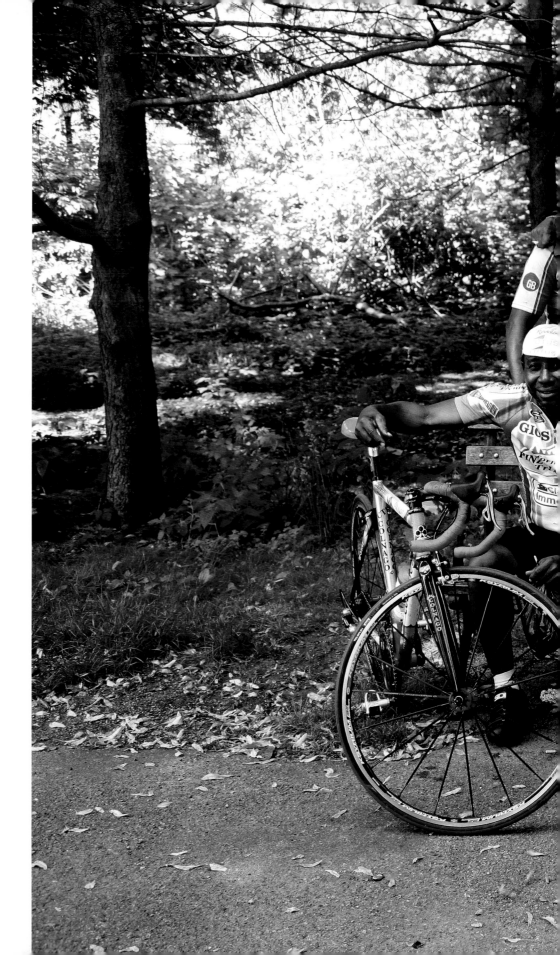

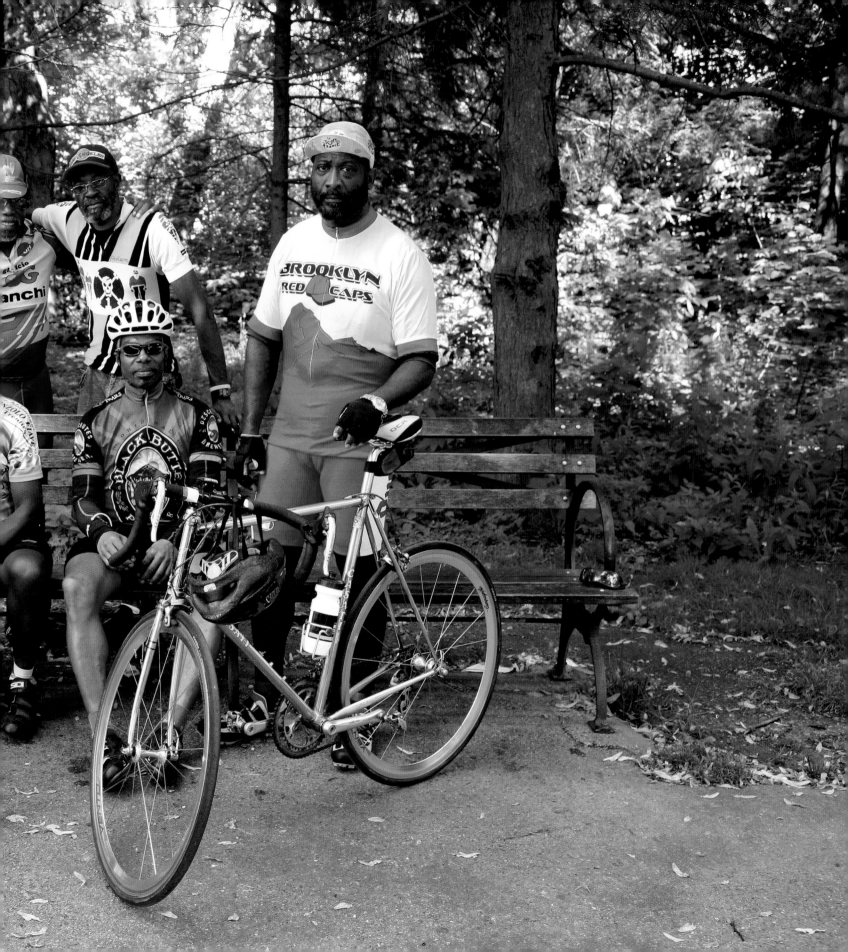

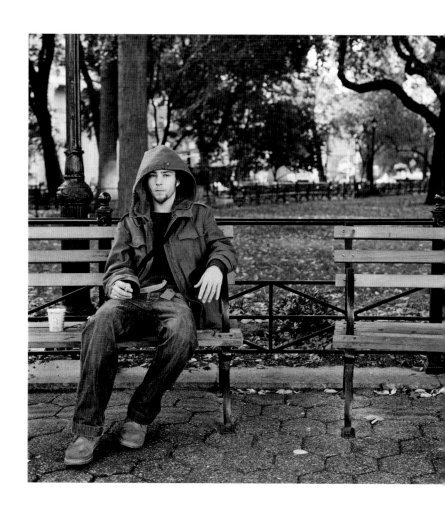

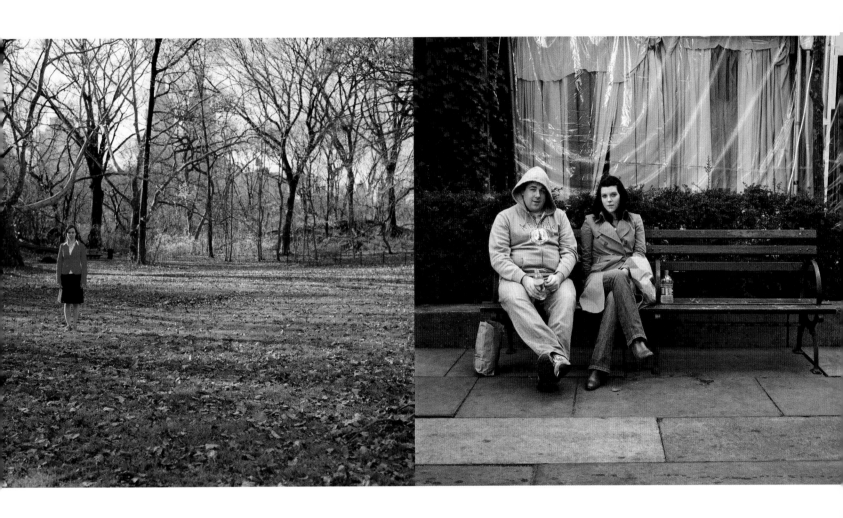

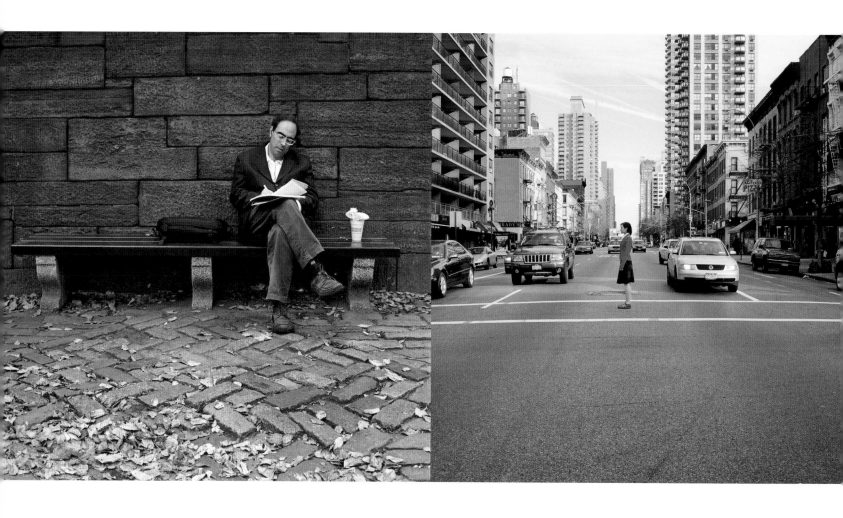

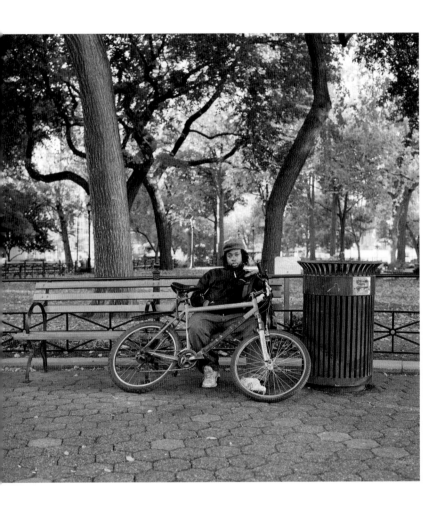

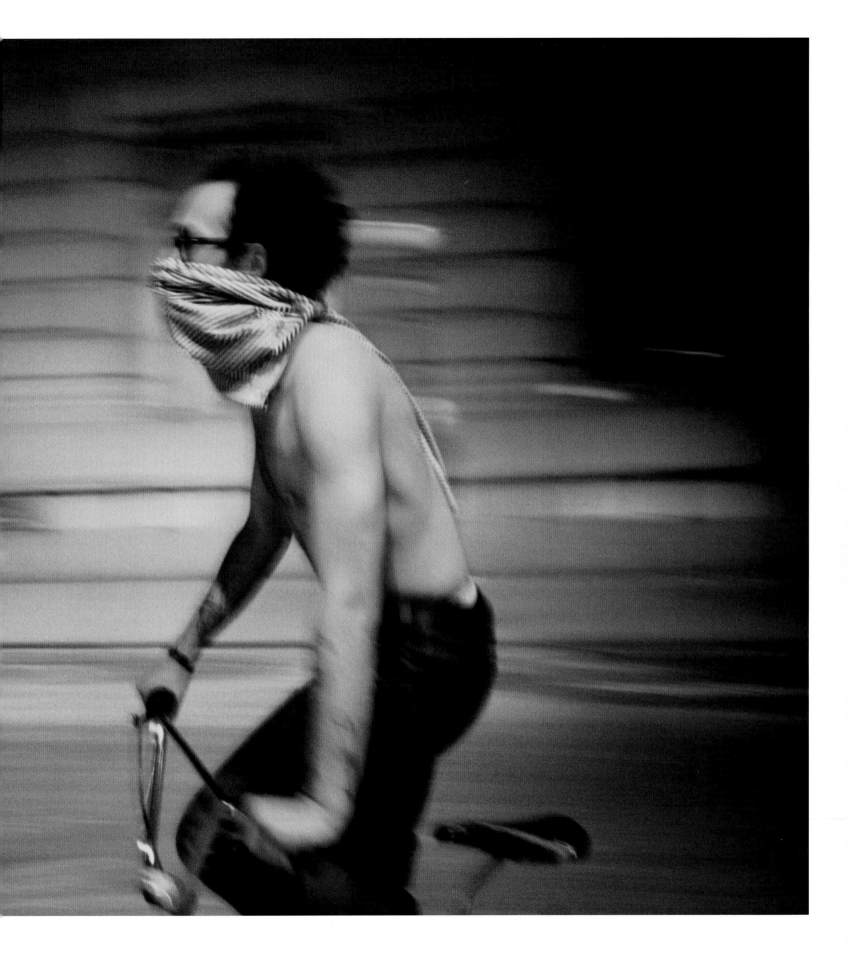

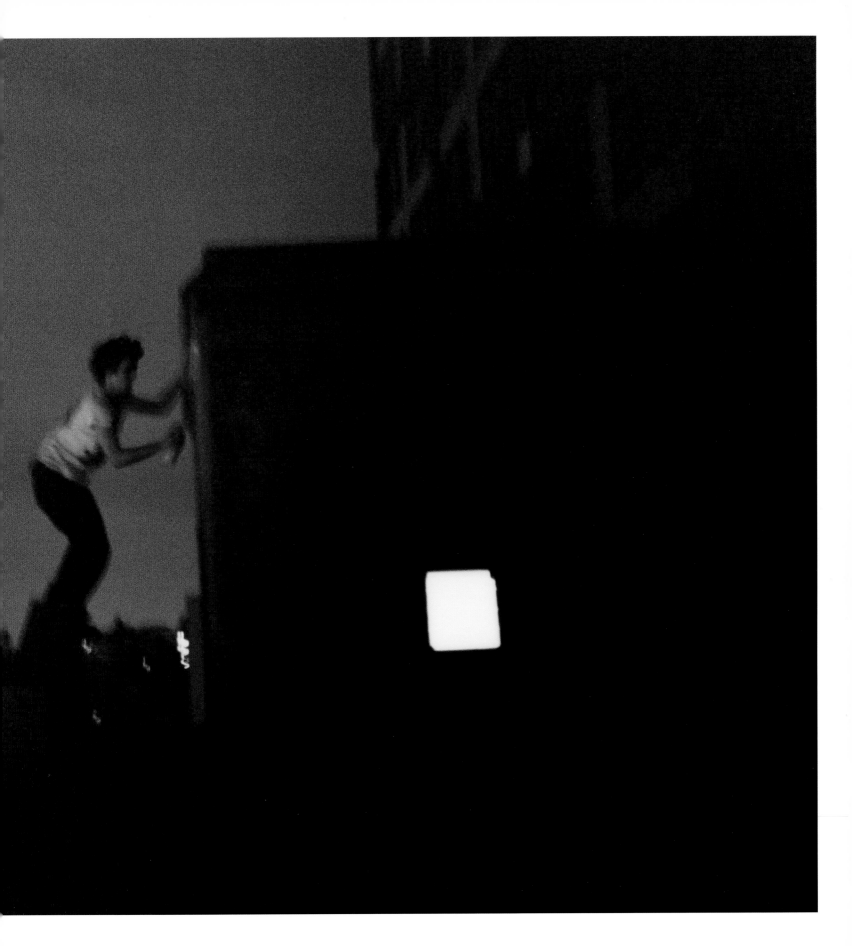

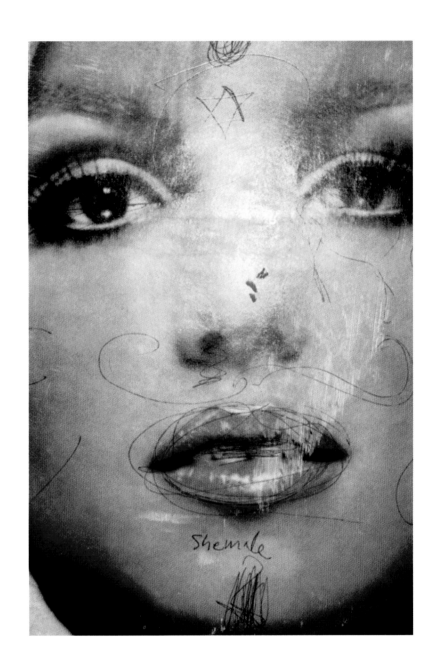

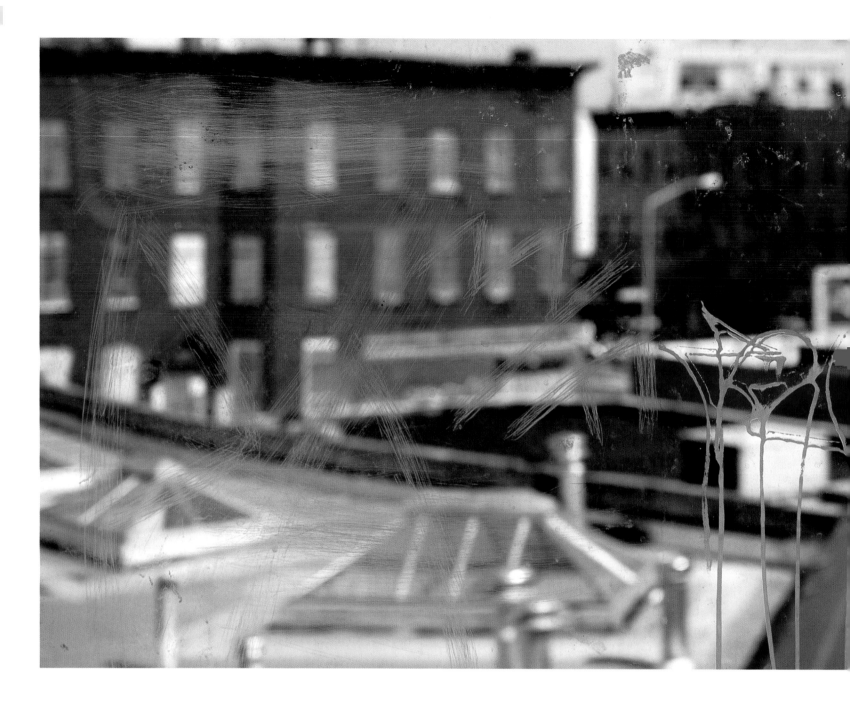

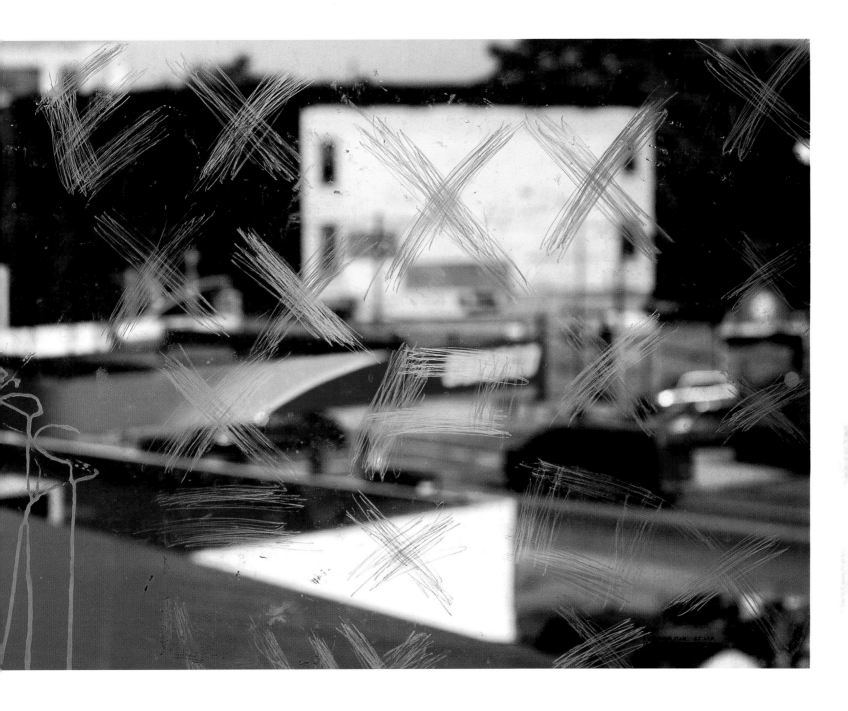

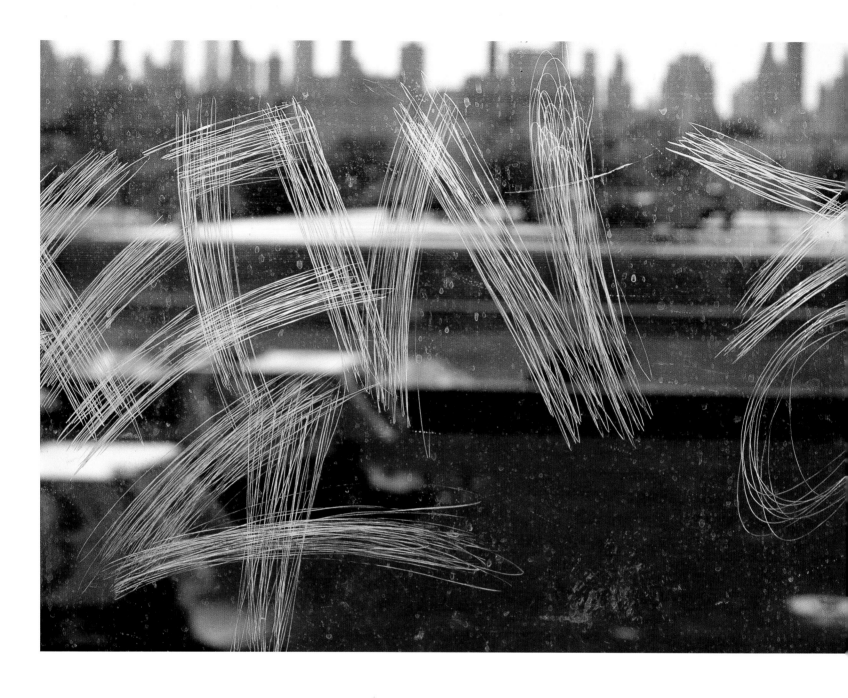

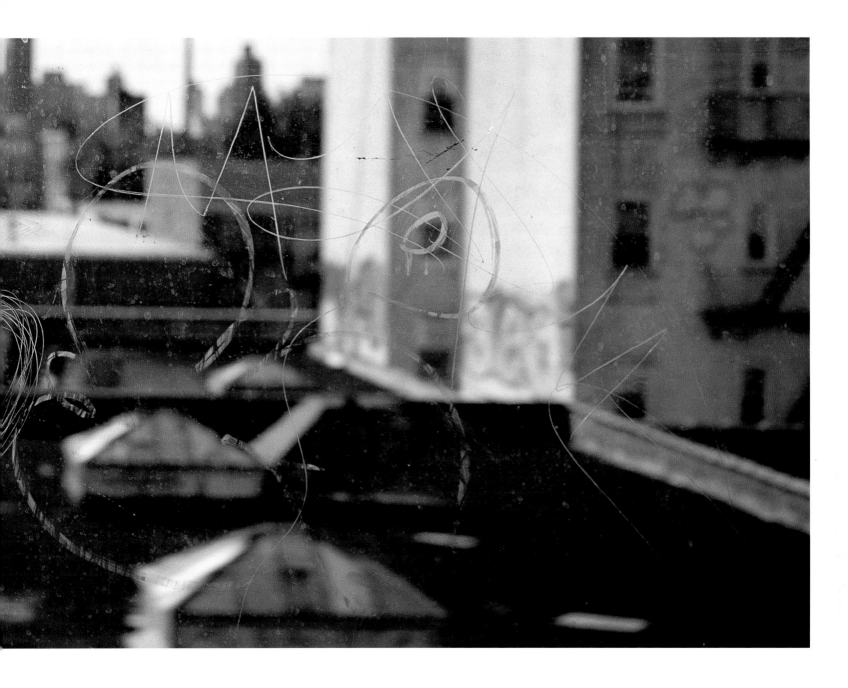

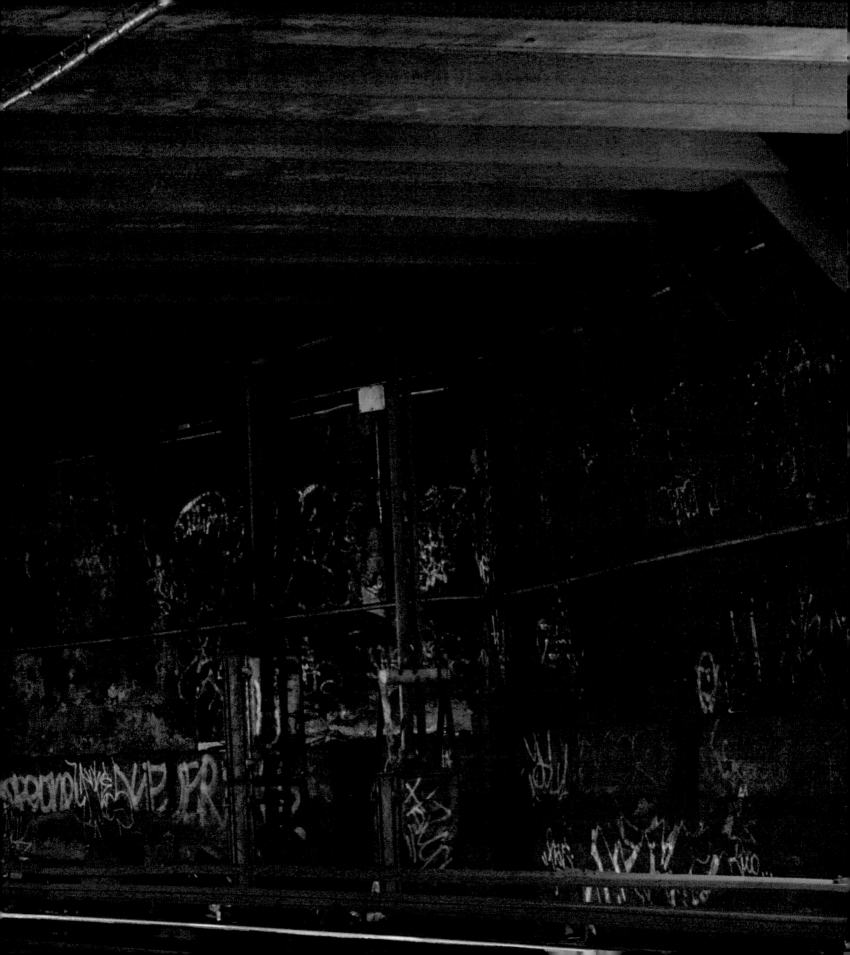

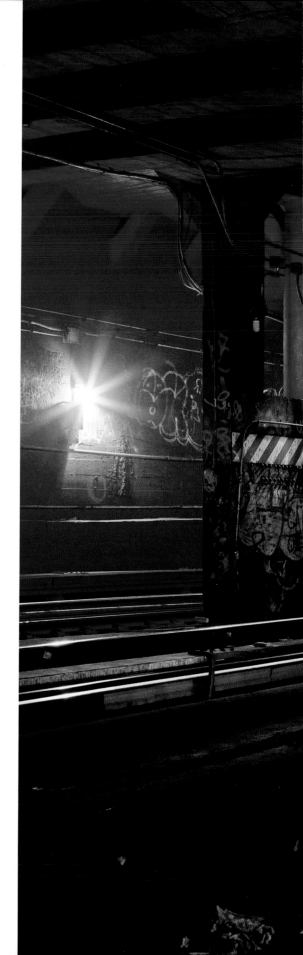

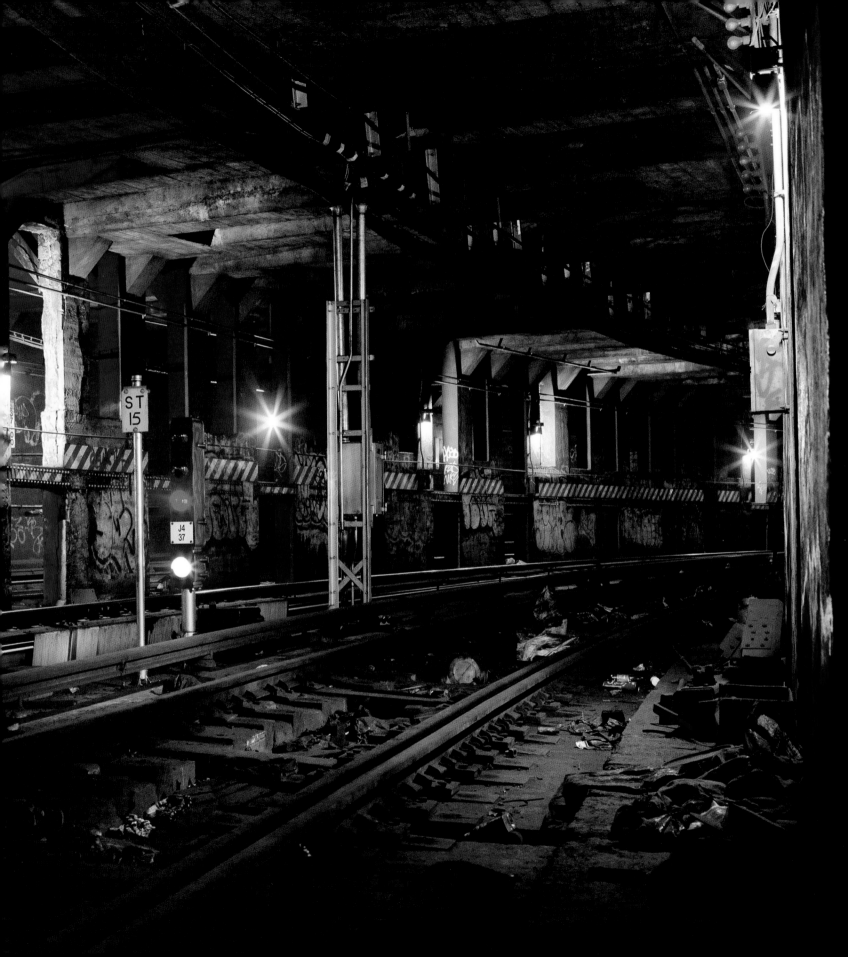

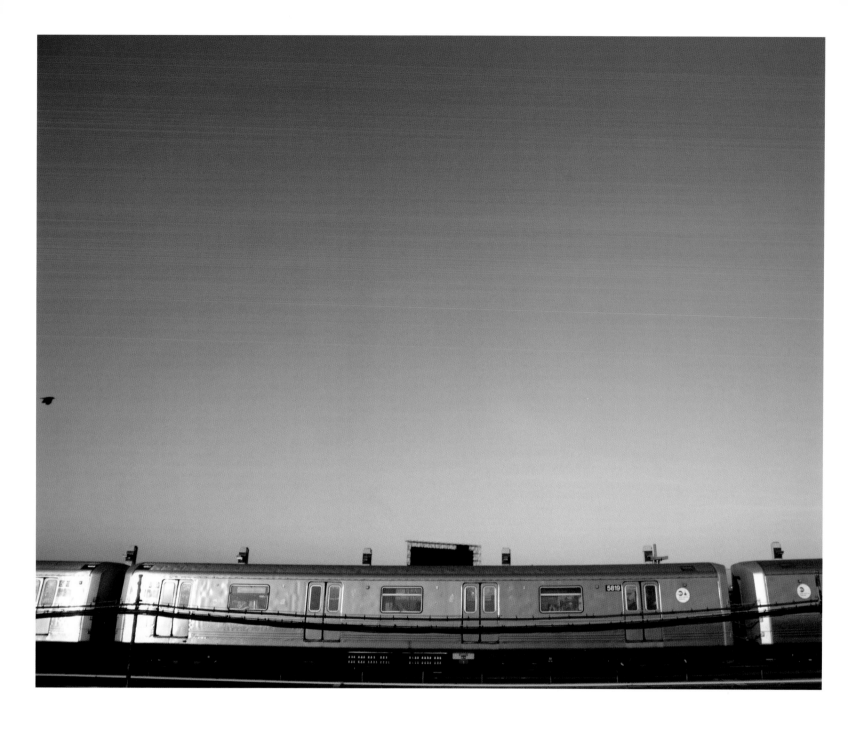

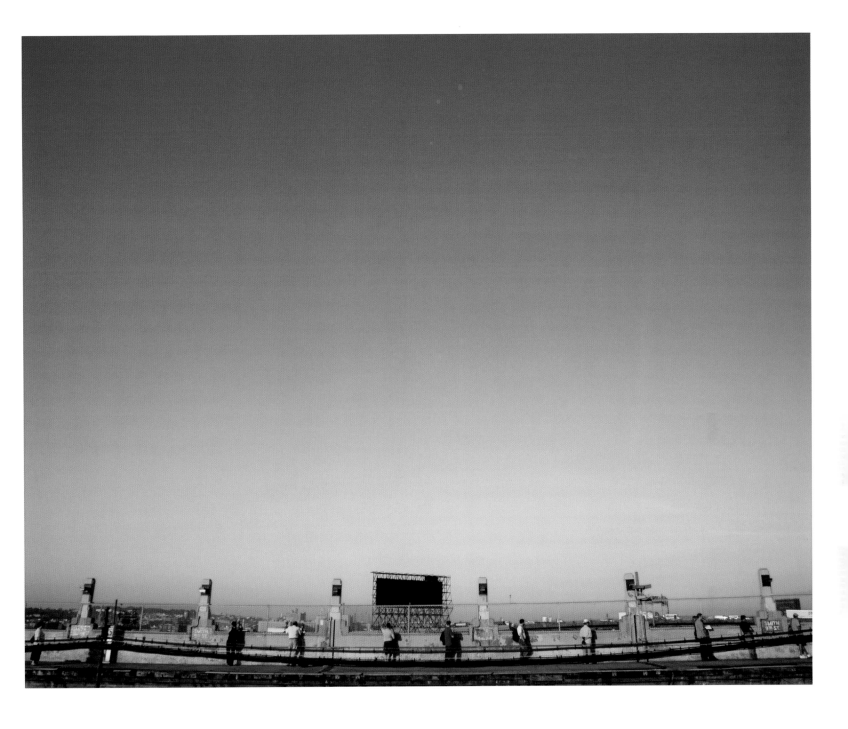

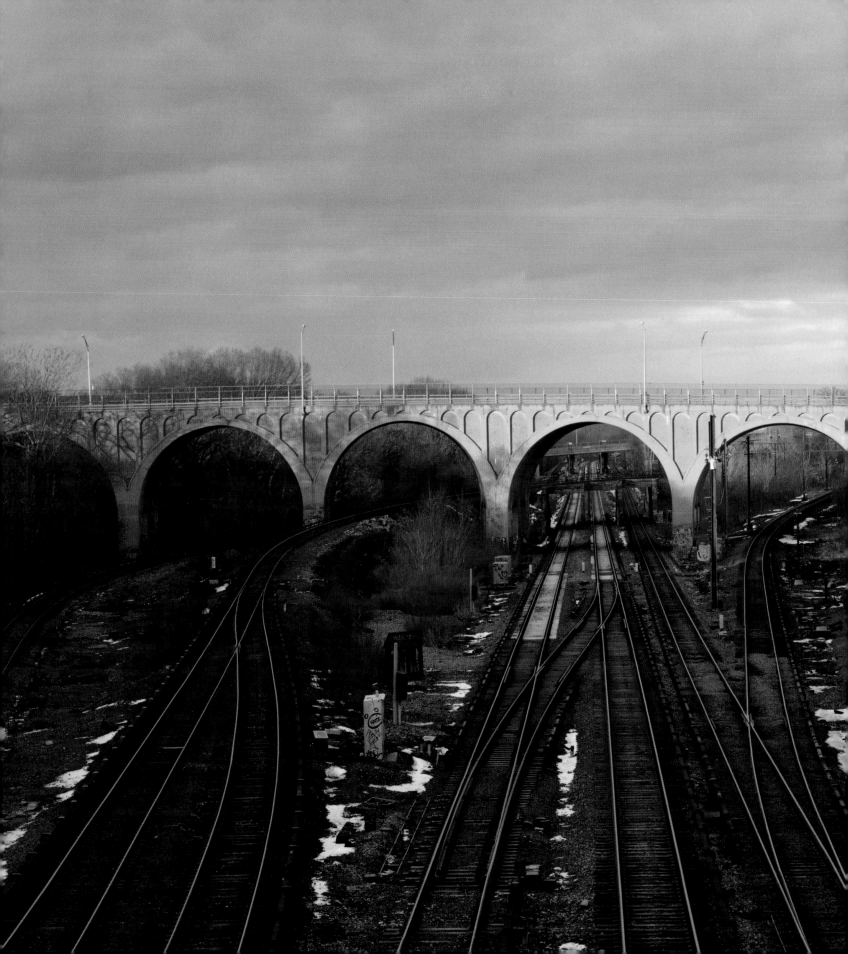

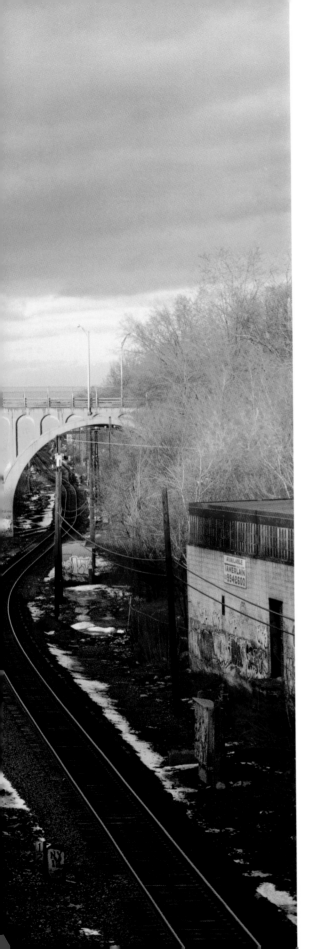

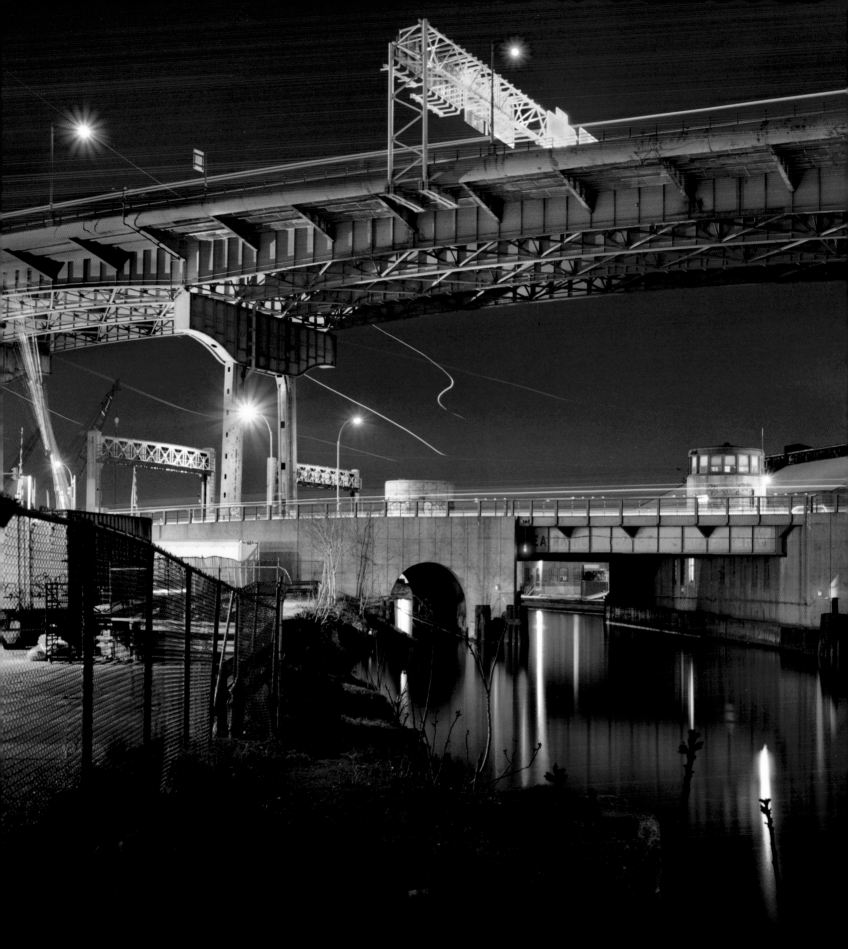

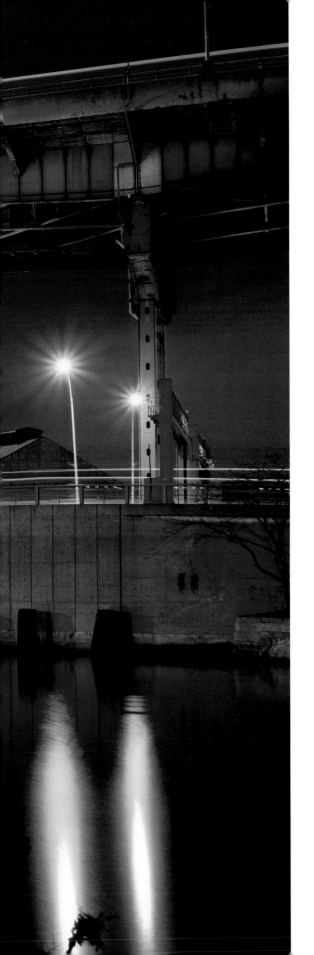

WONDER
WHEEL

WONDER
WHEEL

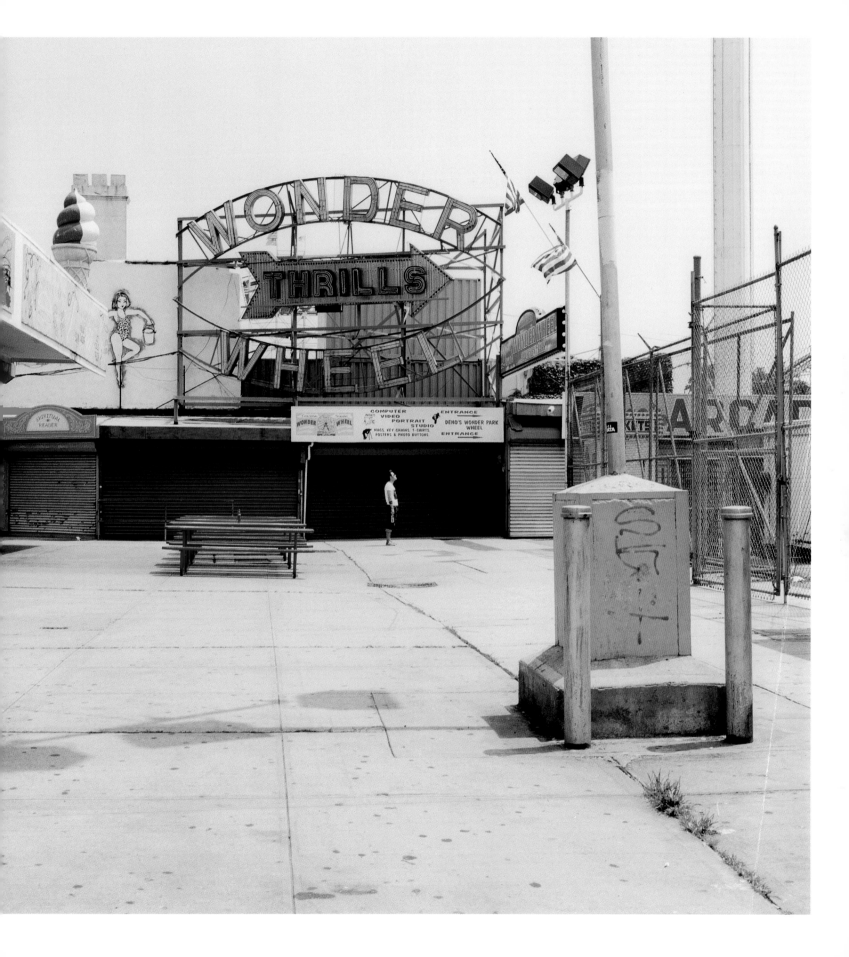

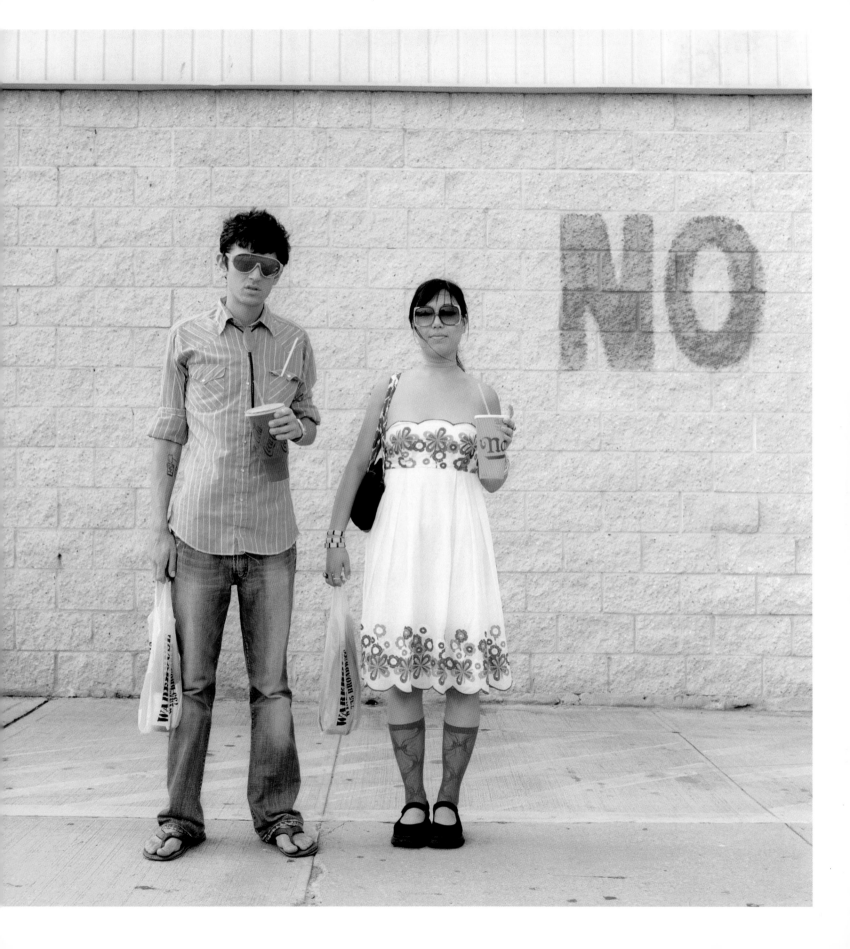

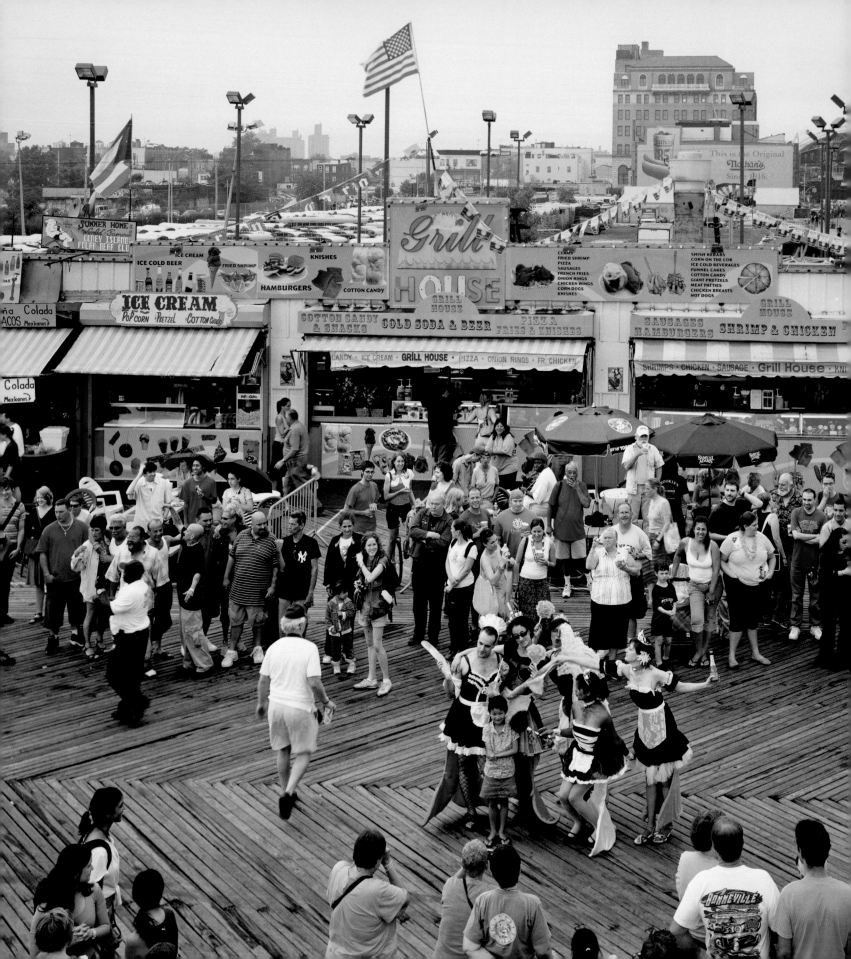

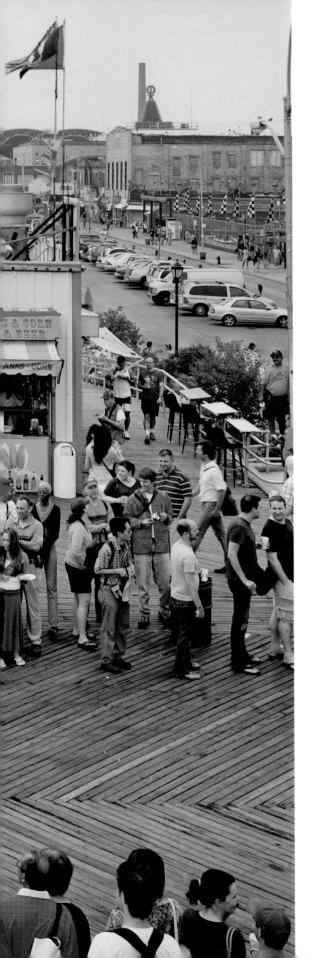

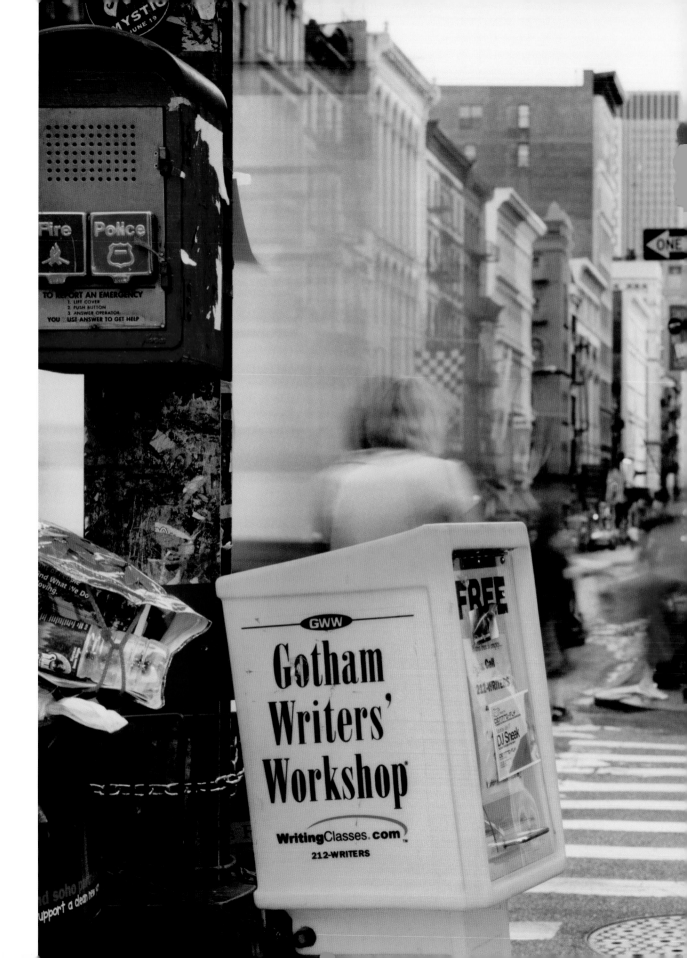

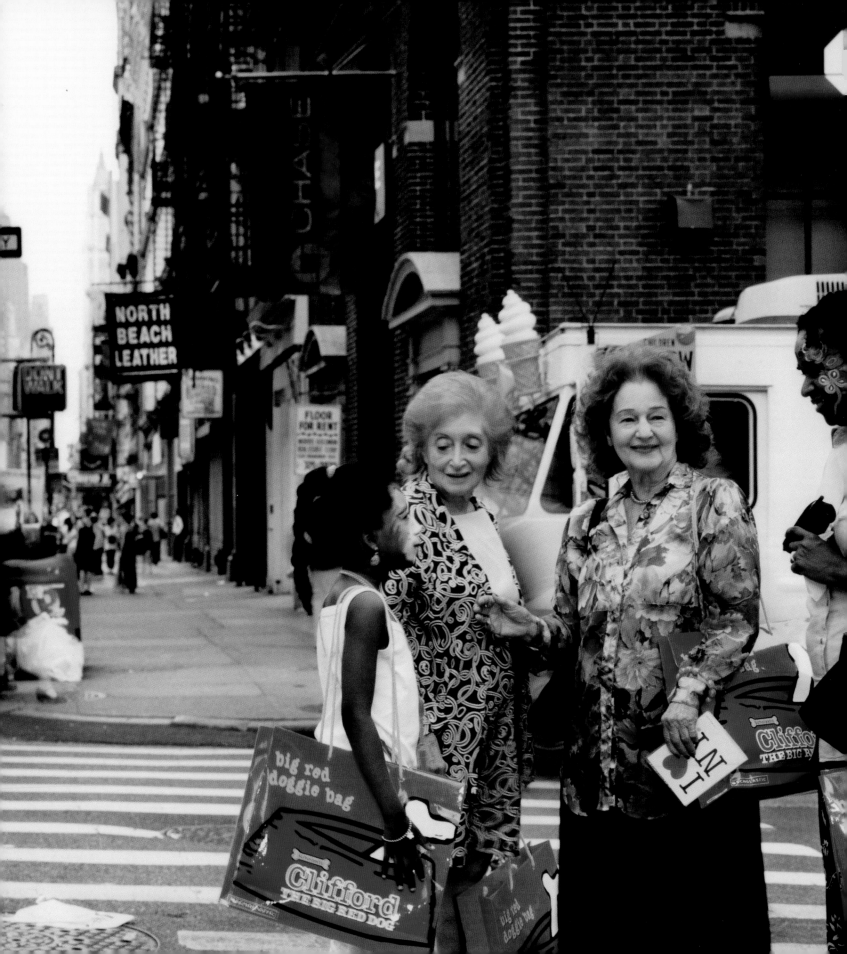

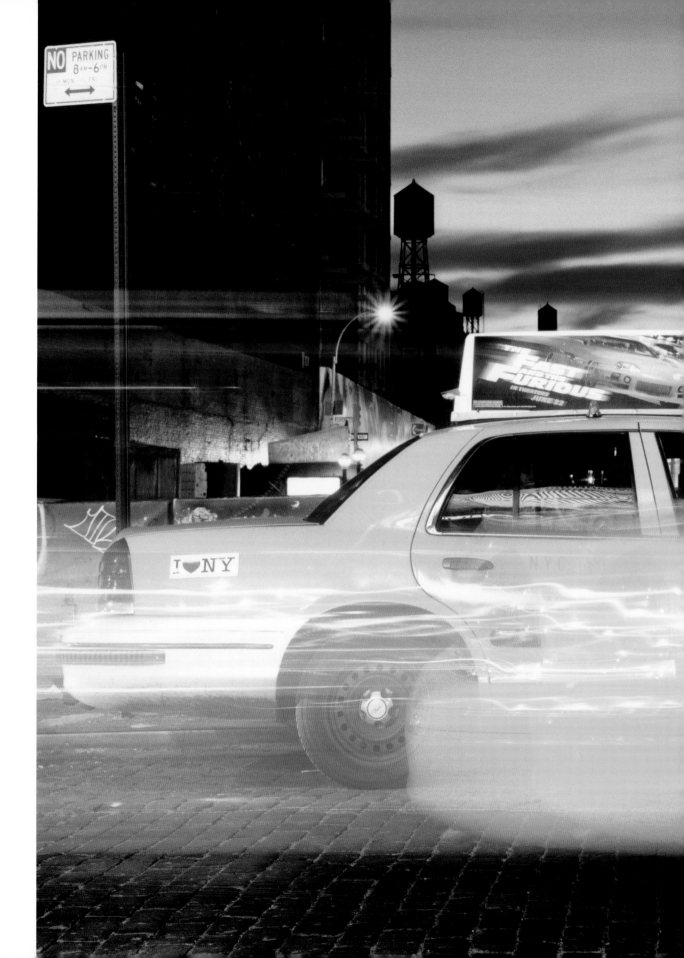

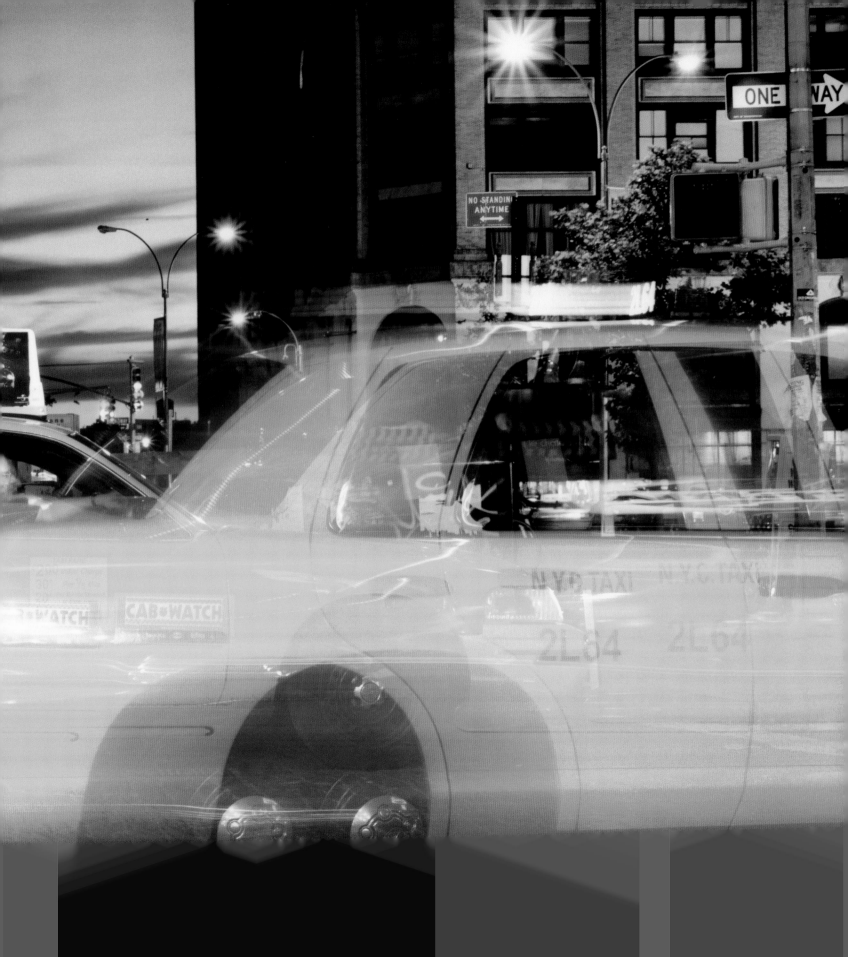

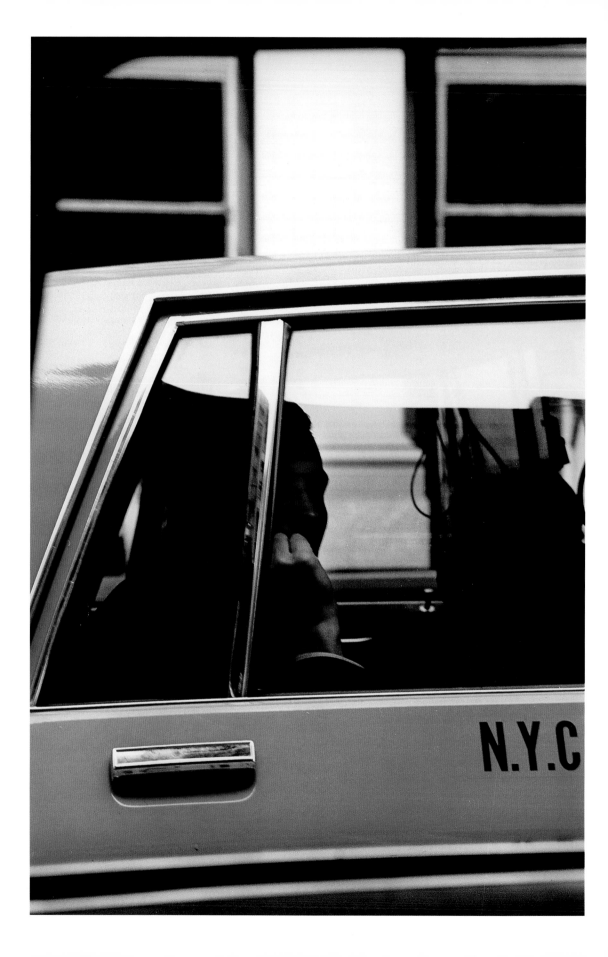

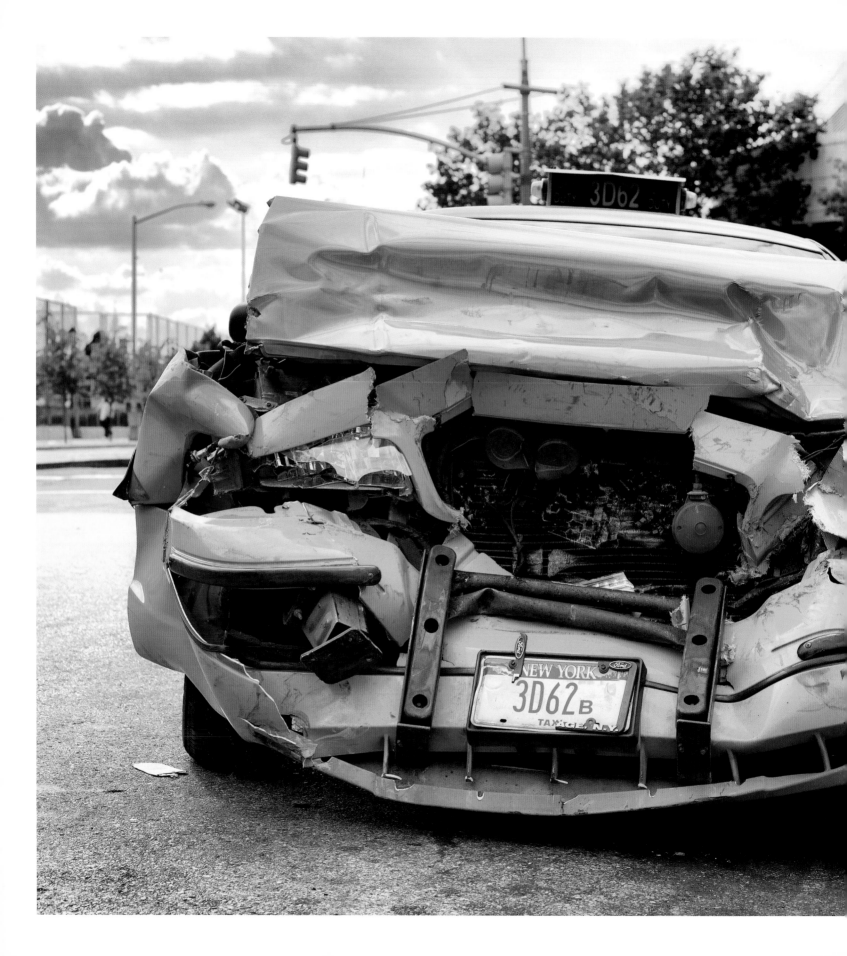

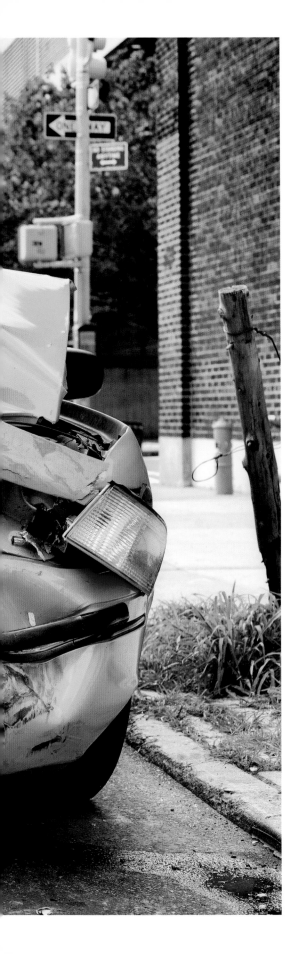

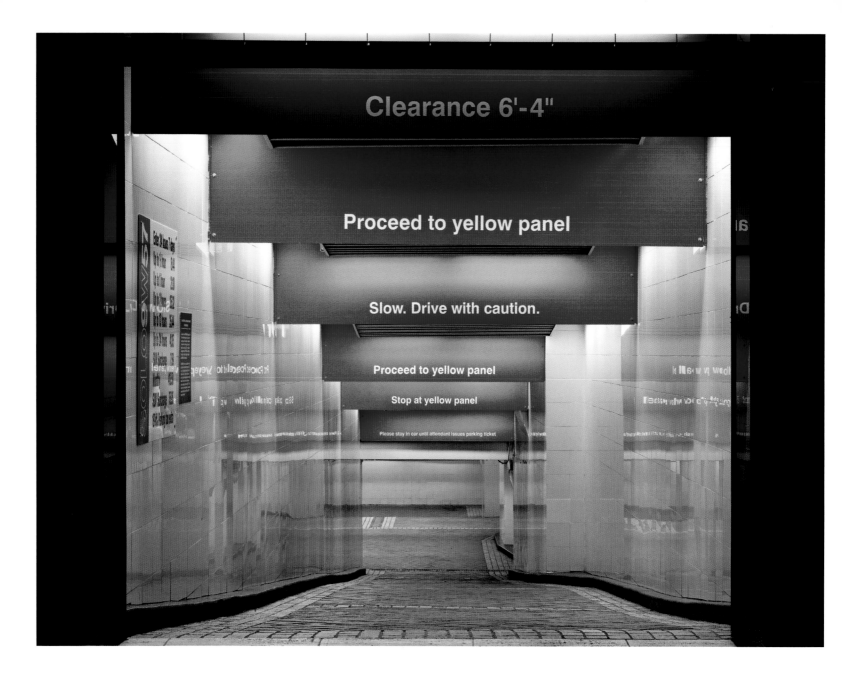

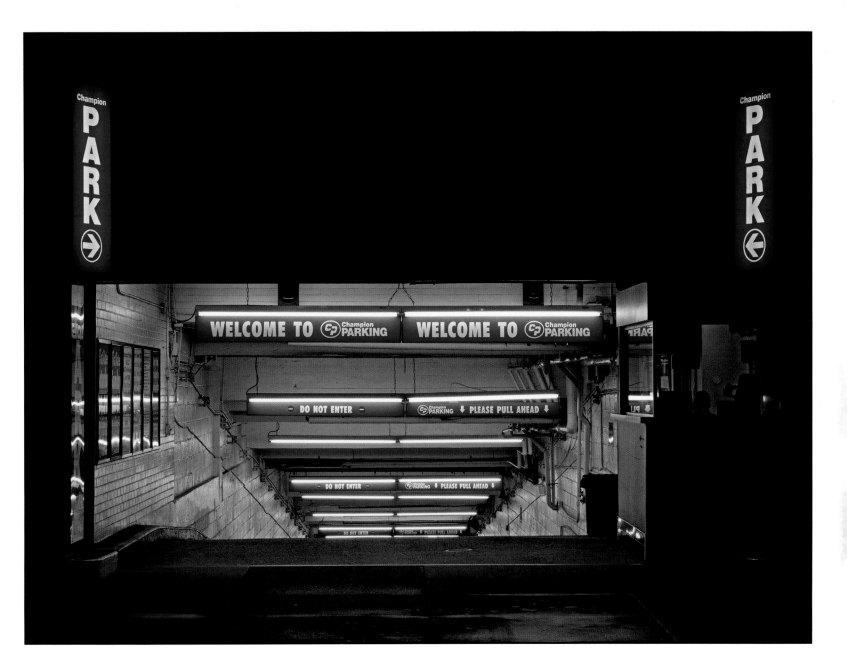

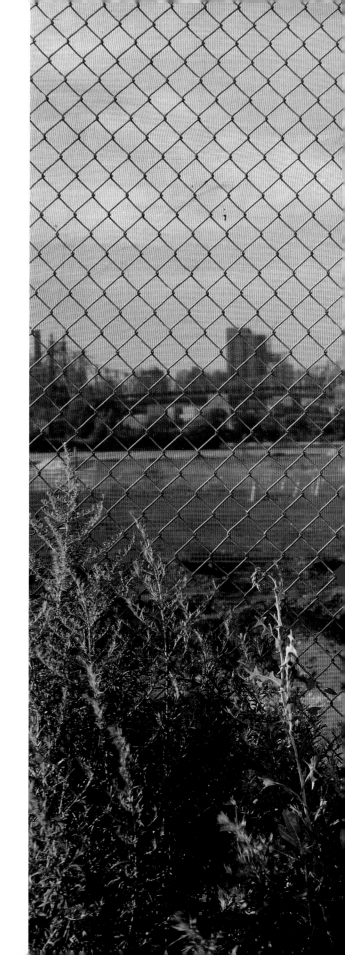

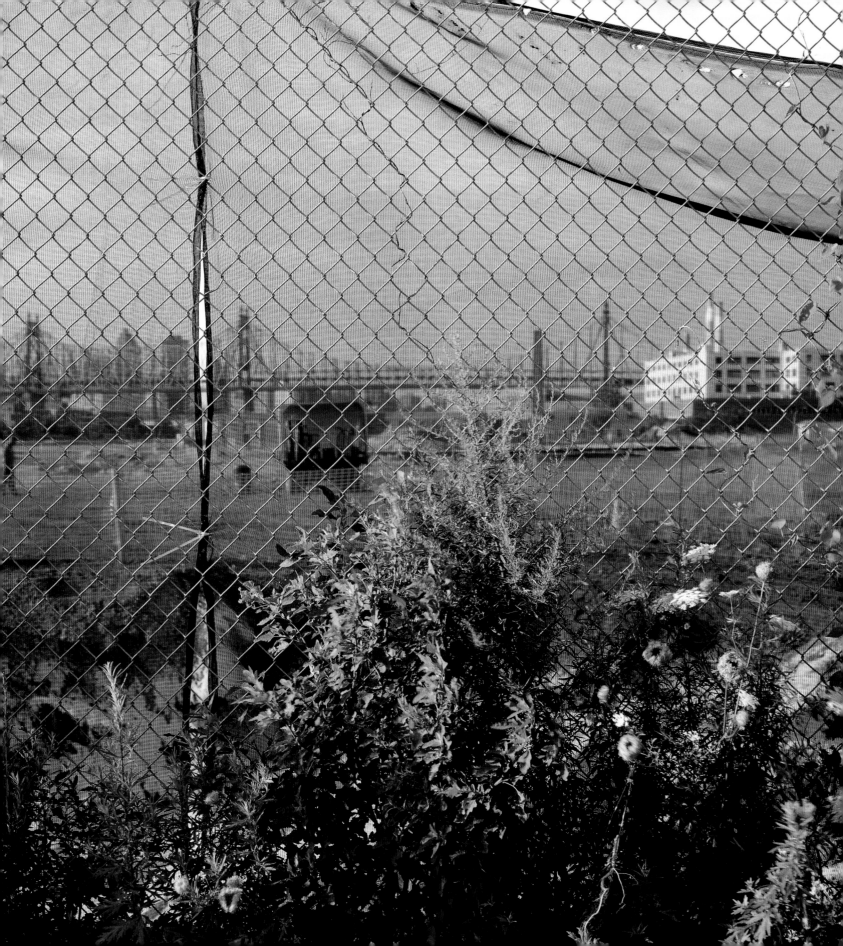

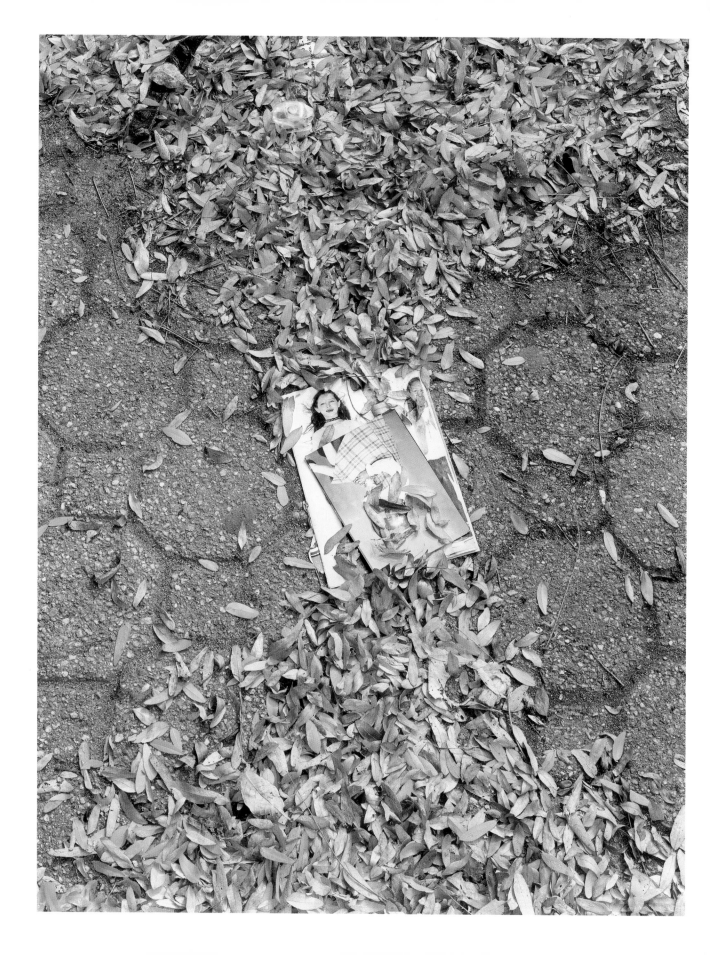

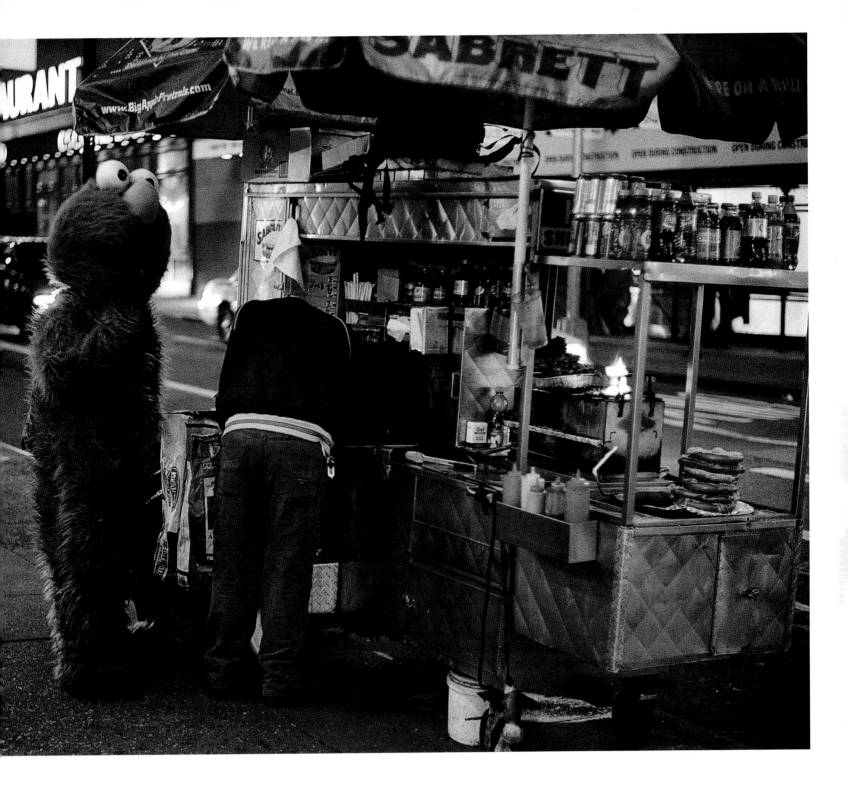

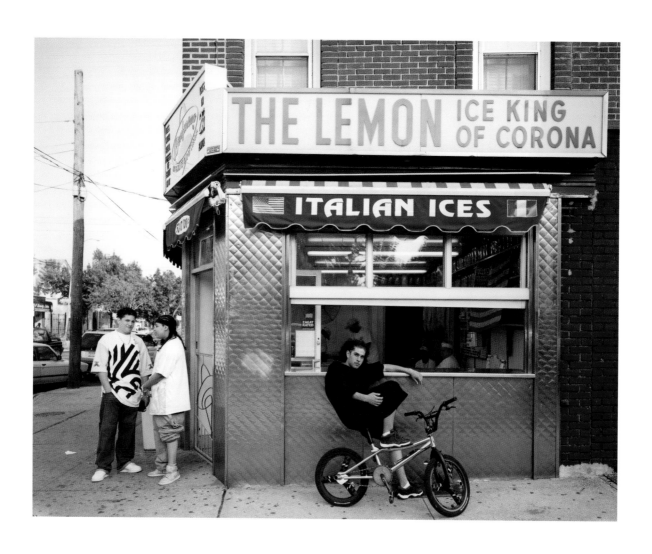

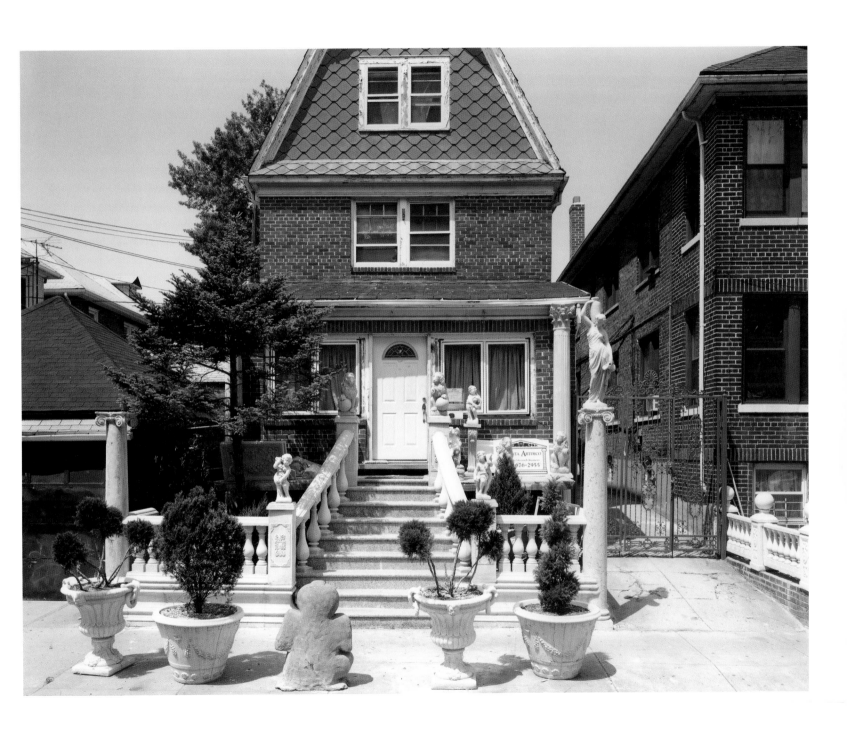

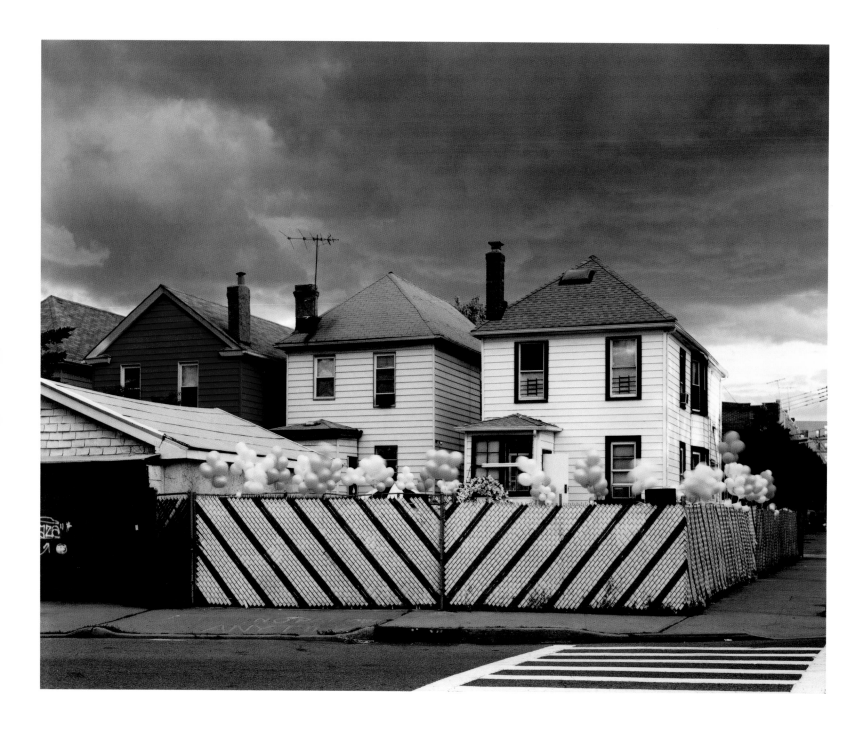

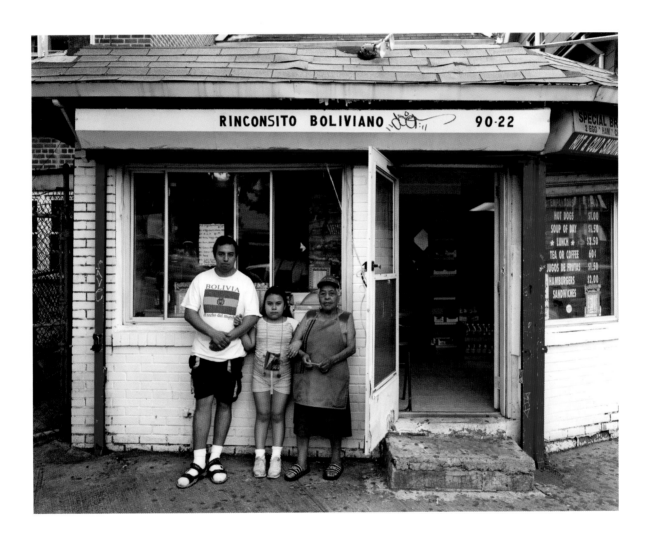

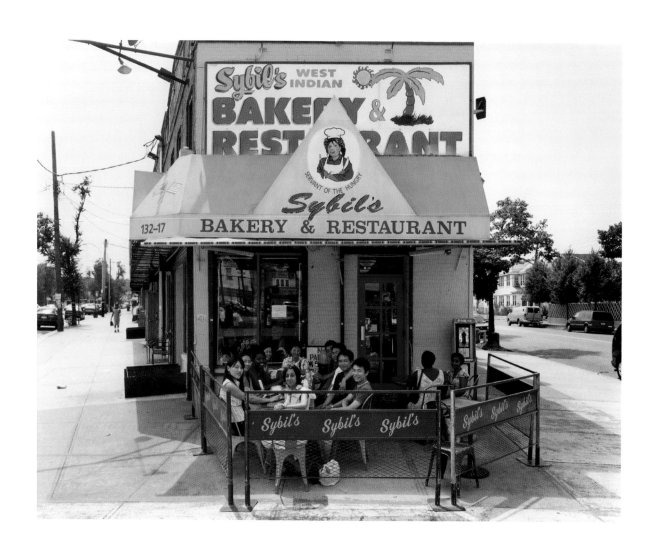

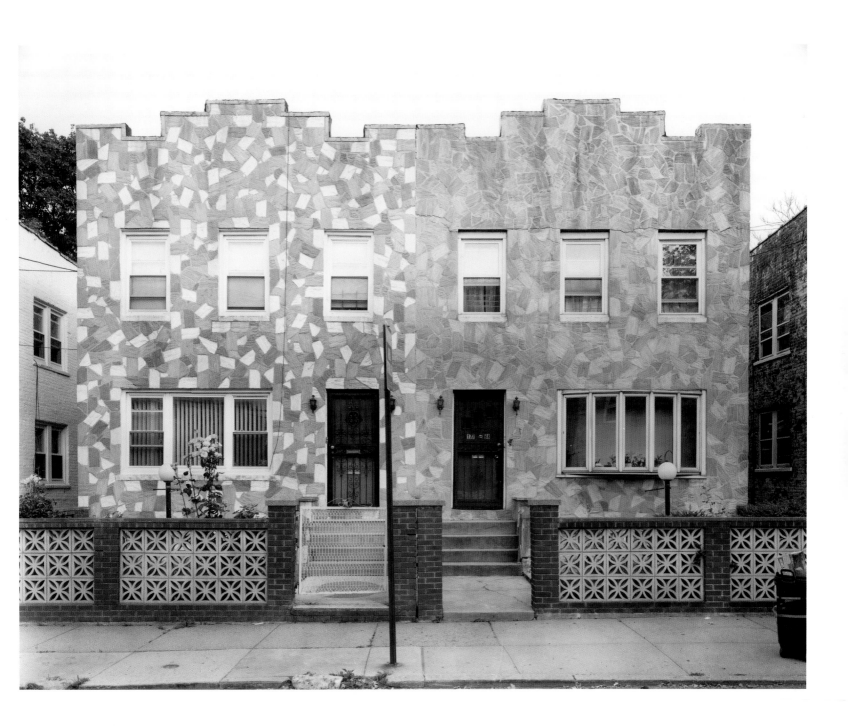

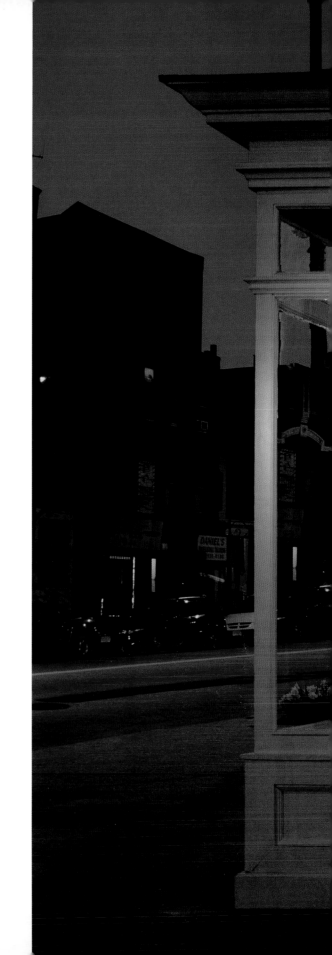

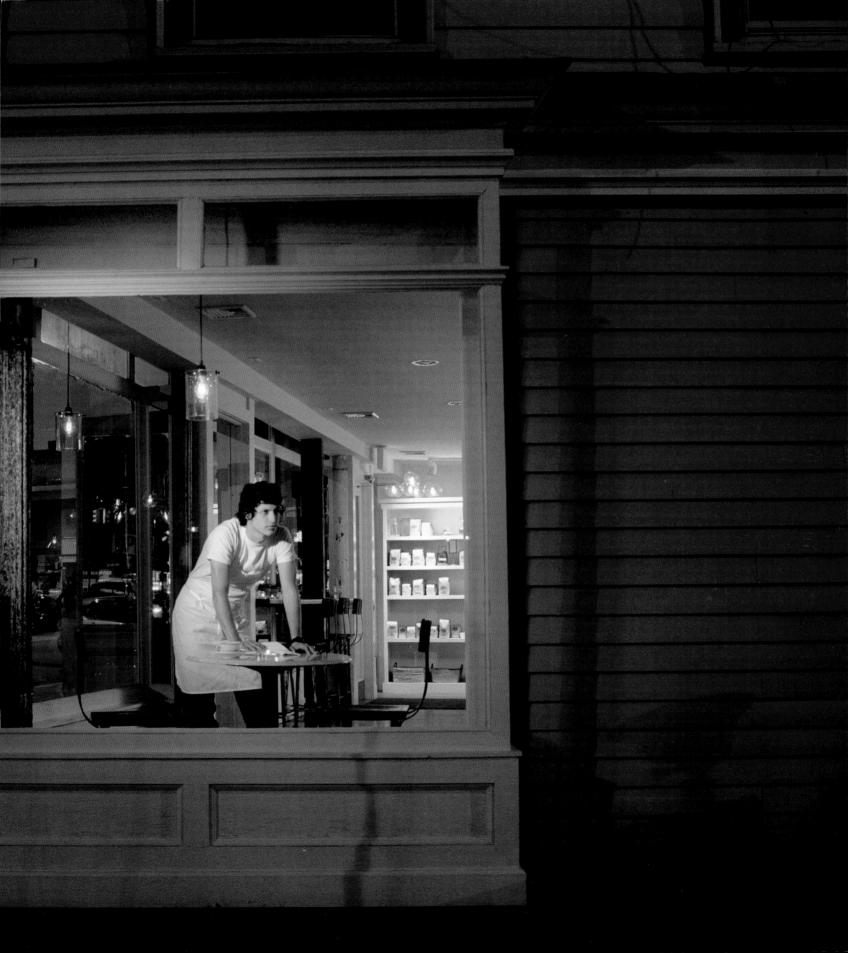

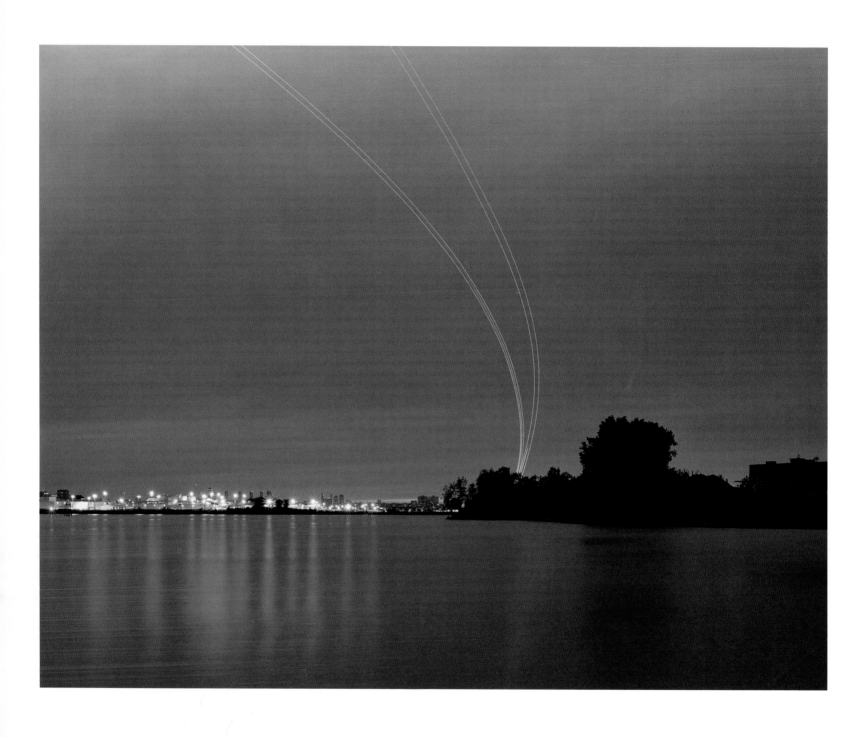

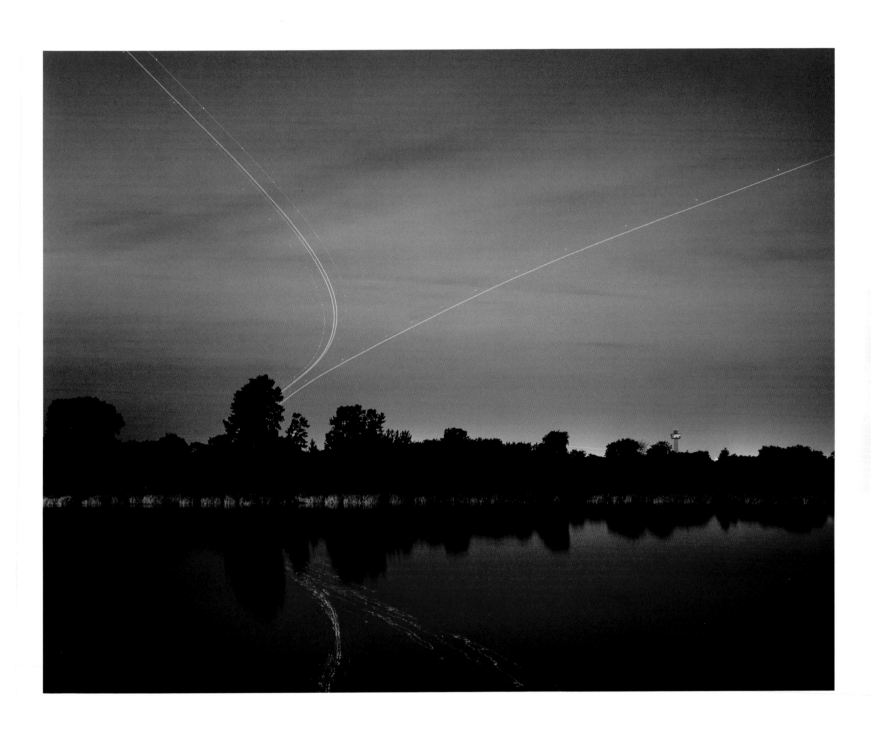

48 X 61 IN.
COURTESY SIKKEMA & JENKINS CO.
ART © VIK MUNIZ/LICENSED BY VAGA,
NEW YORK, NY

PAGES 66–67
VINCENT LAFORET
CONEY ISLAND, JUNE 18TH, 2006
INKJET PRINT
40 X 60 IN.
COURTESY THE ARTIST
© 2006 VINCENT LAFORET

PAGES 68–69
VINCENT LAFORET
BRYANT PARK, MAY 31ST, 2006
INKJET PRINT
40 X 60 IN.
COURTESY THE ARTIST
© 2006 VINCENT LAFORET

PAGES 70–71
SANGBIN IM
PEOPLE-MOMA (DIPTYCH), 2009
LAMBDA PRINT
TOP: 31.5 X 72 IN. BOTTOM: 13.5 X 72 IN.
COURTESY THE ARTIST, MARY RYAN GALLERY,
AND PKM GALLERY
© SANGBIN IM

PAGES 72–73
JOHN FITZGERALD
*ASTORIA POOL DURING THE BLACKOUT, JULY 22,
2006*
COURTESY THE ARTIST
© JOHN FITZGERALD

PAGES 74–75
DAVID DREBIN
GIRL IN WINDOW, 2009
C-PRINT
48 X 60 IN.
COURTESY THE ARTIST
© DAVID DREBIN

PAGES 76–77
DAVID DREBIN
THE GIRL IN THE ORANGE DRESS, 2009
C-PRINT
48 X 72 IN.
COURTESY THE ARTIST
© DAVID DREBIN

PAGES 78–79
DAVID HILLARD
WHITE NOISE, NYC, 2009
DIPTYCH
24 X 20 IN.
COURTESY YANCEY RICHRDSON GALLERY
© DAVID HILLARD

PAGES 80–81
YASMINE CHATILA
THE BACHELOR—WALL ST. FRI 11:34 PM, 2008
DIGITAL C-PRINT
54 X 67 IN.
COURTESY THE ARTIST
© YASMINE CHATILA

PAGES 82–83
YASMINE CHATILA
STONERS IN OVAL WINDOW—SOHO, THU 10:32 PM,
2008
DIGITAL C-PRINT
54 X 67 IN.
COURTESY THE ARTIST
© YASMINE CHATILA

PAGE 85
CLOCKWISE FROM TOP LEFT:
TONY OURSLER
GROUND ZERO 3, 2002
C-PRINT
20 X 24 IN.
COURTESY THE ARTIST AND
LEHMANN MAUPIN, NY
© TONY OURSLER

TONY OURSLER
GROUND ZERO 5, 2002
C-PRINT
20 X 24 IN.

COURTESY THE ARTIST AND
LEHMAN MAUPIN, NY
© TONY OURSLER

TONY OURSLER
GROUND ZERO 6, 2002
C-PRINT
20 X 24 IN.
COURTESY THE ARTIST AND
LEHMANN MAUPIN, NY
© TONY OURSLER

TONY OURSLER
GROUND ZERO 7, 2002
C-PRINT
20 X 24 IN.
COURTESY THE ARTIST AND
LEHMANN MAUPIN, NY
© TONY OURSLER

TONY OURSLER
GROUND ZERO 1, 2002
C-PRINT
20 X 24 IN.
COURTESY THE ARTIST AND
LEHMANN MAUPIN, NY
© TONY OURSLER

TONY OURSLER
GROUND ZERO 2, 2002
C-PRINT
20 X 24 IN.
COURTESY THE ARTIST AND
LEHMANN MAUPIN, NY
© TONY OURSLER

PAGES 86–87
JEFF MERMELSTEIN
TWIRL # 2, 2001
CHROMOGENIC PRINT FLUSH-MOUNTED TO
DIBOND
12 X 16 IN.
COURTESY JEFF MERMELSTEIN AND RICK
WESTER FINE ART
© JEFF MERMELSTEIN

PAGES 88–89
JEFF MERMELSTEIN
TWIRL # 13, 2008
CHROMOGENIC PRINT FLUSH-MOUNTED TO
DIBOND
12 X 16 IN.
COURTESY JEFF MERMELSTEIN AND RICK
WESTER FINE ART
© JEFF MERMELSTEIN

PAGE 90
NORITOSHI HIRAKAWA
*AN ATTRIBUTE OF LIVING (DELMESHIA / PINE
STREET, NEW YORK / 11:50 A.M., FEBRUARY 9TH,
2007)*
FROM *AT A POINT OF VERGE* TRIPTYCH, 2010
ILFORD RC DIGITAL PRINT
16.75 X 25.2 IN.
COURTESY ZENO X GALLERY, ANTWERP
© NORITOSHI HIRAKAWA

PAGES 90–91
NORITOSHI HIRAKAWA
AT A POINT OF VERGE, 2010
DURAFLEX PRINT
38 X 25.2 IN.
COURTESY THE ARTIST
© NORITOSHI HIRAKAWA

PAGE 91
NORITOSHI HIRAKAWA
*AN ATTRIBUTE OF LIVING (MARISSA / STONE
STREET, NEW YORK / 12:30 P.M., FEBRUARY 18TH,
2007)*
FROM *AT A POINT OF VERGE* TRIPTYCH, 2010
ILFORD RC DIGITAL PRINT
16.75 X 25.2 IN.
COURTESY ZENO X GALLERY, ANTWERP
© NORITOSHI HIRAKAWA

PAGES 92–93
LARRY RACIOPPO
SUNBATHER AND GIGLIO, 1998
CHROMOGENIC COLOR PRINT
20 X 30 IN.
COURTESY THE ARTIST
© LARRY RACIOPPO

PAGES 94–95
PASCAL PERICH
*SEUNGLUNG ON THE MANHATTAN BRIDGE,
10/19/2007*
ARCHIVAL PIGMENT PRINT.
20 X 30 IN.
COURTESY THE ARTIST
© 2007 PASCAL PERICH

PAGE 96
KATE SCHERMERHORN
SILVERCUP 1, 2009
GLICEE PRINT
16 X 20 IN.
COURTESY FIFTY ONE FINE ART / KATE
SCHERMERHORN
© KATE SCHERMERHORN

PAGE 97
KATE SCHERMERHORN
SILVERCUP 2, 2009
GLICEE PRINT
16 X 20 IN.
COURTESY FIFTY ONE FINE ART / KATE
SCHERMERHORN
© KATE SCHERMERHORN

PAGES 98–99
BARRY FRYDLENDER
MUSEUM (METROPOLITAN), 2005
CHROMOGENIC COLOR PRINT
48 X 104.5 IN.
COURTESY ANDREA MEISLIN GALLERY, NY
© BARRY FRYDLENDER

PAGES 100–101
TOP–BOTTOM:
DOUG FOGELSON
BROADWAY & PRINCE
C-PRINT
11.5 X 118 IN.
COURTESY THE ARTIST
©DOUG FOGELSON

DOUG FOGELSON
LOWER EAST SIDE
C-PRINT
9 X 118 IN.
COURTESY THE ARTIST
©DOUG FOGELSON

DOUG FOGELSON
PRINCE & LAFAYETTE
C-PRINT
9 X 118 IN.
COURTESY THE ARTIST
©DOUG FOGELSON

PAGES 102–103
PETER FUNCH
DOBBELTGANGER, 2007
C-PRINT
51 X 23 IN.
COURTESY VI GALLERY
© PETER FUNCH

PAGES 104–105
PETER FUNCH
INFORMING INFORMERS, 2006
C-PRINT
51 X 23 IN.
COURTESY VI GALLERY
© PETER FUNCH

PAGES 106–107
PETER FUNCH
SMOKING SMOKERS, 2006
C-PRINT
51 X 23 IN.
COURTESY VI GALLERY
© PETER FUNCH

PAGE 108–109
ARASH RADPOUR
ROOSEVELT ISLAND #3, 2004
D-PRINT
29.5 X 39.3 IN.
COURTESY GRAZIELLA LEONARDI COLLECTION
© 2010 ARASH RADPOUR

PAGES 110–111
ANTHONY GOICOLEA
SMOKE STACK, 2007

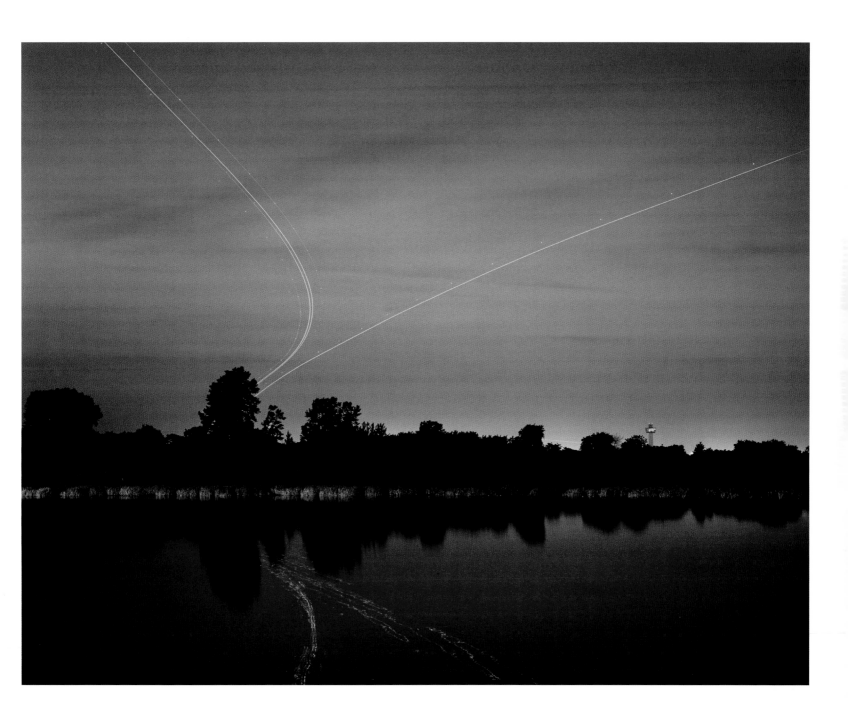

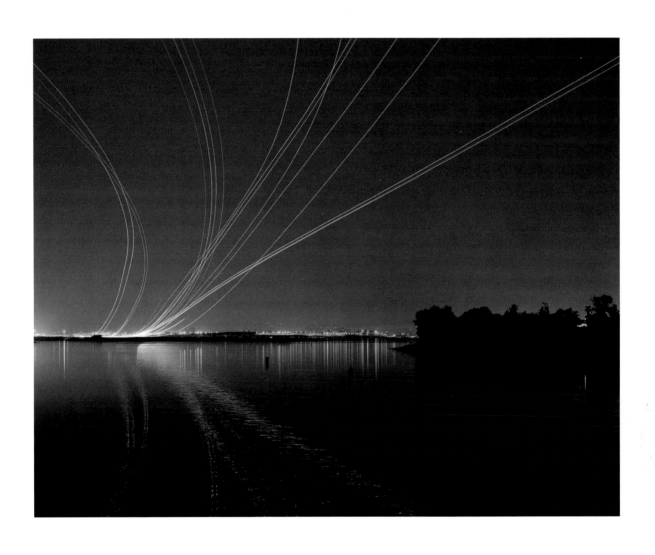

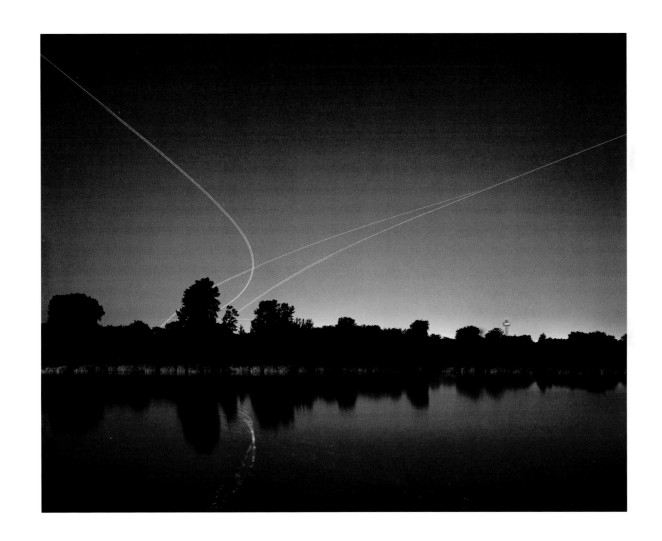

PAGES 7–9
JENNY HOLZER
PERMANENT INSTALLATION: 7 WORLD TRADE
CENTER, NEW YORK, 2006
ELECTRONIC SIGN WITH WHITE DIODES
13.5 X 65 FT.
TEXT (PICTURED): "THE WORLD TRADE CENTER,"
© 1993 FIRST APPEARED IN *THE PARIS REVIEW*
AND IS ALSO FOUND IN THE BOOK *VALENTINE
PALACE BY* DAVID LEHMAN (SCRIBNER, 1996).
ALL RIGHTS RESERVED
PHOTO: ANDREAS KELLER
© JENNY HOLZER, MEMBER ARTISTS RIGHTS
SOCIETY (ARS), NEW YORK

PAGE 10
TSENG KWONG CHI
NEW YORK, NEW YORK, 1979
FROM *EXPEDITIONARY SELF PORTRAITS
1979–1989*
GELATIN SILVER PRINT
36 X 36 IN.
COURTESY MUNA TSENG DANCE PROJECTS INC.
& PAUL KASMIN GALLERY, NEW YORK
© MUNA TSENG DANCE PROJECTS INC.

PAGE 14
ROBERT J. VIZZINI
LIBERTY WATCH, NEW YORK, NY, NOVEMBER
1999
LITH-DEVELOPED, GELATIN SILVER PRINT
17 X 17 IN.
©1999 ROBERT J. VIZZINI

PAGES 18–19
JEAN-MICHEL BERTS
STATUE OF LIBERTY
GELATIN SILVER PRINT
42.9 X 59.1 IN.
COURTESY THE ARTIST
© JEAN-MICHEL BERTS

PAGES 20–21
JEAN MICHEL BERTS
BATTERY PARK CITY VIEW
GELATIN SILVER PRINT
42.9 X 59.1 IN.
COURTESY THE ARTIST
© JEAN-MICHEL BERTS

PAGE 23
JOSEF HOFLEHNER
LIBERTY ISLAND, 2009
GELATIN SILVER PRINT
20 X 20 IN.
COURTESY THE ARTIST
© 2010 JOSEF HOFLEHNER

PAGE 25
JOSEF HOFLEHNER
VERRAZANO NARROWS BRIDGE, 2008
GELATIN SILVER PRINT
20 X 20 IN.
COURTESY THE ARTIST
© 2010 JOSEF HOFLEHNER

PAGE 26
TIM WHITE-SOBIESKI
*UPPER WEST SIDE, GEORGE WASHINGTON
BRIDGE*
FROM *FOG IN NEW YORK* SERIES, DECEMBER 30,
2005
PHOTOGRAPHIC COLOR PRINT
56 X 44 IN.
COURTESY THE ARTIST
© TIM WHITE-SOBIESKI

PAGE 27
TIM WHITE-SOBIESKI
*UPPER WEST SIDE, VIEW FROM THE LINCOLN
CENTER*
FROM *FOG IN NEW YORK* SERIES, DECEMBER 30,
2005
PHOTOGRAPHIC COLOR PRINT
66 X 44 IN.
COURTESY THE ARTIST
© TIM WHITE-SOBIESKI

PAGE 28
HIROSHI SUGIMOTO
CHRYSLER BUILDING, 1997
GELATIN SILVER PRINT
58.75 X 47 IN.
COURTESY GALLERY KOYANAGI
© HIROSHI SUGIMOTOHIROSHI SUGIMOTO

PAGE 29
EMPIRE STATE BUILDING, 1997
GELATIN SILVER PRINT
58.75 X 47 IN.
COURTESY GALLERY KOYANAGI
© HIROSHI SUGIMOTO

PAGES 30–31
CHI PENG
DAY AFTER TOMORROW, 2006
C-PRINT
47.25 X 59.75 IN.
COURTESY CHI PENG AND CHAMBERS FINE ART

PAGES 32–33
ROE ETHRIDGE
WILLIAMSBURG BRIDGE, 2008
C-PRINT
40 X 50 IN.
COURTESY ANDREW KREPS GALLERY, NEW YORK

PAGES 34–35
MICHAEL WESELY
*THE MUSEUM OF MODERN ART, NEW YORK
(7.8.2001–7.6.2004)*, 2004
C-PRINT, DIASEC, STEEL FRAME
49.2 X 59.1 IN.
COURTESY THE ARTIST
© 2004 MICHAEL WESELY

PAGES 36–37
LORI NIX AND KATHLEEN GERBER
AVAILABLE, 2007
C-PRINT
16 X 20 IN.
COURTESY CLAMPART GALLERY, NEW YORK, NY
© LORI NIX

PAGES 38–39
ALEX MACLEAN
*NEW LUXURY RESIDENTIAL TOWERS IN THE WEST
VILLAGE AND HUDSON, RIVER PARK AT PIER 46*
INKJET PRINT
30 X 40 IN.
COURTESY THE ARTIST
© ALEX S. MACLEAN/LANDSLIDES AERIAL
PHOTOGRAPHY

PAGES 40–41
BETTINA JOHAE
BX_0220 SPENCER ESTATE, THE BRONX
FROM THE SERIES *BOROUGH EDGES, NYC*, 2004
DIGITAL C-PRINT
9 X 12 IN.
COURTESY THE ARTIST
© BETTINA JOHAE

PAGE 42
ED BURTYNSKY
NEWTOWN CREEK #1, NEW YORK, USA, 2005
DIGITAL C-PRINT
48 X 60 IN.
COURTESY HASTED HUNT KRAEUTLER, NEW
YORK & NICHOLAS METIVIER, TORONTO
© EDWARD BURTYNSKY

PAGE 43
ED BURTYNSKY
NEWTOWN CREEK #3, NEW YORK, USA, 2005
DIGITAL C-PRINT
48 X 60 IN.
COURTESY HASTED HUNT KRAEUTLER, NEW
YORK & NICHOLAS METIVIER, TORONTO
© EDWARD BURTYNSKY

PAGES 44–45
ATTA KIM
ON-AIR 110-1 THE NEW YORK SERIES, 2005
C-PRINT
74 X 97.5 IN.
COURTESY THE ARTIST
© ATTA KIM

PAGES 46–47
ATTA KIM
ON-AIR 110-9 THE NEW YORK SERIES, 2005
C-PRINT
74 X 97.5 IN.
COURTESY THE ARTIST
© ATTA KIM

PAGE 48
DAVID ARMSTRONG
42ND STREET, TIMES SQUARE, 1997
MATTE CIBACHROME PRINT
20 X 30 IN.
COURTESY THE ARTIST

PAGE 49
DAVID ARMSTRONG
8TH AVENUE IN THE FIFTIES, 2000
MATTE CIBACHROME PRINT
20 X 30 IN.
COURTESY THE ARTIST

PAGES 50–51
JACK PIERSON
TWILIGHT TIME, 1997
C-PRINT
40 X 30 IN.
COURTESY CHEIM & READ, NY
© JACK PIERSON

PAGE 52
JOSE MANUEL BALLESTER
NOCTURNO SOBRE BROADWAY 2–2,
KODAK PROFESSIONAL PAPER
70.16 X 100 IN.
COURTESY CHARLES COWLES GALLERY, NY
© JOSE MANUEL BALLESTER

PAGE 53
JOSE MANUEL BALLESTER
NOCTURNO SOBRE BROADWAY 1, 2006
KODAK PROFESSIONAL PAPER
70.28 X 104.09 IN.
COURTESY CHARLES COWLES GALLERY, NY
© JOSE MANUEL BALLESTER

PAGES 54–55
LYNN SAVILLE
COLUMBUS CIRCLE, 2007
CHROMOGENIC COLOR PHOTOGRAPH
30 X 40 IN.
COURTESY YANCEY RICHARDSON GALLERY
© LYNN SAVILLE

PAGES 56–57
OLIVO BARBIERI
GUGGENHEIM MUSEUM, 2007
INKJET PRINT ON ARCHIVAL PAPER
43.7 X 59.4 IN.
COURTESY YANCEY RICHARDSON GALLERY
© OLIVO BARBIERI

PAGES 58–59
OLIVO BARBIERI
IAC BUILDING, 2007
INKJET PRINT ON ARCHIVAL PAPER
43.7 X 59.4 IN.
COURTESY YANCEY RICHARDSON GALLERY
© OLIVO BARBIERI

PAGES 60–61
MICHAEL LIGHT
*$3 BILLION NEWTOWN CREEK WASTEWATER
TREATMENT PLANT LOOKING WEST, BROOKLYN,
NY*, 2007
PIGMENT PRINT ON ALUMINUM
40 X 50 IN.
COURTESY THE ARTIST AND CRAIG KRULL
GALLERY, SANTA MONICA
© 2007 MICHAEL LIGHT

PAGES 62–63
MICHAEL LIGHT
*JACQUELINE KENNEDY ONASSIS RESEVOIR SEEN
FROM 98TH STREET AND LEXINGTON AVENUE,
NEW YORK, NY*, 2007
PIGMENT PRINT ON ALUMINUM
40 X 50 IN.
COURTESY THE ARTIST AND CRAIG KRULL
GALLERY, SANTA MONICA
© 2007 MICHAEL LIGHT

PAGES 64–65
VIK MUNIZ
*CROWD AT CONEY ISLAND, TEMPERATURE 89°,
THEY CAME EARLY AND THEY STAYED LATE, JULY
1940, AFTER WEEGEE (PICTURES OF PAPER)*, 2009
DIGITAL GELATIN SILVER PRINT

48 X 61 IN.
COURTESY SIKKEMA & JENKINS CO.
ART © VIK MUNIZ / LICENSED BY VAGA,
NEW YORK, NY

PAGES 66–67
VINCENT LAFORET
CONEY ISLAND, JUNE 18TH, 2006
INKJET PRINT
40 X 60 IN.
COURTESY THE ARTIST
© 2006 VINCENT LAFORET

PAGES 68–69
VINCENT LAFORET
BRYANT PARK, MAY 31ST, 2006
INKJET PRINT
40 X 60 IN.
COURTESY THE ARTIST
© 2006 VINCENT LAFORET

PAGES 70–71
SANGBIN IM
PEOPLE-MOMA (DIPTYCH), 2009
LAMBDA PRINT
TOP: 31.5 X 72 IN. BOTTOM: 13.5 X 72 IN.
COURTESY THE ARTIST, MARY RYAN GALLERY,
AND PKM GALLERY
© SANGBIN IM

PAGES 72–73
JOHN FITZGERALD
*ASTORIA POOL DURING THE BLACKOUT, JULY 22,
2006*
COURTESY THE ARTIST
© JOHN FITZGERALD

PAGES 74–75
DAVID DREBIN
GIRL IN WINDOW, 2009
C-PRINT
48 X 60 IN.
COURTESY THE ARTIST
© DAVID DREBIN

PAGES 76–77
DAVID DREBIN
THE GIRL IN THE ORANGE DRESS, 2009
C-PRINT
48 X 72 IN.
COURTESY THE ARTIST
© DAVID DREBIN

PAGES 78–79
DAVID HILLARD
WHITE NOISE, NYC, 2009
DIPTYCH
24 X 20 IN.
COURTESY YANCEY RICHRDSON GALLERY
© DAVID HILLARD

PAGES 80–81
YASMINE CHATILA
THE BACHELOR–WALL ST. FRI 11:34 PM, 2008
DIGITAL C-PRINT
54 X 67 IN.
COURTESY THE ARTIST
© YASMINE CHATILA

PAGES 82–83
YASMINE CHATILA
STONERS IN OVAL WINDOW–SOHO, THU 10:32 PM,
2008
DIGITAL C-PRINT
54 X 67 IN.
COURTESY THE ARTIST
© YASMINE CHATILA

PAGE 85
CLOCKWISE FROM TOP LEFT:
TONY OURSLER
GROUND ZERO 3, 2002
C-PRINT
20 X 24 IN.
COURTESY THE ARTIST AND
LEHMANN MAUPIN, NY
© TONY OURSLER

TONY OURSLER
GROUND ZERO 5, 2002
C-PRINT
20 X 24 IN.

COURTESY THE ARTIST AND
LEHMANN MAUPIN, NY
© TONY OURSLER

TONY OURSLER
GROUND ZERO 6, 2002
C-PRINT
20 X 24 IN.
COURTESY THE ARTIST AND
LEHMANN MAUPIN, NY
© TONY OURSLER

TONY OURSLER
GROUND ZERO 7, 2002
C-PRINT
20 X 24 IN.
COURTESY THE ARTIST AND
LEHMANN MAUPIN, NY
© TONY OURSLER

TONY OURSLER
GROUND ZERO 1, 2002
C-PRINT
20 X 24 IN.
COURTESY THE ARTIST AND
LEHMANN MAUPIN, NY
© TONY OURSLER

TONY OURSLER
GROUND ZERO 2, 2002
C-PRINT
20 X 24 IN.
COURTESY THE ARTIST AND
LEHMANN MAUPIN, NY
© TONY OURSLER

PAGES 86–87
JEFF MERMELSTEIN
TWIRL # 2, 2001
CHROMOGENIC PRINT FLUSH-MOUNTED TO
DIBOND
12 X 16 IN.
COURTESY JEFF MERMELSTEIN AND RICK
WESTER FINE ART
© JEFF MERMELSTEIN

PAGES 88–89
JEFF MERMELSTEIN
TWIRL # 13, 2008
CHROMOGENIC PRINT FLUSH-MOUNTED TO
DIBOND
12 X 16 IN.
COURTESY JEFF MERMELSTEIN AND RICK
WESTER FINE ART
© JEFF MERMELSTEIN

PAGE 90
NORITOSHI HIRAKAWA
*AN ATTRIBUTE OF LIVING (DELMESHIA / PINE
STREET, NEW YORK / 11:50 A.M., FEBRUARY 9TH,
2007)*
FROM *AT A POINT OF VERGE* TRIPTYCH, 2010
ILFORD RC DIGITAL PRINT
16.75 X 25.2 IN.
COURTESY ZENO X GALLERY, ANTWERP
© NORITOSHI HIRAKAWA

PAGES 90–91
NORITOSHI HIRAKAWA
AT A POINT OF VERGE, 2010
DURAFLEX PRINT
38 X 25.2 IN.
COURTESY THE ARTIST
© NORITOSHI HIRAKAWA

PAGE 91
NORITOSHI HIRAKAWA
*AN ATTRIBUTE OF LIVING (MARISSA / STONE
STREET, NEW YORK / 12:30 P.M., FEBRUARY 18TH,
2007)*
FROM *AT A POINT OF VERGE* TRIPTYCH, 2010
ILFORD RC DIGITAL PRINT
16.75 X 25.2 IN.
COURTESY ZENO X GALLERY, ANTWERP
© NORITOSHI HIRAKAWA

PAGES 92–93
LARRY RACIOPPO
SUNBATHER AND GIGLIO, 1998
CHROMOGENIC COLOR PRINT
20 X 30 IN.
COURTESY THE ARTIST
© LARRY RACIOPPO

PAGES 94–95
PASCAL PERICH
*SEUNGLUNG ON THE MANHATTAN BRIDGE,
10/19/2007*
ARCHIVAL PIGMENT PRINT.
20 X 30 IN.
COURTESY THE ARTIST
© 2007 PASCAL PERICH

PAGE 96
KATE SCHERMERHORN
SILVERCUP 1, 2009
GLICEE PRINT
16 X 20 IN.
COURTESY FIFTY ONE FINE ART / KATE
SCHERMERHORN
© KATE SCHERMERHORN

PAGE 97
KATE SCHERMERHORN
SILVERCUP 2, 2009
GLICEE PRINT
16 X 20 IN.
COURTESY FIFTY ONE FINE ART / KATE
SCHERMERHORN
© KATE SCHERMERHORN

PAGES 98–99
BARRY FRYDLENDER
MUSEUM (METROPOLITAN), 2005
CHROMOGENIC COLOR PRINT
48 X 104.5 IN.
COURTESY ANDREA MEISLIN GALLERY, NY
© BARRY FRYDLENDER

PAGES 100–101
TOP–BOTTOM:
DOUG FOGELSON
BROADWAY & PRINCE
C-PRINT
11.5 X 118 IN.
COURTESY THE ARTIST
©DOUG FOGELSON

DOUG FOGELSON
LOWER EAST SIDE
C-PRINT
9 X 118 IN.
COURTESY THE ARTIST
©DOUG FOGELSON

DOUG FOGELSON
PRINCE & LAFAYETTE
C-PRINT
9 X 118 IN.
COURTESY THE ARTIST
©DOUG FOGELSON

PAGES 102–103
PETER FUNCH
DOBBELTGANGER, 2007
C-PRINT
51 X 23 IN.
COURTESY VI GALLERY
© PETER FUNCH

PAGES 104–105
PETER FUNCH
INFORMING INFORMERS, 2006
C-PRINT
51 X 23 IN.
COURTESY VI GALLERY
© PETER FUNCH

PAGES 106–107
PETER FUNCH
SMOKING SMOKERS, 2006
C-PRINT
51 X 23 IN.
COURTESY VI GALLERY
© PETER FUNCH

PAGE 108–109
ARASH RADPOUR
ROOSEVELT ISLAND #3, 2004
D-PRINT
29.5 X 39.3 IN.
COURTESY GRAZIELLA LEONARDI COLLECTION
© 2010 ARASH RADPOUR

PAGES 110–111
ANTHONY GOICOLEA
SMOKE STACK, 2007